SEV

Books should be returned or renewed by the last date above. Renew by phone **08458 247 200** or online *www.kent.gov.uk/libs*

ibraries & Archives

SHAKESPEARE'S RESTLESS WORLD

Neil MacGregor

PENGUIN BOOKS

PENGUIN BOOKS

Published by the Penguin Group
Penguin Books Ltd, 80 Strand, London WC2R ORL, England
Penguin Group (USA) Inc., 375 Hudson Street, New York, New York 10014, USA
Penguin Group (Canada), 90 Eglinton Avenue East, Suite 700, Toronto, Ontario,
Canada M4P 2Y3 (a division of Pearson Penguin Canada Inc.)
Penguin Ireland, 25 St Stephen's Green, Dublin 2, Ireland
(a division of Penguin Books Ltd)
Penguin Group (Australia), 707 Collins Street, Melbourne, Victoria 3008, Australia
(a division of Pearson Australia Group Pty Ltd)
Penguin Books India Pvt Ltd, 11 Community Centre,
Panchsheel Park, New Delhi – 110 017, India
Penguin Group (NZ), 67 Apollo Drive, Rosedale, Auckland 0632, New Zealand
(a division of Pearson New Zealand Ltd)
Penguin Books (South Africa) (Pty) Ltd, Block D, Rosebank Office Park,
181 Jan Smuts Avenue, Parktown North, Gauteng 2193, South Africa

Penguin Books Ltd, Registered Offices: 80 Strand, London WC2R ORL, England

www.penguin.com

First published by Allen Lane 2013
First published by Penguin Books 2014
001

Copyright © the Trustees of the British Museum and the BBC, 2012
All rights reserved

The moral right of the author has been asserted
By arrangement with the BBC and the British Museum
The BBC logo and the Radio 4 logo are registered trademarks of the British Broadcasting
Corporation and are used under licence

BBC logo copyright © BBC 1996
Radio 4 logo copyright © 2008

Without limiting the rights under copyright
reserved above, no part of this publication may be
reproduced, stored in or introduced into a retrieval system,
or transmitted, in any form or by any means (electronic, mechanical,
photocopying, recording or otherwise) without the prior
written permission of both the copyright owner and
the above publisher of this book

Set in 10.6/13.75 pt Sabon LT Std

Typeset by Jouve (UK), Milton Keynes
Printed in Great Britain by Clays Ltd, St Ives plc

ISBN: 978-0-718-19570-0

www.greenpenguin.co.uk

MIX
Paper from
responsible sources
FSC
www.fsc.org FSC™ C018179

Penguin Books is committed to a sustainable
future for our business, our readers and our planet.
This book is made from Forest Stewardship
Council™ certified paper.

Contents

Introduction:
Inside the Wooden O

Can this cockpit hold
The vasty fields of France? Or may we cram
Within this wooden O the very casques
That did affright the air at Agincourt?

Piece out our imperfections with your thoughts:
Into a thousand parts divide one man,
And make imaginary puissance.
Think, when we talk of horses, that you see them
Printing their proud hoofs i' th' receiving earth;
For 'tis your thoughts that now must deck our kings . . .

On a number of occasions Shakespeare speaks directly to his public. The author, in the guise of Prologue, Epilogue or Chorus, invites the audience to join him in a shared act of poetic creation: together they will for a few hours imagine and inhabit another world. 'Piece out our imperfections with your thoughts', the Chorus famously requests at the opening of *Henry V*. As Shakespeare's publics entered the theatre – 'the wooden O' – what were their thoughts? What were the formative communal memories, assumptions and misconceptions that enabled them to 'make imaginary puissance'? What fears and faith, what shared bits and pieces of history let them 'deck

our kings'? What, in short, was the mental scenery they carried with them, against which they would hear Henry V rally the English troops, watch a weaver become an ass, and see Julius Caesar die?

We can travel into those private worlds through contemporary texts, the scholarly and literary publications of the day, as E. M. W. Tillyard memorably did in the late 1940s in *The Elizabethan World Picture*, and as other great scholars have done since. But works of literature and philosophy, science and religion, which allow us today to recover an entire cosmology, were not read by many at the time, and hardly at all by those in the cheaper seats. Economic and social historians bring us much closer to the daily concerns of this part of the audience, and recent literary historians have fruitfully begun to relocate Shakespeare in his town and in his time.

The chapters that follow do not draw principally on literary resources; nor do the things in them make for a narrative history of England around 1600. They aim instead to take us immediately to a particular person or place, to a way of thinking and of acting which may be difficult to recover if we work only from texts, or look top-down at broader historical currents. They are a physical starting point for a three-way conversation between the objects themselves, the people who used or looked at them, and the words of the playwright which have become such an embedded part of our language and our lives.

It is the strange potency of things that, once we have made them, they can change us. This is a truth the world's great religions have always understood and exploited. Holy relics or sacred sites have the power to transport us in time, and to transform us. We feel that we can stand beside the prophets or the saints, share their humanity, inhabit – for a brief, intense moment – their world. This book is about twenty such journeys, through the charisma of things, to a past world. But its purpose is not to bring us close to any particular saint or hero,

or indeed even to the figure at its centre, William Shakespeare himself. We know little about what Shakespeare did, and cannot hope to recover his thoughts or his faith with any degree of certainty. Shakespeare's inner world remains exasperatingly opaque. The objects in this book allow us instead to share the experiences of Shakespeare's public – the thousands of men and women who were in the theatres of Elizabethan and Jacobean London when his plays were first performed, and for whom he wrote them. What was their world?

The fact that ordinary men and women were in a theatre at all in the 1590s shows it was a world very different from the one their parents had inhabited. The commercial playhouse as we know it today was then a new development, an innovation in mass entertainment as radical as television in the 1960s. When Shakespeare was a boy, most theatrical productions would have taken place in the house of a nobleman or a royal palace, or in a large public room – like the Gildhall in Stratford. There would have been few spaces specifically designed for stage productions. The first purpose-built theatre in England opened in London in 1576, when Shakespeare was twelve years old. These new buildings were a new kind of business, operating on a new financial model. By the time Shakespeare's career took off in the 1590s, the pattern of a commercial theatre with seats (or standing places) at all prices, and – crucially – catering for all classes of society, was well established. It, and its public, shaped his plays.

As with television in the 1960s, the new theatres attracted some of the greatest writing talents of the day. It was the most lucrative route for young professional writers to follow, and they wrote with an eye to their audiences. Everybody who paid to see a play would hope to see people like themselves have a part in its story: consequently, and unlike the noble dramas of French classical theatre, English plays include all sorts – the porters and the gravediggers, the constables of the

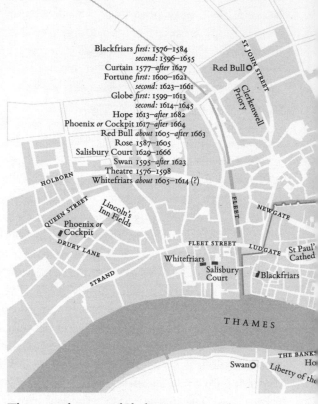

Blackfriars *first:* 1576–1584
second: 1596–1655
Curtain 1577–after 1627
Fortune *first:* 1600–1621
second: 1623–1661
Globe *first:* 1599–1613
second: 1614–1645
Hope 1613–after 1682
Phoenix *or* Cockpit 1617–after 1664
Red Bull *about* 1605–after 1663
Rose 1587–1605
Salisbury Court 1629–1666
Swan 1595–after 1623
Theatre 1576–1598
Whitefriars *about* 1605–1614 (?)

The main theatres of Shakespeare's London

watch and the lads just hanging around in the street. They were in the audience. They were on the stage.

There was nothing quite like these theatres on the Continent. Yet the shape of these very English buildings carried echoes of another, distant world; for in constructing their new places of entertainment, the modern Londoners had in their minds the theatres of ancient Rome – indeed they called them by the ancient name 'theatres' in conscious emulation of the classical world. It was a building type that had hardly been constructed for over a thousand years, but it was known from

the many survivals in France and Italy, described in travellers' narratives and familiar from architectural engravings. In London, playhouses were built not in severe dressed stone after the high Roman fashion, but in wood and plaster. To go to the theatre is always to visit other worlds. Yet simply to enter one of these new-built open-air theatres was – in some measure at least – to assert your place in the classical tradition, to live for two hours among the stories, and sometimes among the heroes, of the ancient Mediterranean world. For an afternoon, you could be both an antique Roman and a modern English man or woman. This is the assumption behind the temporary

triumphal arches of Chapter Eighteen. And since everybody then knew for a fact that Julius Caesar himself had built the Tower of London, it was not perhaps such a surprising assumption for Shakespeare's Londoners as it would be today.

It is the founding principle of all advertising that we can become the people we long to be if only we own the right things. This was as true in 1600 as it is today. For example, we know from texts and memoirs, and indeed from the settings of Shakespeare's plays, how fervently many Elizabethans adulated and emulated contemporary Italy. But we grasp that adulation with a sharper intensity when we confront a stylish, expensive fork, proudly initialled A.N., which was dropped in the Rose Theatre and 300 years later found among the rubble.

We know nothing of A.N.'s life, whether he was a smart young aristocrat or she a high-end whore, but we do, I think, know something about how A.N. wanted to be seen. What survives of A.N. is not, as Larkin would have it, love, but aspiration. For A.N., whoever he or she was, was clearly eager to be thought fashionable and elegant – and willing to pay a lot for it. And the home of elegance, of sharp clothes and smart behaviour, was not England, but Italy. Looking at that long-lost fork, as we shall in Chapter Three, we glimpse what its owner wanted to be – the very model of Milanese or Venetian good manners. Like the French cigarettes eagerly smoked by British undergraduates in the 1960s, the fork placed A.N. in a world of culture and sophistication that thousands of contemporaries longed to be part of. To go to Italy was the privilege of the few. But for as little as a penny, if *Much Ado About Nothing* was showing, you could be in Messina, in the company of young lords from Florence and Padua: a trip to the theatre was a day out in the land of A.N.'s dreams.

The rapier lost one night on the foreshore of the Thames (Chapter Five), another swagger Italianate gadget, also spoke loudly of status and style, and like the fork brought with it a

particular way of moving that, once learned, would be widely admired. If push came to shove, this high-class weaponry also brought with it a new, foreign set of fighting conventions, fatally embraced by the sword-carrying young of London, and put on stage in the Verona of *Romeo and Juliet*. Eating or brawling, objects like these showed you for the sophisticate you strove so hard to be.

Such objects also break down completely the division we naturally make today between on- and off-stage, between the audience, the cast and the city. They bring the action of the plays first into the pit and then into the street. Rapiers just like the one lost in Chapter Five would have been used on stage by Hamlet and Laertes, and both the actors playing them would have been expert in handling them. They would also have been used on the very same stage in prize contests between professional swordsmen to keep up revenues when there was no play showing. Many in the audience would have been carrying similar weapons, and might well use them to defend themselves or pick a quarrel on the way home. A number of them would be arrested; some would be killed. Modern Italy, as much as ancient Rome, was a world that Shakespeare's public wanted not just to visit but to appropriate, and acquiring these new things made it exhilaratingly graspable.

There was another world to which the theatre, or in this case, the Chorus, invited the public to travel. It was a world no less beguiling than contemporary Italy, although much harder to possess or to know. But then knowing medieval England was never really the point: it was a land to imagine, to be proud of, and to strive to match. The making of modern Elizabethan England went hand in hand with the invention of an earlier one. At a moment of national crisis, of Spanish threat and Irish war, plays focused on English history were the great hits of the 1590s, staples of the new commercial theatre, a key element in forging a new communal consciousness. They made Shakespeare's reputation and his fortune.

Could his theatre contain 'the very casques that did affright the air at Agincourt'? No. The helmets at the Globe would be stage props. But that hardly mattered, because his audience could see the only casque that really counted for a penny at Westminster Abbey; and great numbers of them did. The price of entrance to the Abbey was the same as the price of a standing place in the pit at the Globe, and for that penny the Elizabethan visitor could see the monument to Henry V, Scourge of the French, and above, his helmet, and the sword with which he had led his troops to victory (Chapter Six).

These were as real and as popular as Churchill's wartime bunker today, as solid and reliable a foundation for a fantasy of historic national unity and continuing national triumph. To Shakespeare's generation, the first for almost 500 years to inhabit an England with no possessions in France (Calais had been lost in 1558), and struggling with an interminable war in Ireland, Henry's helmet and sword must have spoken as powerfully as Shakespeare's verse. A newly Protestant England had few public objects it could invest with such exceptional collective meaning. Westminster Abbey, for centuries the shrine of saints, had become a shrine of kings.

These are secular relics of a high order, all the more potent since religious relics had largely disappeared from public view as a result of the brutal destructions of the Reformation. The breach with Rome had also led to new notions of a Church of England, distinct from other parts of Christendom. For Shakespeare's audience, to look at Henry's funeral achievements in the Abbey and then to hear him address his men on stage was to experience the overlapping claims between the religion of the nation and the nation as religion. As we shall see in a number of chapters, this carefully contrived conflation of the spirit and the state both created a new national self and divided it.

There were worlds which the theatre did not – dared not – enter. The world of the plague, central to the audience's

existence (or, for many of them, non-existence), is rarely and only marginally present in the plays. The neighbouring, yet infinitely distant, world of Ireland, a constant preoccupation of politicians, a threat to public security and a huge drain on public expenditure, is effectively invisible in Shakespeare's texts. And the consuming, unspoken fear of what would happen to the country when the Queen died with no heir was for decades a subject banned by law – a topic that nobody could discuss without fear of imprisonment or worse.

Here objects can do what textual criticism cannot. They bring into view anxieties not voiced by actors, but which the audience brought with them to the theatre – anxieties which shaped their response to the dynastic struggles and the foreign wars that they watched being enacted on stage. The most unsettling of all these fears was that the Queen would be murdered by England's enemies. With a solid foundation in truth, as we shall see in Chapter Eleven, it was fear carefully nurtured by the authorities themselves. The anxiety that all around were secret agents, plotting in concealment the killing of the monarch and the overthrow of the state, must have sharpened the edge of Shakespeare's many speeches about assassination and conspiracy. And Edward Oldcorne's eye (Chapter Nineteen) is evidence that agents of a foreign power had indeed, just as people feared, successfully infiltrated the country. It is easy for us to disparage such fears as paranoia. But the disguises in the pedlar's trunk of Chapter Fourteen are proof that there really was a network of those believed to be disloyal to the Queen, moving, dissembling and concealed, through England.

That shrivelled eye is also one of those objects which, like the fork and the rapier, link the theatre to the street. Oldcorne's execution was a public spectacle, a crowd-pleasing scene in a theatre of cruelty which first drew, then horrified, mesmerized and entertained huge numbers. This relic makes Shakespeare's use of the word 'scaffold' to mean a stage for mounting both

plays and executions not just an inventive linguistic elision, but a recognition that the same public sought the same thrill in both events. Scenes of killing, dismemberment and decapitation were usual and were enjoyed in real life as in theatre. On London Bridge, theatre-goers walked past severed heads on pikes. No surprise to see them carried on to the stage.

Oldcorne's eye, far more compelling than any symbol, connects us directly to the religious division of the nation, and its human cost. It also brings us back to the power of relics to strengthen faith. For those who held to the old, Catholic faith, his eye, preserved and enclosed in precious metal, represented the courage of those willing to make the ultimate sacrifice for their beliefs. Its purpose was to honour Oldcorne, and to inspire and prepare others to follow his example. No text could plead so powerfully as this thing. We may all in some measure understand (share?) the Shakespearean public's bloodlust, but few of us would assume as easily as they did that it was not just admirable, but to be expected, that a man would die for his faith – that many recently had, and that many more in this bitterly divided England soon would. This is a world far from our modern western mind, baffled by those consciously seeking martyrdom.

When Shakespeare's plays were published in the First Folio in 1623, they themselves became an object, which could eventually be replicated without limit all round the world. It is a pleasing closing of the circle that with the last object discussed in this book – the Robben Island Bible – the text of Shakespeare has itself become a relic, in this case a witness to the long struggle against apartheid. In a way none of the prisoners on Robben Island could have expected, our engagement with the passages they marked is changed by knowing that they read them in their captivity. *The Complete Works of William Shakespeare*, disguised as a holy Hindu book, has itself become an eloquent object.

Napoleon famously said that, to understand a man, you need to understand the world when he was twenty years old. This book aims to understand not a man but a generation – those born in England around 1560. When this generation was twenty, it was not just England that was confronting new realities: the consciousness of all Europe was in flux. Religious conflict had scarred most of the Continent, fracturing states and leading to violent civil wars. In the 1580s it was not at all clear how those conflicts would – or could – end. Political and economic power was moving from central and Mediterranean Europe to the Atlantic in a world that, to its alarmed enemies, seemed to be dominated by one military superpower – Spain.

And beyond Europe? 'Our world has just found another,' wrote the French essayist Michel de Montaigne in the 1580s, 'and who can be sure this will be the last of its brothers?' The Spanish and the Portuguese, the French, the Dutch and the English had all ventured into lands previously unknown to Europeans. And they had found peoples and kingdoms which not only dazzled and frightened them, but undermined all their certainties about what mankind was meant to be.

If these were our new 'brothers', how many more were there? And if, as Othello told Desdemona, some were 'Cannibals that each other eat' and 'men whose heads do grow beneath their shoulders', what sort of family did we all belong to? Nothing in the Bible or the Classical authors had quite equipped us for this. It was up to new writers and new thinkers to imagine a new humanity.

If the generation born around 1560 survived into adulthood these were the people who in their thirties and forties first saw Shakespeare's plays: they had to confront a world radically unlike that of their parents, a world recently expanded in size, yet collapsed in many of its central assumptions. It is the world of Chapter One.

Chapter One

England Goes Global

Sir Francis Drake's circumnavigation medal

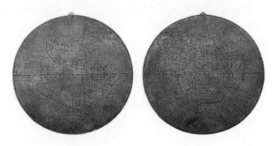

OBERON: We the globe can compass soon,
 Swifter than the wandering moon.

PUCK: I'll put a girdle round about the earth
 In forty minutes.

On Christmas Eve 1968, *Apollo 8* became the first manned spaceship to circle the moon, and the film footage that NASA sent back changed our perception of the world. For there, as the three astronauts rounded the dark side of the moon, was the earth itself, a great globe suspended in the vast darkness of space. It was the first time any human being had seen the whole planet at a single glance, and the world has thought about itself differently ever since.

Nearly four hundred years earlier, a very different journey had caused a comparable revolution if on a smaller, national scale. In 1580, Sir Francis Drake became the first Englishman,

and only the second captain in history, to sail his ship round the globe. In consequence, to the English, the world looked suddenly different. Its limits were known: it could be mapped and plotted. It could be circled and crossed by a single English ship. In 1580, Shakespeare was sixteen. For him and his contemporaries, the boundaries of human possibility – for travel, adventure, knowledge and conflict – had been dramatically expanded.

In *A Midsummer Night's Dream*, the mischievous Puck boasts to Oberon, king of the fairies, that he can circumnavigate the globe in just over half an hour – even faster than a modern satellite, which at 200 miles up takes about ninety minutes. As everybody in the audience knew, it had taken Francis Drake nearly three years. The silver medal struck to celebrate Drake's achievement shows the world that he traversed. It is about seven centimetres in diameter and almost paper-thin. On one side are Europe, Africa and Asia, and on the other the Americas. As you turn it in the light, you can see tiny dots indicating the route that Drake followed. From Plymouth down to the tip of South America, up the coast of South America, where Lima and Panama are both marked, on to California, over the Pacific to the Spice Islands in Indonesia, then round the Cape of Good Hope, up the coast of West Africa and home. An inscription around the South Pole tells us, in abbreviated Latin, 'D. F. Dra. Exitus anno 1577 id. Dece.' ('The departure of Francis Drake, in the year 1577, on the ides [13th] of December'), and one on the other side records his 'Reditus anno 1580. 4 Cal. Oc.' ('Return in the year 1580 on the 4th of the calends of October [28 September]').

Created about the time that Shakespeare began his theatrical career in London, this silver souvenir map – glamorous, scientific, fashionable – lets us grasp, literally, how you could imagine the world in the 1580s and 1590s. For the Elizabethan play-goer watching *A Midsummer Night's Dream* in the 1590s for the first time, encompassing the globe, putting a

girdle around the earth, was news – patriotic news that every person in the audience would have known about. In their Athenian wood, Shakespeare's very English fairies are, in their whimsical, poetical way, restating the nation's pride in Drake's accomplishment, just like this silver medal.

One of Drake's crew described the end of the dramatic round-the-world journey on the *Golden Hind*:

> And the 26 of September* we safely with joyful minds and thankful hearts to God arrived at Plimouth, the place of our setting forth after we had spent 2 yeares 10 moneths and some odd few days besides in seeing the wonders of the Lord in the deep, in discouering so many admirable things, in going through so many strange adventures, in escaping out of so many dangers, and ouercoming so many difficulties in this our encompassing of the neather globe, and passing round the world.

This 'passing round the world' brought with it exotic goods and even more exotic tales that would go on to fire the public imagination. Just as importantly, it was the sixteenth-century equivalent of the 'space race', as England, with far fewer resources, first tried to match Spain's skill and technology in navigating and then began to raid the huge wealth of the Spanish Empire. This circumnavigation medal celebrates England's first great success on both fronts, and the next two decades saw dozens of English adventurers set off to emulate Drake's example. England's passion for seafaring became a heady confluence of plundering and exploration, scientific inquiry and geopolitical manoeuvring.

During his journey, Drake discovered two important facts till then unknown to Europeans. He 'found' the new lands

* The return of the *Golden Hind* to Plymouth was incorrectly recorded as the 4th of the Calends of October (in other words, 28 September) in the inscription on the medal.

north of present-day California, but, of more immediate strategic significance, he showed that Tierra del Fuego was part of an archipelago, and not connected to the supposed southern continent, the Terra Australis. This meant he had found a new route, later to be named Drake's Passage, from the South Atlantic to the Pacific, which did not involve passing through the Spanish-controlled Strait of Magellan. For strategic reasons, the precise details of Drake's voyage, in particular his discovery of the true extent of Tierra del Fuego, were treated as a state secret for several years. It was only after the English saw off the Spanish Armada in 1588 that a large map of the circumnavigation went on triumphant public display on the walls of Elizabeth I's palace in Whitehall. The palace was a public place, where much business was done, open to thousands of visitors – and Shakespeare would almost certainly have been amongst them. Our silver medal was a reduced, portable version of the Whitehall wall map with exactly the same purpose – to be a patriotic statement of Drake's great feat. The medal, like the map, was a calculated piece of political propaganda.

Peter Barber, responsible for the maps at the British Library, is intrigued by the way the Drake map/medal presents its 'information':

> If you look, you'll see that at the top of North America, there is a little note saying that this was discovered by the English (which historically speaking is fairly outrageous) and further down you have a marking of the Virginia colony, which would have made any Spaniard see red. But what is particularly interesting is that the Virginia colony, which is marked on the medal, was founded after Drake got back from his round the world cruise. So this map we now know was not made in 1580, but 1589, in other words a year after the Armada.

The provocative teasing of the Spaniards goes on all over this very cheeky medal. Just above California you can see in large letters the words 'Nova Albion' (New England or New Britain) striding across much of North America. Below, 'N. Hispania' (New Spain) looks as though it could be just a cattle ranch west of Texas.

Somewhere off the coast of Peru and Panama, Drake had raided Spanish ships and had captured nearly ten tons of silver, and to add insult to Spanish injury the medal is almost certainly made from that stolen silver. The silver also bought spices in the East Indies (the Spice Islands are named in surprising detail) so Drake came home to Plymouth with a cargo worth a fortune, having turned a serious profit on his expedition. His financial backers recovered their investment many times over, while the Queen took a share that almost doubled her annual income. An exploration of this kind was not just an adventure, it was also big business, and maps and globes allowed everybody, not just the investors, to share in the fun. Maps had of course been in circulation for a long time. Globes were rarer, but much sought after, and by the 1590s were being produced in London – two magnificent examples made by Emery Molyneux can still be seen in Middle Temple.

In *The Comedy of Errors*, written around 1592, Dromio, the quick-witted servant, outrageously compares a plump kitchen maid to a globe as he sets off on a raunchy geography lesson, looking for treasure all over her.

DROMIO: She is spherical, like a globe. I could find out countries in her.

ANTIPHOLUS: In what part of her body stands Ireland?

DROMIO: Marry, in her buttocks. I found it out by the bogs.

ANTIPHOLUS: Where Scotland?

DROMIO: I found it by the barrenness, hard in the palm of her hand.

The wretched maid is the butt of one sexist, xenophobic joke after another.

ANTIPHOLUS: Where America, the Indies?

DROMIO: Oh, sir, upon her nose all o'er embellished with rubies, carbuncles, sapphires, declining their rich aspect to the hot breath of Spain; who sent whole armadoes of carracks to be ballast at her nose.

ANTIPHOLUS: Where stood Belgia, the Netherlands?

DROMIO: Oh, sir, I did not look so low.

Eventually the kitchen maid, like the globe, is completely circumnavigated. Like the maid, like Spanish silver, the world is there for the taking. The Drake silver medal is merely the top end of a huge market for maps that let the English of all classes see where their ships had been venturing.

Jonathan Bate, Shakespeare scholar and biographer, describes this development:

It is not really until the period when Shakespeare's plays are being written, the end of Queen Elizabeth's reign, that people get a real visual sense of the whole world, and in particular the roundness of the world. There is a lovely moment in *Twelfth Night* where Malvolio is being forced to smile and the smile is causing lines to crease his face, and Maria says 'he does smile his face into more lines than is in the new map with the augmentation of the Indies'. She is referring there to a very famous map that was made in 1599 to accompany Hakluyt's *Principall Navigations*, a book that gave an account of the voyages of the English navigators around the world, and in that map there are lines of latitude and longitude, so it looks like a sort of creased face. But that map of the augmentation of the Indies [that is, with the very latest geographical information added] was clearly a great novelty at the time.

Richard Hakluyt's famous and widely read book *The Principall Navigations, Voiages and Discoveries of the English Nation* had first appeared in 1589, but a significant new edition, updated and expanded into three volumes, was published ten years later. It was a work that both commemorated the triumph of English seafaring and urged further exploration and swifter colonization. The 1590s saw Sir Walter Raleigh's exploration of Guiana and Venezuela and in 1596, the year after his return, publication of his book, *The Discovery of Guiana*. Its heated claims of adventure and untold riches caught the public imagination, and in *Merry Wives of Windsor* Falstaff compares one of the two women he hopes to conquer to the great golden city described by Raleigh:

> FALSTAFF: Here's another letter to her. She bears the purse too.
> She is a region in Guiana, all gold and bounty. I will be
> cheaters to them both, and they shall be exchequers to me.
> They shall be my East and West Indies, and I will trade to
> them both.

Most of Shakespeare's plays that bring in exploration and discovery in this way cluster in the 1590s, the high days of Elizabethan seafaring.

The maps in Hakluyt, like this medal and indeed all maps and globes in Elizabethan England, were not of course navigational tools to be used to find your way around, but evidence of journeys taken by others. Peter Barber again:

> The first place an Elizabethan would have most likely have
> found a map would have been in a Bible. Protestant Bibles
> particularly contained maps to prove the veracity of the scriptures. This is where you went to see where important things
> happened, and to prove that they actually happened there. As
> English sailors told the authorities repeatedly in the 16th
> century, maps were a fat lot of use when you were actually at

sea. So the sort of maps we are looking at in the context of Shakespeare are really for armchair travelling, and they are interesting for their symbolic and educational aspects. In 1570 the first book of entirely modern maps was published, called *The Theatre of the Lands of the World*. So this idea of the world as a stage, which was picked up by Shakespeare, was around long before him.

The Flemish cartographer Abraham Ortelius's *Theatrum Orbis Terrarum* (*The Theatre of the Lands of the World*) was the first atlas as we would recognize it. The year before, in 1569, his compatriot Gerard Mercator had produced a 'new and augmented description of Earth corrected for the use of sailors', as he called it, based on what we now know as the Mercator projection. Mercator's mathematical calculations allowed for the planetary sphere to be expressed as a two-dimensional image and became the basis for the map of the world most familiar to us today. Gerard Mercator also sired a great dynasty of cartographers; one of the nine surviving Drake Circumnavigation medals is actually inscribed in abbreviated Latin: 'Micha. Merca: fecit extat Londi: prope templum Gallo: An 1589' ('Michael Mercator made this. It is available in London near the French Church, 1589'). Perhaps Michael, Gerard Mercator's grandson, produced a prototype Circumnavigation medal for Drake, who then commissioned more for distribution among friends and followers. When it was reproduced, Mercator's name was omitted, probably to allow Drake's name greater prominence. The connection with the Mercator family continues further, because the outline on the medal is based on the double-hemisphere world map drawn by Rumold Mercator, one of Gerard's sons, published in the first volume of Gerard Mercator's great *Atlas* of 1589.

The theatre which is most associated with Shakespeare today is a great London tourist attraction on the south bank of the Thames. But when Shakespeare and the equivalent of his marketing department sat down at the end of the 1590s to name it, they must have wanted a name that would fire the public imagination and outdo all the existing theatres – the Curtain, the Rose, and the one called, with a startling lack of originality, simply The Theatre. Shakespeare's company by contrast chose a name that was topical, one that, like that book of maps, was the *Theatre of the Lands of the World*, outlining all human experience. The name they chose was the Globe – a new way of thinking and showing the world.

Imagine you are a young Londoner in the mid 1590s. You have been on business at Whitehall palace, where you have seen the great wall map of Drake's voyage, and then you decide to go to that Shakespeare play you have heard about, *A Midsummer Night's Dream*. When you come to the scene between Oberon and Puck, just how much more resonant will these words be to you than to your jaded and globalized descendants some four hundred years later?

> OBERON: We the globe can compass soon,
> Swifter than the wandering moon.

> PUCK: I'll put a girdle round about the earth
> In forty minutes.

Chapter Two
Communion and Conscience
The Stratford Chalice

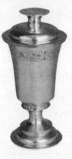

In every society, sharing a drink together affirms friendship and builds community. It's a universal ritual. It can be joyous, it can be ceremonial – and it can be dangerous. What you drink and who you drink it with is always significant. For Shakespeare's generation, if you were handed a cup by a bishop or a king and told to drink, how you responded could be, quite literally, a matter of life or death – in real life just as much as in the theatre.

Here is part of the closing scene of *Hamlet*:

KING: Stay, give me drink. Hamlet, this pearl is thine,
Here's to thy health. Give him the cup.
HAMLET: I'll play this bout first; set it by a while.
Come.
[*They play*]
Another hit. What say you?
LAERTES: A touch, a touch. I do confess't.
KING: Our son shall win.

QUEEN: He's fat and scant of breath.
 Here, Hamlet, take my napkin. Rub thy brows.
 The Queen carouses to thy fortune, Hamlet.
HAMLET: Good madam!
KING: Gertrude, do not drink.
QUEEN: I will, my lord. I pray you, pardon me.
 [*She drinks*]
KING: [*aside*] It is the poisoned cup. It is too late.

In 1600, when Shakespeare's audience at the Globe heard *Hamlet* for the first time, every one of them knew very well what it meant to be handed a cup of wine by a figure in authority and told to drink. And for every one of them, the stakes were high. This small silver cup with a matching lid, which is kept at Shakespeare's parish church, Holy Trinity in Stratford-upon-Avon, was, so far as we know, never used to poison anybody. But what this cup held, and what that meant, was a matter of life and death in this church as in every other church in sixteenth-century Europe.

It is quite a plain silver goblet: the only decoration is a run of engraved leaves and flowers round the rim. It is about thirteen centimetres high, stands on a small base and looks a little like a bell turned upside down. It is a communion cup, but it is specifically a Protestant communion cup, much simpler than the usual ornate Catholic chalice – a new kind of vessel for a new kind of religious service. It came to Stratford when Shakespeare was a boy as part of a nationwide campaign to make it clear to every town in England that Catholicism was well and truly finished, and that the Protestant Reformation was not only back under Elizabeth, but here to stay.

Henry VIII's break with Rome in the 1530s and the Reformation that followed had been brutal, but piecemeal. After Henry's death in 1547 came a dizzying six years of extreme Protestantism under his son, Edward VI, followed by a no

less vertiginous five years of vigorously reimposed Roman Catholicism under Edward's half-sister Mary, daughter of Henry's first wife, the Spanish princess Catherine of Aragon. When Elizabeth came to the throne in 1558 and reinstated Protestantism once more, many people must have wondered whether her reign and her religion were going to last long enough for it to be worth converting again.

In the Catholic mass, the wine in the chalice was drunk only by the priest. In the new Protestant service, every parishioner was allowed – indeed obliged – to sip it in commemoration of the Last Supper. A silver cup like this one therefore was, for Elizabethans, a kind of Protestant team-building exercise – a new communal experience, not just a religious innovation but a social and a political one, and one in which everybody had to join: drinking from this cup meant not just that you were a Protestant, but that you were a loyal subject of the Queen. To refuse to drink from this cup would have been a grave step.

In Shakespeare's day church attendance was compulsory, imposed by act of parliament and enforced by law, so every religious change affected the fabric of the whole society. Every life was lived within the framework provided by the church, but ever since Henry VIII's break with Rome that framework had become more and more unstable. The generation that first heard *Hamlet* had never known the changeless security of the faith of their grandparents.

Shakespeare's own life is marked out in Holy Trinity in Stratford, the place where he made his entrance and his exit: he was baptised in its medieval font and it was there, fifty-two years later, that he was buried on 25 April 1616. The entry in the parish register for Shakespeare's birth lists him as '*Gulielmus filius Johannes Shakspere*' and gives the date, 26 April 1564. The Reverend Martin Gorick, the vicar of Holy Trinity Church, says:

But that is his baptism date, rather than his birth date, which we don't actually know. We do know that people then baptised their children as soon as possible after birth; Shakespeare would have been baptised when he was only a few days old. But in fact this was not a good moment to be born in Stratford: on 11 July there is an entry which says: 'Here begins the plague,' and then the deaths start: one on the 20th, two on the 24th, three on the 26th. Within a couple of days in July there were two children from the same family dying here of the plague. The pattern continued until the end of the year – and this in a town of only 3,000 people at the time. So you could imagine that number going on week by week, each death a great mound of earth in the churchyard. Dramatic really.

Shakespeare was lucky to survive. Of the eight children born to his family, five made it to adulthood, of whom William was the eldest.

Although Shakespeare was baptised into a clearly Protestant church, there were still many physical traces of the old Catholic faith around him, and indeed many worries that the Catholic past might still be dangerously present. The lid of the Stratford chalice is engraved '1571', a highly significant date, because only a year earlier the Pope had excommunicated Elizabeth and declared that English Catholics were no longer bound to obey her. It was an explosive, provocative move on the part of the Papacy – a great polarizing moment in the struggle between Catholicism and Protestantism in England. From that point on, English Catholics could be seen as unreliable subjects, and to be a practising Catholic was perilously close to treason.

The Stratford cup was made during a push towards religious conformity. It was part of a political calculation that, after a decade of gradual Protestant adjustments and changes, a swing back towards Catholicism was now highly unlikely:

reform could be more trenchantly enforced. This cup, and many others like it, were a form of physical propaganda introduced diocese by diocese across the country in a design dictated centrally by the Archbishop of Canterbury. It was the orchestrated imposition of a new, more simple, Protestant aesthetic to replace the traditional, elaborate chalices, which, in their precious intricacy, gave undue reverence to the rites of the old mass.

During Shakespeare's childhood, the visible signs of Catholicism were being systematically removed, and few played a bigger part in that process in Stratford than his own father. John Shakespeare was a glover by profession, and he did well for himself, at least for a while. He bought a house in Henley Street, Stratford, in 1556, after which his ownership of freehold property made him eligible for public office – at various times he was elected bailiff, the town's most senior civic office, and senior alderman. At the height of his public career, the elimination of Catholic objects and symbols was part of his official remit.

Just a couple of streets away from Holy Trinity church is Stratford's Gildhall, whose chapel provides a striking example of how the world changed as the Reformation bit deeper. Inside the chapel we can still see the remains of a great wall painting of the Last Judgement. In the middle, a cross; on one side, the heavenly city; and on the other, hell. Everybody sitting in this chapel would have known that the Day of Judgement was going to be the most important moment of their existence, the goal of their spiritual life. But Protestants were taught to dislike images of all sorts, and so in 1564, the year of Shakespeare's birth, his father John arranged for the whole of this Last Judgement scene to be whitewashed over, and for 250 years it disappeared. A huge part of the inherited spiritual landscape, familiar for centuries, was wiped out. John Shakespeare was also responsible for taking down the

guild chapel's rood loft – which would have carried a rood (a sculpture of the crucifixion), and in 1571, the same year that the cup arrived in Stratford, he organized the removal of the old Catholic stained-glass windows in the gild chapel and had them replaced with clear glass – a scene of destruction probably witnessed by his seven year-old son. It would be very hard to now to go back to Catholicism.

The Stratford Gildhall may also have been the place where the young William Shakespeare saw plays being performed for the first time. Though we do not know their repertoire, there were at least thirteen visits by touring companies of players while Shakespeare was between the ages of four and seventeen. These touring performances were usually held in the largest available roofed space and in the presence of town officials, so John Shakespeare and his family would have been present at many of the shows.

Such was the environment that Shakespeare grew up in. Unlike his parents, he never heard a church service in Latin. He read and heard the Bible and the prayer book in English. He drank communion wine from a communal cup in a church where virtually all the images had been suppressed. But in this Protestant environment, just below the whitewash, in the Gildhall chapel in Stratford and across the whole of England, memories and images of the Catholic faith were still present, and still potent.

Historian Eamon Duffy of the University of Cambridge says:

> The shift from one way of doing things to a new service, which was often seen as being imposed from London, would certainly have been noticed. Some people were thrilled by it, like the arrival of the English Bible. For many people that was literally a revelation and an empowerment; for others it was tiresome gobbledegook. It took people time to accustom

themselves to these changes, so when we look at this cup, we are looking at a whole culture in movement, adjusting itself.

In his plays Shakespeare captures this painful transition, the moment when the Catholicism that his parents had practised became something to be spoken of only in the past tense. By the time *Hamlet* was written in 1600, you probably had to be about fifty to remember the mass taking place in an English parish church – and in 1600, not many people made it to fifty. In *Titus Andronicus* a soldier wanders off to gaze upon the decaying remains of a monastery. And in one of the loveliest lines in his Sonnets, Shakespeare conjures the monastic ruins which would have been one of the visible remnants of the old Catholic world: 'Bare ruined choirs, where late the sweet birds sang'.

Yet Shakespeare knew, as well as anyone, that the reality was more complex. Hamlet and his student friends have all just returned to Denmark from studying at the University of Wittenberg, the German city where Luther had originally proclaimed the new Protestant beliefs in 1517. Like Shakespeare himself, this Hamlet generation is caught up in the new Protestant future of northern Europe. But it is a future dangerously haunted, as Shakespeare shows us, by the ghosts of the past, in England, as on the ramparts of Elsinore.

> GHOST: I am thy father's spirit,
> Doomed for a certain term to walk the night,
> And for the day confined to fast in fires,
> Till the foul crimes done in my days of nature
> Are burnt and purged away.

When the ghost of Hamlet's father appears, he speaks not the language of Lutheran Protestantism, but in the older terms of a soul suffering in purgatory – an idea that Protestantism had vigorously denied. And throughout the play, the old speak the language of an abandoned faith to the bewildered young.

Polonius continues to swear 'by the mass'. The habits and the haunting fears of the past just would not die. Catholicism could be suppressed – blotted out, like the whitewashed image of the Last Judgement in Stratford's Gildhall – but it was never eliminated. Eamon Duffy again:

> There would still have been old people when Shakespeare was young saying the rosary, crossing themselves when there was thunder, using holy water. Catholic beliefs remained current in one form or another, especially around things like funerals, for a very long time.

*

Things seem to have started to go wrong for John Shakespeare in the 1570s; he got into trouble for illegal trading and usury. He had mortgaged and then lost some property by 1580 and was arrested for debt. The likeliest explanation is that in his twenty-year rise to the top in Stratford, he had over-extended himself – his time in civic office was over by 1586, when he was discharged from common council for non-attendance. In 1592, falling further, he was one of nine recusants (non-attenders at church services) arraigned 'for feare of processe of Debtte' – a fear that appearance in public made him vulnerable to arrest. His family's shifting fortunes may explain Shakespeare's careful management of his own career: in London, he lived in relatively inexpensive lodgings, but when he made his fortune he invested in property in his home town, acquiring New Place – the second-largest house in Stratford at the time, where his family always remained. The year before he bought the house, in 1596, Shakespeare's eleven-year-old son, Hamnet, died. The grieving Constance in *King John*, written around this time, laments

CONSTANCE: Grief fills the room up of my absent child,
 Lies in his bed, walks up and down with me,

Puts on his pretty looks, repeats his words,
Remembers me of all his gracious parts,
Stuffs out his vacant garments with his form . . .

Hamnet, like Shakespeare's father and Shakespeare himself, is almost certainly buried somewhere at Holy Trinity.

*

KING: Give him the cup . . .

The last Act of *Hamlet* is set in a palace. But even in a church, as the Stratford chalice demonstrates, drinking as the sovereign commands was inescapably about political obedience. The ghosts of the old faith lingered on, and, as Elizabeth's reign drew to a childless close, so an old fear was revived and strengthened – the fear of a succession crisis and of civil war. Hamlet ends with that fear coming true – there is no clear heir to the Danish throne, and the country is invaded by a foreigner who takes the crown. In 1600 everybody watching *Hamlet* knew that this fear, which had preoccupied the nation for over thirty years, was now becoming of unavoidable urgency. Chapter Four examines a painting made only a year after the Stratford cup, which addresses the fearful question of what is going to happen if the Queen dies.

Chapter Three

Snacking Through Shakespeare

Brass-handled iron fork from the Rose Theatre

I think most of us have some idea of what people are likely to have felt when they first watched the great love scenes from *Romeo and Juliet* or heard Macduff being told of the killing of his children. The words move us now as we imagine they must always have moved an audience. But in this chapter I want to ask a less elevated question: what did Shakespeare's public *eat* in the theatre? What were you likely to be nibbling or crunching as you first heard 'To be or not to be'? Modern audiences embark on films and plays armed with chocolate and popcorn, glasses of wine or bottles of water. What about the Elizabethans? It is a question that recent archaeological work has taken us a long way towards answering. Over the last few decades the Museum of London has excavated the sites of a number of Elizabethan theatres: they have found huge quantities of glass and pottery fragments, fruit seeds, nuts and mussel shells, and, in among all the detritus, this sharp and stylish fork.

It has a slender shape, a little longer (9 inches) and much narrower than the kind of fork we use today, with two fierce-looking prongs at the end; it is easy to imagine somebody languidly pronging a delicacy with it while watching a play. But this is not the equivalent of disposable plastic cutlery, thrown away at the end of the performance: this fork is made of durable iron and it once had an elegant wooden handle – you can still see the pins that held the wooden plates in place – with at the end a tiny brass knop (a rounded ornamental handle) beautifully engraved with the initials 'A.N.' This sort of fork, a sucket fork as it is known, is for spearing suckets or sweetmeats – selections of marchpane (marzipan), sugar-bread, gingerbread and the like, the equivalent of a box of chocolates. This is very smart cutlery, and it is meant to last. And last it did, for this particular fork lay for centuries on the site of the Rose Theatre on the south bank of the River Thames. It was excavated from the layers associated with the second phase of the Rose's life, from 1592 to 1603. The fork comes from the remains of the theatre's inner gallery walls, where it nestled in the debris and dirt among an eclectic range of discarded food, the remains of clothes and shoes, and pieces of weaponry, such as a sword scabbard, which may have been stage props.

In the 1590s, if you wanted a good day out in London, you went to Southwark, on the south bank of the Thames, and eating was very much part of the pleasure. You ate when you went to a play. You ate as you took in some bear- or bull-baiting for a bit of fun. And if you were a young blade, out on the town and likely to end up in a tavern or a brothel, eating would certainly be among the many pleasures on offer there. Sex does not usually leave a lot behind that archaeologists can study, but food and drink do – and so, surprisingly, has the whole business of going to the theatre in Shakespeare's London.

Julian Bowsher, of the Museum of London Archaeology, who has pioneered the excavation of Elizabethan playhouses, describes the experience of going to the play:

> When you arrived at a Shakespearean playhouse, you entered through a main door and paid a one-penny entrance fee to the 'gatherer', who would have held a little money-box rather like a piggy bank with a bright green glaze on it and a slot through which to put a penny. All that we have left of these are bits of broken pottery, as they were smashed open when they were taken back stage. The coins were then put into a large money chest in a back room, which must be the origin of the term 'box office'.

The public theatres of Shakespeare's London were an entirely new form of (very commercial) entertainment, aimed at every section of society. An indication of just how lucrative they were is that money-boxes account for nearly one-fifth of the identifiable pottery that has been excavated in Elizabethan theatres; they were as commonplace then as cash-desks or credit card readers are today, something every play-goer would have had to walk past before they saw *Hamlet* or *Henry V*. Unusually for a playwright, Shakespeare himself was a shareholder in the Globe, entitled to a percentage of its profits – it's the main reason he became so rich. The smashing open of money-boxes at the end of the day must have been a happy sound for him.

Once the theatre-goers had put their money into the slot and walked into the theatre, it seems that food – the buying and selling, the cracking open and consumption of it – formed a large part of the experience. From the samples that have been collected on site botanists have identified quite a range of foodstuffs. Nuts were popular, and lots of fruit, dried and fresh: grape, fig, elderberry, plum, pear and cherry. A large amount of shellfish was also eaten: mussels, periwinkles,

whelks, even a cuttlefish has been dug up. Oyster shells in particular have been found on the site in large numbers, unsurprisingly as they were a popular cheap food at the time: 'oyster-wenches', girls selling oysters as street food, were familiar figures in Elizabethan cities, and, because oyster consumption required knives, the standard dagger that every man carried was as much a piece of cutlery as it was a weapon. In the theatre, all this cheap shellfish was winkled out and eaten, and the shells were then dropped on the floor by the groundlings – the people standing in the yard. In other words, the cheap 'seats' were associated with cheap food. The only drinks we know about at the theatre are beer and ale; when the Globe burned down in 1613, 'bottle ale' was used to extinguish a man's burning breeches. Ale was a fizzy, bottled drink, and a common complaint in the theatre was the noise of a gaseous bottle being opened, the equivalent to the modern-day complaint about the rustling of crisp packets and sweet wrappers.

After all this drinking, people were going to need to relieve themselves – but, as Julian Bowsher describes, the theatres made no provision for this:

> We have a nasty suspicion that dark corners were used by men. There is some evidence that ladies would take some sort of bottle with them. For more serious defecation, the theatregoers would have to go outside somewhere, possibly to the riverside.

The open-air theatres of Shakespeare's day depended on daylight. So all public plays were matinees, with performances beginning in the early afternoon and probably running no later than 5 p.m., certainly not in winter. Normally the audience would eat their main meal of the day first, as the Swiss visitor Thomas Platter did when he visited the Globe in 1599:

On September 21st after lunch, about two o'clock, I and my party crossed the water, and there in the house with the thatched roof witnessed an excellent performance of the tragedy of the first Emperor Julius Caesar ... daily at two in the afternoon, London has two, sometimes three plays running in different places, competing with each other, and those which play best obtain most spectators.

Shakespeare was competing in a crowded commercial market.

There were no intervals at performances in the open-air theatres, and even in the indoor playhouses like the Blackfriars there were only short breaks for the candles to be trimmed. There was no room for a bar or foyer in the modern sense, so people would be moving around inside the theatre, selling the nuts, fruit, beer and ale which could be consumed on the spot. As Platter again records: 'And during the performance food and drink are carried round the audience, so that for what one cares to pay one may also have refreshment.'

The theatre areas were generally surrounded by inns, which served as the pubs, restaurants and cafés of the time. We know that the Rose, Globe and Fortune Theatres each had a tap house attached, where refreshments were prepared. In Shakespeare's company, one of its members, John Heminges, had the responsibility for running the tap house built next to the Globe, which presumably contributed directly to the company's profits. These booming new theatres also supported the many lucrative catering establishments of Southwark. It is much the same along the south bank today, where popular restaurants crowd together from the restored Globe to the National Theatre and Royal Festival Hall.

While the groundlings bought apples or oysters, or opened a beer, the rich would have brought their own, more upmarket food, with their own glasses and cutlery. It was this kind of

person who dropped the elegant fork that was excavated in the Rose Theatre. It would undoubtedly have belonged to someone with cosmopolitan tastes, someone probably of some social status. We can no longer attach a name to the initials 'A.N.', to discover who it was that might have owned this particular fork and carelessly left it or dropped it near the expensive seats at the side of the stage. But Shakespeare, who was acting on the Rose stage around the time, might well have known who the fashionable, fork-wielding 'A.N.' was.

One might imagine a lord or gentleman, having lunched before the show, taking his dessert at the theatre in his private room. These privileged areas (what the dramatist Thomas Heywood called 'a place ... onely for the Nobilitie') often seem to have been adjacent to the stage; they may have had separate entrances, so the elite didn't have to mingle with the groundlings who paid a penny to stand in the yard, or they may have been reached through the 'tiring room', the back-stage area, to allow the quality to chat with the players.

Forks were something of a novelty in the 1590s, when this one was dropped, and a disagreeably foreign novelty for the no-nonsense English, who preferred to eat with their fingers. Julian Bowsher explains:

> The travel writer Thomas Coryate went to Italy in 1608 and came home saying: 'They've got these strange things over there that they eat with, called forks, and they're made of iron.' He brought one back with him and was ribbed mercilessly for it, with everyone saying, 'What are you doing with this funny foreign thing?'

In table manners, just as in sword-fighting, Italian elegance in late Elizabethan London was for most people suspect, flashy and foreign. So to find a fork like this one next to cheap mussel and winkle shells is a powerful demonstration of the social

range of a Shakespearean audience. These plays were quite clearly aimed at the whole of society.

But consumption was not just for the spectators. While the audience was drinking fizzy ale, they were sometimes watching actors enjoying a much more lavish feast on stage. In many Shakespeare plays, eating food is a moment of social spectacle and high theatricality and, inevitably, of character-revealing truth. For Falstaff – Shakespeare's epic glutton – every scene brings hope of a potential new feast:

> FALSTAFF: My doe with the black scut! Let the sky rain potatoes. Let it thunder to the tune of 'Greensleeves', hail kissing-comfits, and snow eryngoes. Let there come a tempest of provocation, I will shelter me here.

Joan Fitzpatrick, a historian of Elizabethan food, explains what Falstaff's cosmic banquet would have meant to his audience:

> Potatoes would have been considered very exotic, very new to an English audience. Most ordinary people probably would never have seen or come across a potato. So Falstaff is chic with his foreign food. He then goes on to 'kissing comfits', something that would have sweetened the breath. It was an indulgent food, associated with romance, an aphrodisiac. The last thing that he asks for is eryngoes, the candied root of the sea holly, which is also considered an aphrodisiac.

We can be confident that the archetypal Englishman would not have been eating kissing comfits and eringoes with a foreign fork, but someone out to impress at the Rose Theatre clearly was.

In turning up such a wide array of food remains – from lowly oyster shells to elegant sucket forks – archaeologists have demonstrated just how different the English public theatre

was from the mostly court-based theatres on the Continent. In London, courtiers and commoners alike came to one building. Whether they ate with their dirty fingers or with the refinement of cutlery, the whole audience was sharing the experience of the same play. Shakespeare's astonishing variety of characters on stage simply mirrored the social mix of his audience.

Chapter Four
Life Without Elizabeth
Portrait of the Tudor dynasty

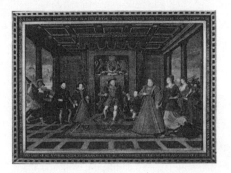

The really big political questions – in Britain at least – have often been the ones that nobody has dared to speak about. As late as 1936, the constitutional crisis threatened by King Edward VIII's relationship with Mrs Simpson was widely discussed in the American and Continental press, but the topic was entirely absent from British newspapers.

In the 1590s, the people going to see Shakespeare's plays would certainly have been talking among themselves about the big constitutional issue of their day, but Queen Elizabeth had by law forbidden any public discussion of it. It was the question that had been central to English politics for over a generation: who would succeed the ageing monarch? In 1936 the constitutional crisis was largely about sex and religion, much as it had been exactly 400 years earlier, in 1536, when Henry VIII had had Anne Boleyn executed and begun to dissolve England's monasteries. In the 1590s, it was about something even more important – national survival.

On the London stage at the same time the popular genre of

the history play was being redefined, in fact reinvented. The anonymous history dramas of the earlier sixteenth century have now largely been forgotten, obliterated by the vigour and sophistication of the plays written by Shakespeare and Christopher Marlowe in the 1590s. At their core, Shakespeare's history plays are a dissection of the disputed succession and civil wars of the fifteenth century: the Wars of the Roses. Indeed, it was Shakespeare who created the imaginary moment that came to define the Wars, when a red rose and a white rose were symbolically plucked as a statement of loyalty to either the House of Lancaster or York:

> WARWICK: And here I prophesy: this brawl today,
> Grown to this faction in the Temple garden,
> Shall send between the red rose and the white
> A thousand souls to death and deadly night.
> RICHARD: Good Master Vernon, I am bound to you
> That you on my behalf would pluck a flower.
> VERNON: In your behalf still will I wear the same.

It was a new dynasty, the Tudors, who eventually ended the Wars of the Roses by uniting the different feuding branches of the old royal house. *Richard III* finishes with a stirring speech by Richmond, the victorious Henry VII, who is about to marry Elizabeth of York and so eventually become Queen Elizabeth's grandfather:

> RICHMOND: We will unite the White rose and the Red.
> Smile, heaven, upon this fair conjunction,
> That long have frowned upon their enmity!
> What traitor hears me, and says not amen?
> England hath long been mad and scarred herself,
> The brother blindly shed the brother's blood,
> The father rashly slaughtered his own son,
> The son, compelled, been butcher to the sire:

> All this divided York and Lancaster,
> Divided in their dire division;
> O, now let Richmond and Elizabeth,
> The true succeeders of each royal house,
> By God's fair ordinance conjoin together!
> And let their heirs, God, if Thy will be so,
> Enrich the time to come with smooth-faced peace,
> With smiling plenty, and fair prosperous days!

In these lines, Henry VII, the first Tudor king, is not mincing his words. Hunchbacked Richard (who had brutally murdered his nephews in the Tower) has himself just been killed; Henry is about to install the new Tudor dynasty and put an end, he hopes, to the horrors of the civil wars which had ravaged England in the second half of the fifteenth century.

But from the beginning, one question always remained unanswered: for how long could such a settlement last? There was never *not* a succession crisis in sixteenth-century England, from Henry VII's establishment of the insecure new royal house of Tudor, through Henry VIII's desperate search for a son, and the problems of who would be the next heir during each of Edward's, Mary's and Elizabeth's reigns. It was this contemporary drama of royal succession that gave Shakespeare's history plays so much bite for his public. If the monarch fell, everybody at every level of society would feel the misery that followed. Fear of instability stalks these plays, and the kings who tensely inhabit them:

> HENRY IV: Canst thou, O partial sleep, give thy repose
> To the wet sea-son in an hour so rude,
> And in the calmest and most stillest night,
> With all appliances and means to boot,
> Deny it to a king? Then, happy low, lie down!
> Uneasy lies the head that wears a crown.

*

From the beginning of Elizabeth's reign, who would succeed her was the critical question. But while the succession issue could not be openly discussed in the 1590s, it could be pictured – and the pictures that reached the widest possible public were prints, cheap to produce and easily distributed. If you want to know what large parts of the population were thinking, the prints they were buying are valuable evidence, and there is one print that goes straight to the heart of the matter. It was produced in the early 1590s and it shows, on the right-hand side at the front, Elizabeth I. Behind her, seated on the throne, is her father, Henry VIII, on his left Edward VI, his short-lived son, and on his right Mary Tudor, his elder daughter, with her husband, Philip of Spain. The striking thing about this, of course, is that in the 1590s all the Tudors depicted here except Elizabeth were dead. Henry VIII had died a long time before, and his two other children had also died without producing an heir.

Susan Doran, of Jesus College, Oxford, says the print:

was as near as anyone could get to asking Elizabeth to name her successor. The issue of the succession was a totally taboo subject; it had been so from 1571, when the Treasons Act was passed, which made it treason to discuss the succession, and particularly the title of any potential successors to Elizabeth. This silencing of the issue became an even more significant concern as her reign went on: another Act was passed in 1581, which reinforced the need for silence on the succession. This was the great elephant in the room in Shakespeare's early life, the fear that dared not speak its name. So when you go to see a Shakespeare play about dynastic difficulties or problems with succession, the English history plays or *Julius Caesar*, this question was in the air, but not spoken. And of course this was not just in Shakespeare's plays, but in other plays as well, in masques and entertainments, and the subtext of succession would have been easily read by contemporary audiences.

tectum

porticus

sedilia

orchestra

mimorum
aedes

ingressus

proscenium·

planities sive arena.

...untium sed dispari et structura, bestiarum conflictationi destinatum, in quo multi ursi, tauri, et stupendae magnitudinis canes, distinctis caueis et septis aluntur, qui ad...

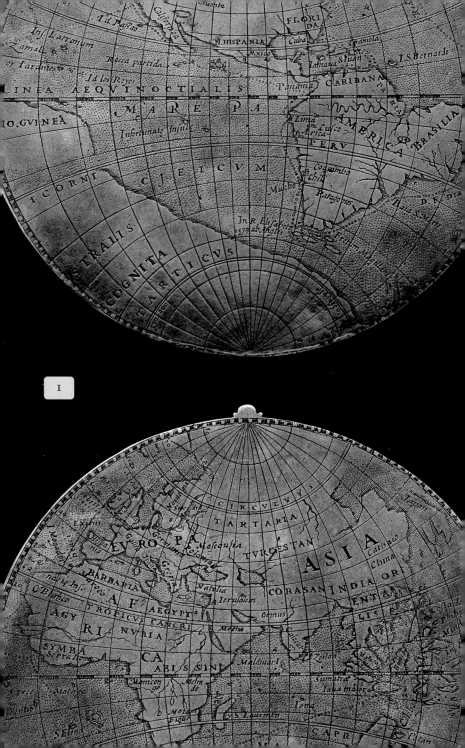

I

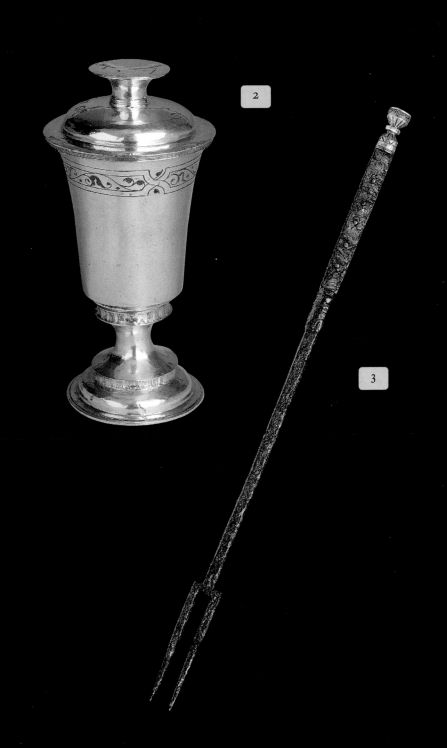

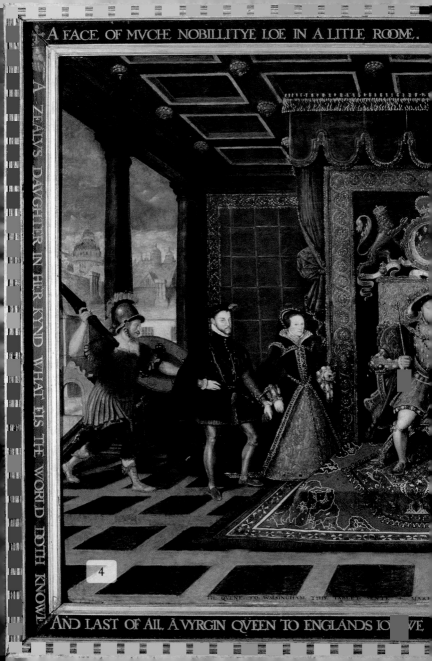

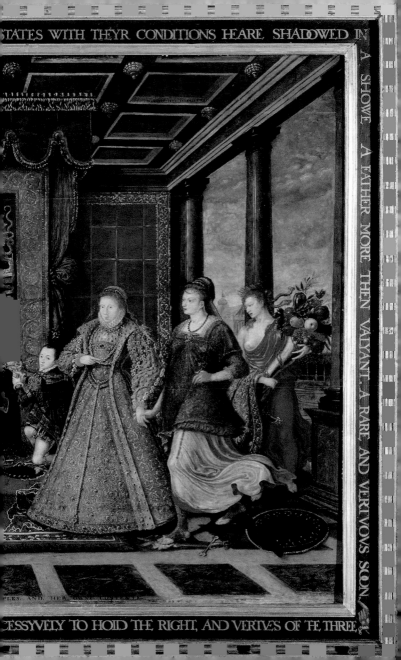

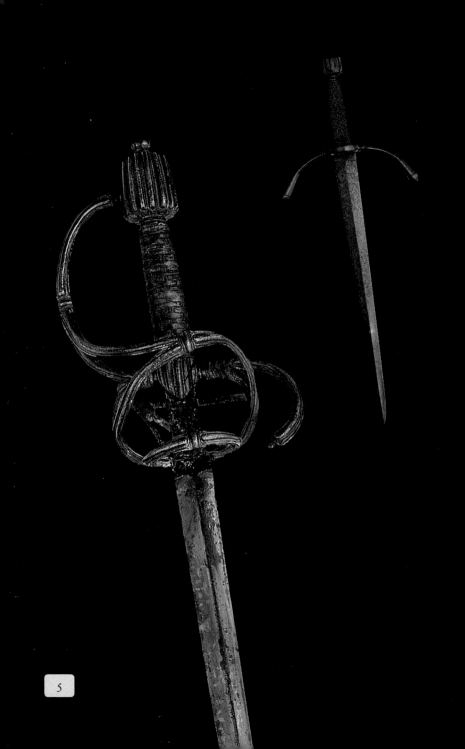

5

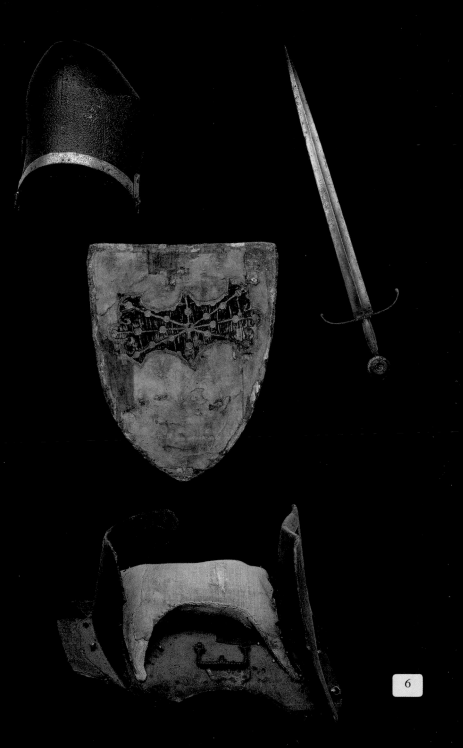

6

By the time this print was published, Elizabeth was nearly sixty, much too old to produce her own heir, so who might succeed her was a very tricky topic. But the astonishing thing is that, although printed in the 1590s, this image is actually a copy of another one made twenty years earlier. If we want to gauge the continuity, indeed the growth, of the national obsession with who would follow Elizabeth, then the twenty years between the print and its source are a very useful measure.

The original painting on which the print is based is kept at the National Museum of Wales in Cardiff. Its painter, Lucas de Heere, was Flemish; he was born in Ghent and converted to Calvinism, which made him suspect to the Spanish authorities (the King of Spain was also ruler of most of the Low Countries). This probably accounts for his move to England, perhaps in the 1560s. For the Earl of Lincoln he painted a gallery, now destroyed, of the costumes of all nations, in which the Englishman was depicted as unable to choose what to wear, an image that supposedly greatly amused Queen Elizabeth.

The inscription around the frame of De Heere's painting of Elizabeth and the Tudor dynasty tells us what we are to think of the Queen, her father, and her brother and sister:

A FACE OF MVCHE NOBILLITYE LOE IN A LITTLE ROOME,
FOWR STATES WITH THEYR CONDITIONS HEARE SHADOWED
IN A SHOWE.
A FATHER MORE THEN VALYANT. A RARE AND VERTVOVS SOON.
A ZEALVS DAVGHTER IN HER KYND. WHAT ELS THE WORLD
DOTH KNOWE
AND LAST OF ALL A VYRGIN QVEEN TO ENGLANDS IOY WE SEE
SVCCESSYVELY TO HOLD THE RIGHT, AND VERTVES OF THE
THREE.

The more you look at the painting, the more you see that the point of it is to tell us, the viewers, how lucky England is to

have the Tudors. Because of them, we have enjoyed a hundred years of peace. Philip of Spain, Mary's unpopular husband, has been seen off and sent home – he is painted on the left wearing black, looking almost like a pantomime villain, and the only royal figure not allowed on the grand carpet. The figure of War lurking behind Philip is a sour reminder of how the Spanish King entangled England in his European wars – in which, disastrously, Calais was lost to France – and how Philip then deserted his former ally. On the right-hand side, hurrying in to support Elizabeth and loaded with fruit and flowers, come Peace and Plenty. Below Peace's feet are discarded weapons of war. On the throne are the royal arms supported by the English lion and the Welsh dragon. The painting's purpose is to assert the legitimacy and benefits of Elizabeth's reign and her place in the culmination of an orderly succession of Tudor rulers.

De Heere's picture, painted around 1571, has one of the strongest claims to represent Elizabeth as she wanted herself to be seen – she certainly approved it after the fact, even if she did not actively commission it. It is not a great piece of painting. Nobody would thrill to the way that Lucas de Heere has painted the folds of the velvets, or the light (not) sparkling on the jewels. But if its surfaces are lacklustre, its message is still crystal clear: England and Wales were fortunate to have Elizabeth as their Sovereign. And while Elizabethan spectators would certainly have been grateful for what her reign had brought with it, they would also have been apprehensive because this peace and prosperity, although real, was fragile. Everything hinged on the Queen's survival, and everything would be in jeopardy if she made the wrong marriage, or died without an heir. It is fair to say that all of this would have been immediately understandable to any Elizabethan standing in front of Lucas de Heere's painting.

Shakespeare was seven years old when this picture was

made, and these were the concerns of the world in which he grew up. But the picture was not made for Elizabethan spectators in general: it was made for one in particular. At the very bottom of the picture are written the following words:

THE QVENE TO WALSINGHAM THIS TABLET SENTE
MARKE OF HER PEOPLES AND HER OWNE CONTENTE

The recipient of this gift, Sir Francis Walsingham, was Elizabeth's spymaster, who specialized in foiling conspiracies to kill the Queen. In 1569, a powerful group of Catholic noblemen in the north of England had rebelled against her. Then a foreign banker called Ridolfi had plotted with the Duke of Norfolk to depose Elizabeth with the support of the Spanish. It was Walsingham who unravelled the plot and sent Norfolk to the scaffold. In the early 1570s, as the picture was being painted, the first people who looked at it knew that the Queen had just survived an attempt to overthrow her.

We do not know where Walsingham kept the picture, but we might imagine it hanging over his desk as he despatched his instructions to his queen-preserving network of spies. For the next twenty years, as he looked up at it, he would be able to feel some satisfaction that he played a part in protecting her from a whole series of plots, conspiracies and assassination attempts – indeed Shakespeare was one of the first people we know of to use the word 'assassination' in print, and he and all his contemporaries lived in a country used to the idea of plots and regicides. When Walsingham died in 1590, the picture was, we believe, still in his possession – but the problem of who would succeed the Queen had still not been resolved.

When we look again at the 1590s print that reproduces the painting of 1571, it is startling to realize that in those twenty years nothing had apparently changed. The print has updated Elizabeth's costume to keep the dress in line with 1590s fashion, but apart from that nothing on the face of it has altered.

Here still is the Tudor dynasty, and here still it comes to an end in the person of Elizabeth. She has produced no heir, appointed no successor. The revival of the 'Allegory of the Tudor Succession' as a print in the 1590s can be seen as part of the foreboding felt as Elizabeth began visibly to age and slow down. While the original painting's purpose was to assert the legitimacy of Elizabeth's reign, the resurgence of the image as a more widely accessible print in the 1590s captured darker anxieties in the public consciousness about the future. The original text around the painting was now replaced by a new three-stanza poem, more explicitly anti-Catholic and more condemnatory of Mary:

> Now Prudent Edward dyinge in tender youth,
> Queen Mary then the Royall Sceptre swayd:
> With foraine blood she matchet and put down truth,
> Which England's glory suddainly decayd:
> Who brought in war & discord by that deed.

Susan Doran explains the important developments that had taken place behind the scenes:

> There was a hope that Elizabeth was going to avoid civil war breaking out on her death, avoid there being a transitional period which might be exploited by Catholics and foreign powers, particularly Spain. The danger in 1591 was now that there might be an international war about the succession. That was what was happening in France at that time. On the death of Henry III, the Protestant Henry IV had been challenged and Spain had come in to oppose his accession to the French throne. There was an anxiety in England that that was going to happen on the death of Elizabeth and so pressure was being put on Elizabeth in parliament, quietly by some privy councillors and by James VI of Scotland, who wanted to be named her successor. It was very much a topical issue in the 1590s.

The threat from Philip of Spain was real and multiple: he was the most powerful ruler in Europe, he had been married to Mary Tudor and had held the title 'King of England'; he was a legitimate descendant of the House of Lancaster with a claim to the English throne through John of Gaunt; and, by the 1590s, he had heirs who could follow him. For those who wanted a Catholic monarch, Philip of Spain was the ideal choice.

But there was another candidate closer to home. Mary Stuart, Mary Queen of Scots – the main contender in the 1560s – had by now been executed, but she had a grown son, James, who was also descended from the Tudor family. By the 1590s, when this print was made, Mary's son was an experienced ruler, as King of Scotland, and had a growing family of his own. So for Protestants in England, James VI of Scotland was the great hope.

In England, the Treasons Act forbade any discussion on who could succeed Elizabeth. (Not that some did not risk it. One writer decided what the Queen really needed was a tract that he briskly entitled: *A Pithy Exhortation to Her Majesty for Establishing Her Successor to the Crown.* This was a foolish move. You could end up, as the writer Peter Wentworth did, pithily exhorting from the Tower.) But concerns about the succession could be addressed in prints and obliquely on stage, provided you were as nimble as Shakespeare was in not espousing too specifically any one particular position. When Shakespeare dramatized the Wars of the Roses in the 1590s, it was partly loyal propaganda to show the terrible crisis from which the Tudors had rescued England. At the same time, however, the plays reveal deep anxiety about succession, as one royal kinsman after another struggles for supremacy: the ever-self-dramatizing Richard II cries to the usurper Henry IV, 'Here, cousin, seize the crown.' Rebellion was always very much part of the family.

The Earl of Richmond, about to become Henry VII, had ended the Wars of the Roses with a vision of a reunited England:

> RICHMOND: Abate the edge of traitors, gracious Lord,
> That would reduce [bring back] these bloody days again
> And make poor England weep in streams of blood!
> Let them not live to taste this land's increase
> That would with treason wound this fair land's peace!
> Now civil wounds are stopped, peace lives again;
> That she may long live here, God say amen!

But, as we have seen, by the 1590s fears for the future were growing stronger once again. Everybody knew about the civil wars that were going on in France, where foreign powers were intervening in a bloody struggle that had already lasted for a generation. It could easily happen in England.

As it turned out, England was luckier than France. The picture in Cardiff is a kind of history play of the whole Tudor dynasty, and when eventually the leading lady left the stage, the play had an unexpectedly happy ending. The Welsh Tudors were succeeded on the English throne by the Scottish Stuarts. There was no rebellion, no foreign invasion, no civil war. And in 1603 James VI of Scotland came peacefully to London as James I of England. This smooth succession did not, however, end Shakespeare's dramatic investigation of these themes; indeed his most intense explorations of them were still to come in *Macbeth* and *King Lear*. The enduring issues of political violence, stability and legitimacy continued to preoccupy Shakespeare as the world around him shifted towards a new set of uncertainties.

Chapter Five
Swordplay and Swagger
Rapier and dagger from the Thames foreshore

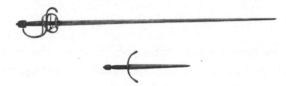

The streets of London were a dangerous place in the sixteenth century. In Shakespeare's day you could calmly admire a sword-fight on stage and then find yourself perilously embroiled in one when you stepped beyond the theatre walls. In London, just as in Verona, an evening out could end up a very bloody business:

> ROMEO: Gentle Mercutio, put thy rapier up.
>
> MERCUTIO: Come, sir, your *passado*!
>
> [*They fight*]
>
> ROMEO: Draw, Benvolio. Beat down their weapons.
>
> Gentlemen, for shame! Forbear this outrage!
>
> Tybalt, Mercutio, the Prince expressly hath
>
> Forbid this bandying in Verona streets.
>
> Hold, Tybalt! Good Mercutio!
>
> [*Tybalt under Romeo's arm thrusts Mercutio*]
>
> MERCUTIO: I am hurt.
>
> A plague a' both houses! I am sped.

Romeo and Benvolio try their best to stop the swordfight between their friend Mercutio and the hotshot swordsman Tybalt, but it is hopeless. Mercutio is stabbed, and once again the streets of Verona run with blood.

We tend to think of *Romeo and Juliet* as essentially the balcony scene, a play about the romantic tribulations of young love. In fact it is just as much a play about bands of privileged lads slicing each other to death and the failure of the authorities to control their brawling. *Romeo and Juliet*, with its upmarket knife gangs and its bloodstained streets, leaves no doubt that urban violence – for Shakespeare and his audience – was one of the big issues of the day.

The weapons of choice were generally a dagger and a rapier, as in these examples, now housed at the Royal Armouries in Leeds. The dagger was made around 1600 and is bigger than you might expect, roughly the size of a modern carving knife – the dagger that hovered before Macbeth was clearly no slight weapon. Its companion piece, the rapier, is not equipment for the battlefield: the slender blade was designed to pierce clothing, not armour. This was the sort of weapon you carried around with you on the streets of Elizabethan England. Part dress accessories, part weapons, a rapier and dagger were essential kit for any young man out on the town.

In Shakespeare's day there were only two ways of getting from the City of London to the south bank. Either you walked over London Bridge or you took a rowing boat or ferry over the river. Our dagger was found on the foreshore of the Thames, on the south bank: probably dropped by a young man as he got in or out of one of those rowing boats. We do not know, of course, whether the young man who lost his dagger was out looking for trouble as he set foot in Southwark. Nor, of course, do we know what clothes he was wearing, but he was almost certainly dressed in his best gear and looking for fun, because one of the main reasons for a young man to

go south of the river was to get to the roaring entertainments on Bankside, which we first encountered in Chapter Three.

There were the theatres, of course – the Rose, the Swan, the Globe. But there were also bear-pits and cock-pits, brothels and inns – all easily accessible, and all conveniently outside the authority of the City of London. There were at least five bear-baiting establishments in the area around the Rose and the Globe, and some bears became national celebrities – the famous bear Sackerson was given a cameo role in *The Merry Wives of Windsor*:

> SLENDER: That's meat and drink to me, now. I have seen Sackerson loose twenty times, and have taken him by the chain. But, I warrant you, the women have so cried and shrieked at it that it passed. But women, indeed, cannot abide 'em – they are very ill-favoured rough things.

The south bank, with its wild entertainments, reckless youths and impresarios determined to make fast money, could be a dangerous place; particularly when groups of Elizabethan lads – not so different from the characters in *Romeo and Juliet* – carried lethal weapons with them. Toby Capwell, curator of arms at the Wallace Collection, says:

> Once they become part of your dress as a gentleman, there is always the temptation to use them. If everybody is going to carry swords around all the time, they are going to come out pretty quickly in the event of an argument.

To be fashionable in the sixteenth century you needed to carry a sword. Only a gentleman was entitled to do so, and a true gentleman was expected to, as we know Shakespeare himself did. So it should be no surprise that the earliest known use of the word 'blade' to refer to a stylish young man appears in *Romeo and Juliet*. If the scenes between those young blades Tybalt and Mercutio are still vivid today, it is because such

fights were not some fanciful invention, but the rough stuff of daily life.

The essential accompaniment to the dagger was the rapier, and this fine one was also found on the Thames foreshore – perhaps another casualty of a young man's night on the town in Southwark, dropped as its drunken owner stumbled back into the rowing boat to take him home. This is an impressive weapon. The blade alone is well over a metre long, and it is sharp on both sides and at the end – you can slash, you can pierce with this rapier, while the matching dagger would be held in the left hand, parrying and stabbing at close range.

It is clearly an expensive, elegant weapon, and the owner must have been sorry to lose it. It has been elaborately worked – at the handle, it looks as though a long, thin metal snake has coiled itself around the base of the blade to protect the owner's hand while he is fighting. A weapon like this would have been worn in what Elizabethans called a hanger, or girdle – a sort of sling. This would have made it easier to carry, because it was certainly not light in the hand. Toby Capwell again:

> We always think of rapiers as a kind of feather-light flashing blade, the weapon of Errol Flynn and Douglas Fairbanks, and of medieval swords, conversely, as being heavy and cumbersome. But actually this is a misconception: medieval swords tend to be very light, while real rapiers tend to be quite heavy and can seem, to an untutored hand, quite ungainly.

Yet when rapiers and daggers found themselves in tutored hands, the result was, in the words of Mercutio, a kind of musical performance, an exquisite dance of death:

> MERCUTIO: He fights as you sing prick-song: keeps time, distance, and proportion. He rests his minim rests, one, two, and the third in your bosom. The very butcher of a silk

> button. A duellist, a duellist. A gentleman of the very first
> house, of the first and second cause. Ah, the immortal
> *passado*! the *punto reverso*! the *hay*!

Mercutio's description of Tybalt's skills with a rapier and dagger captures a fashion in swordsmanship that was new in England. As Alison de Burgh, fight master at the National Theatre, explains, Tybalt's fighting was not just deadly, it was also the last word in foreign chic:

> Shakespeare was picking up on the contemporary conflict between the English school of swordplay and the new Italian school of rapier play. Romeo's family are fighting in the old English style of swordplay, Tybalt's are fighting in the new Italian style; a fact made evident by the terminology Mercutio uses when he makes fun of Tybalt and Tybalt's style of swordplay. Mercutio talks of the *passado*, the *punto reverso*, and makes up a move called the *hay*. Through Mercutio using these words and making fun of the moves, Shakespeare is echoing a gentleman who wrote a manual on English swordplay in which he criticized the Italian school. A famous Italian Master, Vincentio Saviolo, had recently established a school and written a manual on his style of swordplay. The Englishman George Silver wrote a manual on swordplay in which he advocates the English style and denigrates the Italian style. Mercutio is using words and phrases Silver uses in his manual.

So the Montagues are good, true, solid Englishmen in their sword-fighting, while the Capulets – as the audience would have understood – are shown as suspect, modish and foreign.

For the man of fashion, the quality of his rapier and dagger set, like his watch or his trainers today, was crucial. In *Hamlet*, when the prissy courtier Osric announces a bet between the King and Laertes, the blades he mentions are as much status symbols as weapons:

OSRIC: The King, sir, hath wagered with him six Barbary
 horses, against the which he has impawned, as I take it, six
 French rapiers and poniards, with their assigns, as girdle,
 hangers, and so. Three of the carriages, in faith, are very
 dear to fancy, very responsive to the hilts, most delicate
 carriages, and of very liberal conceit.

Betting half a dozen rapiers and daggers against six Barbary
horses shows just how enormously valuable a 'delicate' rapier
and dagger could be.

But it was not just a question of fashion. Rapiers and dag-
gers were about causing serious bodily harm: they proclaimed
honour and defended it. The problem of street violence in
sixteenth-century Europe was met with regulations to restrict
the use of swords:

ROMEO: Tybalt, Mercutio, the prince expressly hath
 Forbid this bandying in Verona streets.

Some military experts despised fencing as a waste of time,
'that men might butcher one another here at home in peace',
and poor preparation for the serious business of war. Others,
such as the clergyman William Harrison, felt the rapier and
dagger needlessly raised the stakes in civilian violence among
fight-happy men who 'carry two daggers or two rapiers in a
sheath always about them, wherewith in every drunken fray
they are known to work much mischief'. In an attempt to
curb such violent brawls, an English law of 1562 limited the
length of rapiers: those over a yard long were physically
broken at the city gates. It seems to have made little differ-
ence: it was rather like saying you could carry only a small
gun. Other laws were no more successful. According to a
1573 proclamation:

None shall wear spurs, swords, rapiers, daggers, skeans,
wood knives, or hangers, buckles or girdles, gilt, silvered or

damasked ... except knights and baron's sons, and others of higher degree and place.

But such prohibitions were widely disregarded, and virtually every adult male carried at least a dagger.

Rather like boxing matches today, the sword fights that Elizabethans saw in the theatre were a hugely popular spectacle, and, barring the odd special-effect creation (like the arrows in Clifford's neck in *Henry VI, Part 3*), the actors used real weapons. In daylight, in the open air, swordplay showed to particular advantage in the new playhouses like the Globe. Some actors became excellent fencers; the great comic actor Richard Tarleton, who could famously get an Elizabethan audience into hysterics simply by poking his face into view, also became a Master of Fencing, which meant he had defeated seven recognized masters in contests. There are over a dozen Shakespeare plays where swords are specifically required in the stage directions or in the action – among them are the great duels between Hal and Hotspur in *Henry IV, Part 1*, between Hamlet and Laertes, the battles in *Henry V* and the fight scenes of *Romeo and Juliet*. Comedy duels, as seen in *Twelfth Night* between Sir Andrew Aguecheek and Sebastian, were also hit scenes. Watching a proper fight, like the one between Hamlet and Laertes, was a two-for-the-price-of-one bargain: you got not only Shakespeare's new play, but an excellent swordfight that the audience would willingly have paid to see on its own; indeed, when theatres were not staging plays they often offered fencing displays instead.

Among those watching *Hamlet* must have been many young men carrying rapiers and daggers like those they saw on stage. Unsurprisingly, they mirrored in real life what they saw in the theatre: in 1600 it was reported that gentlemen about town were fashionably copying the famous actor Burbage's performance as Richard III, 'That had his hand

continuall on his dagger.' Indeed, some members of the audience even fought duels as a result of incidents at the theatre, as when a young Irish lord blocked the view of the Countess of Essex at the Blackfriars Theatre and precipitated a duel with her escort.

Inevitably, actors and playwrights joined in the action off stage. Most famously, in 1593, a knife thrust in a Deptford tavern killed Shakespeare's friend Christopher Marlowe, but there were several other theatrical casualties of the age. Gabriel Spencer, a rising actor in the Admiral's Men, killed a man in a fight in 1596, and two years later he was himself killed in a duel by the playwright Ben Jonson, another good friend of Shakespeare. Philip Henslowe, the theatrical impresario, reported the event to the actor Edward Alleyn:

> Now to let you understand the news, I will tell you some, but it is for me hard and heavy; since you were with me I have lost one of my company, that is Gabriel, for he is slain in Hoxton Fields by the hand of Benjamin Jonson; therefore I would fain have a little of your counsel if I could.

Jonson was indicted for murder but pleaded benefit of clergy; as a pardoned offender, he was branded on the thumb with T for Tyburn.

When it came to sword fighting, life imitated art and art imitated life. So it is perhaps not surprising that in 1596 a man called William Wayte claimed to have been set upon by four assailants outside the Swan Theatre and swore before the Court of Queen's Bench that he had been in 'fear of death'. Among the accused was the author of *Romeo and Juliet*, one William Shakespeare.

Chapter Six

Europe: Triumphs of the Past

Battle gear of Henry V

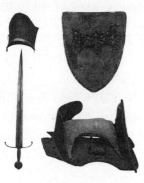

KING HENRY: Once more unto the breach, dear friends, once
 more,
 Or close the wall up with our English dead!

A generation ago, Laurence Olivier created the *Henry V* that everyone knew. In his film version, made during the Second World War, Olivier's King Henry was a handsome, valiant Englishman taking his people onward into battle.

KING HENRY: In peace there's nothing so becomes a man
 As modest stillness and humility:
 But when the blast of war blows in our ears,
 Then imitate the action of the tiger;
 Stiffen the sinews, summon up the blood,
 Disguise fair nature with hard-favoured rage . . .

For a country at war Shakespeare's dashing young Henry was an inspiring figure. He is a king who mingles with commoners,

walks among his soldiers on the eve of battle showing 'a little touch of Harry in the night'. The whole nation is united in arms and becomes one great family, a band of brothers: 'For he today that sheds his blood with me / Shall be my brother; be he ne'er so vile, / This day shall gentle his condition'.

The young hero leads his men to victory against the French, and against the odds, first at Harfleur and then at Agincourt.

> KING HENRY: I see you stand like greyhounds in the slips,
> Straining upon the start. The game's afoot!
> Follow your spirit, and upon this charge
> Cry 'God for Harry, England, and Saint George!'

In the Crypt Museum at Westminster Abbey there remain some of the objects that Henry would have needed, and may actually have used, in 1415 as he led those greyhounds out of the slips and into battle at Agincourt. There is a battered shield and sword, a sturdy helmet and a saddle for a warhorse. They are known as Henry V's 'funeral achievements' – the heraldic term signifying the armour, weapons and banners of a medieval lord, traditionally displayed over his tomb. Henry's shield is made of lime-wood. It has the shape of a garden spade, but is much larger, twenty-four inches high, curved to fit round and protect the body that held it. The sword is hefty and unadorned, a brute of a weapon about three feet long. The wooden saddle still has some of its original hessian padding and leather; the dark metal helmet is battered but edged with gold.

For centuries, these instruments of battle were on public display in Westminster Abbey, hung over Henry V's tomb, and they are, in their way, props in the great theatre of national history that Westminster Abbey has become – emblems of royal display, military might and patriotism. They arrived at the Abbey on 7 November 1422 at Henry V's funeral, after his early death at the age of thirty-five. That spectacular funeral opens *Henry VI, Part 1*:

BEDFORD: Hung be the heavens with black, yield day to night!
 Comets, importing change of times and states,
 Brandish your crystal tresses in the sky,
 And with them scourge the bad revolting stars
 That have consented unto Henry's death –
 King Henry the Fifth, too famous to live long!
 England ne'er lost a king of so much worth.

In the 1590s, when Shakespeare and his audiences came to visit Westminster Abbey, Henry V's military memorials were still colourful and bright. Although the original splendid statue had been despoiled at least twice – most recently in January 1546, when thieves removed the silver head in a night-time raid – the wooden core of the effigy remained on view. The painted arms of the King, the blue and gold velvet, were still on the sumptuously covered saddle; the blue figured Chinese silks that lined his shield had not yet faded, and a painted leopard crest was still in place on the dented helmet. This display of armour – brightly coloured, elaborate and obviously used – offered an emphatic reminder of the martial prowess of the figure in the tomb beneath.

Tourists have been visiting the tombs and monuments of Westminster Abbey for over 400 years, and this sepulchral tourism was already thriving under Elizabeth and her successor James. In 1599 a German visitor to London paid to see the tombs and dutifully recorded them in his diary. Unable to snap a quick photo of Henry V's tomb on his phone as today's visitors can, he carefully transcribed the epitaph: 'Henry, the scourge of France, lies in this tomb. Virtue subdues all things. A.D. 1422.'

Jonathan Bate explains more about the Westminster sight-seers:

It is quite a surprise to discover that Westminster Abbey was a real tourist attraction in London round about 1600. Indeed by

1612, Westminster Abbey had become such a popular tourist attraction that there were actually guides employed there who would give you the guided tour. You would pay a penny (which is exactly what you would pay to get into the theatre), and the guide would take you around the tombs and give you a little history lesson. You would go from tomb to tomb, and on each tomb there would be an effigy of the monarch. There would be a description in Latin of who they were, what their relations were, what their achievements were, and one imagines the guide would have translated these for you. The tombs and effigies of the English kings were the main attractions. So there is an extraordinary parallel between the process of going to the theatre to see the history plays and going to the Abbey to see the 'living monuments', as they called them, the lively statues of the kings and queens in question.

So there were two ways of learning about national history in Shakespeare's time, if you did not want to resort to books: you could go to Westminster Abbey, pay a penny and be instructed about the 'living monuments' of dead kings or you could go to the theatre, pay a penny and see the great kings stride out in front of you. And in each case the hero of the story was most likely to be Henry V. It might seem strange that a king whose reign was so short, and whose conquests vanished so swiftly under his successor, should be given superstar status in the 1590s. Historian Susan Doran explains why Henry V was elevated to the position of national icon and how far Shakespeare's version of him corresponded to the real historical Henry:

The gap between the myth and reality in the presentation of Henry V was not as wide as it might be, compared, for example, with Macbeth or Richard III. Henry V was presented as the exemplary figure of chivalry. He was seen as magnanimous, he had martial courage, he was someone who

could rally his troops to join him in a band of brothers. His value in Elizabethan times, particularly in the 1580s and 1590s, was as a figure that rallied the English against their ancient enemy. And in the late Elizabethan period, of course, England was at war, not against France, but against Spain and in Ireland. The most important aspect of Henry V's character and the myths surrounding him was that he had united Englishmen successfully in war.

The monument of Henry V, with the evocative helmet, shield and saddle hanging high above it, was immensely popular. Many of those in Shakespeare's audience at the playhouse, watching his play *Henry V*, would have seen the funeral achievements at the Abbey. They would have understood that here were memorials of unsurpassed military triumph, but also of admirable, and unusual, royal humility – because for many people these would have been the very sword and helmet mentioned in Shakespeare's account of King Henry's refusal to parade vaingloriously through the streets of London when he came back from his triumphs in France:

> CHORUS: You may imagine him upon Blackheath,
> Where that his lords desire him to have borne
> His bruisèd helmet and bended sword
> Before him through the city. He forbids it,
> Being free from vainness and self-glorious pride,
> Giving full trophy, signal and ostent
> Quite from himself to God.

Henry V is Shakespeare's only history play of the 1590s about a successful king, one in which the story does not focus on conspiracy and revolt. Instead, Henry V's reign is described as one of virtually unadulterated triumph, in which English forces, though ostensibly weaker than their foes, still end victorious. It is true that the King – although charismatic and admirable – is

not altogether whitewashed; events such as the massacre of prisoners during Agincourt are included, and some have sought to see a subversive, anti-war message in the play. But the fact remains that it is nearly impossible, during a live performance, not to be caught up in admiration and patriotism.

The two popular ways of learning national history were closely connected. The playhouses and Westminster's tourist attractions both drew large and diverse audiences. Thanks to Shakespeare and to Christopher Marlowe, the history play as a genre took off in the 1590s and indeed it came to define Elizabethan theatre. Jonathan Bate again:

> The public theatre was a new thing in Shakespeare's lifetime, and one of the big innovations that it brought to the cultural life of the nation was plays about English history. You can roughly trace this from the time of the defeat of the Spanish Armada in 1588. This was really the first opportunity that ordinary people had to discover about the history of their own nation. For ordinary people to get a sense of the history of the nation, the theatre was the place to go.

The history on offer was exhilaratingly jingoistic. *Henry V* contrives to be not just anti-French, but blisteringly anti-Scots.

> ELY: But there's a saying very old and true:
> 'If that you will France win,
> Then with Scotland first begin.'
> For once the eagle England being in prey,
> To her unguarded nest the weasel Scot
> Comes sneaking, and so sucks her princely eggs.

The tabloid nationalism of the history plays was certainly a hit: they made Shakespeare's reputation and eventually his fortune. Printers knew there was a strong market for them: the histories appear in print as much as all the other Shakespeare plays put together. Their popularity was further

buoyed because they were seen as useful, they were based on fact and – it was argued – made the people watching them better citizens. This gave those running the theatres ammunition to defend the stage against its puritanical critics, a line of reasoning the playwright Thomas Heywood ingeniously set out in 1612 in his *Apology for Actors*:

> Plays have made the ignorant more apprehensive; taught the unlearned the knowledge of many famous victories, instructed such as cannot read in the discovery of all our English chronicles: and what man have you now of that weak capacity that cannot discourse of any notable thing recorded even from William the Conqueror, nay from the landing of Brute, until this day, being possessed of their true use? For because plays are writ with this aim and carried with this method, to teach the subjects' obedience to their king; to show the people the untimely ends of such as have moved tumults, commotions and insurrections; and to present them with the flourishing estate of all such as live in obedience, exhorting them to allegiance, dehorting them from all traitorous and felonious stratagems.

In other words, the people standing in the theatre watching history plays are learning to be good, law-abiding Englishmen – learning, above all, to be loyal subjects of the Queen.

There was a slight problem here. Happy though Elizabeth might have been to claim that she descended from Henry V, in fact it was not the case. Her ancestor was Henry's French wife, Katherine of Valois, who after Henry's death married Owen Tudor and thus became the founder of the Tudor dynasty. Shrewdly, and unsurprisingly, Shakespeare does not neglect Elizabeth's fetching foremother when he dramatizes the story for his audience. Katherine of Valois is one of Shakespeare's most captivating young women, whom we see struggling to lisp out a little English before being wooed, kissed and married

by the strapping Henry. On stage, they are the celebrity couple of everybody's dreams. And, like royal couples today, their public kiss in Act V is greeted with cheers from the adoring public.

> KING HENRY: You have witchcraft in your lips, Kate: there is more eloquence in a sugar touch of them than in the tongues of the French Council, and they should sooner persuade Harry of England than a general petition of monarchs.

This was not to be Katherine's last kiss. If Harry and Kate were winners on stage, they continued to be a joint attraction in death. Not far from Henry's is the tomb of his wife, which was also a much-visited tourist sight in the 1590s – and for good reason: Katherine's embalmed corpse lay fully exposed to view. It was perfectly possible to touch her – as indeed the diarist Samuel Pepys did seventy years later. Copying Shakespeare's Henry, Pepys leaned over in Westminster Abbey and kissed Katherine on the lips. We do not know whether he found witchcraft in them, but he was certainly very moved:

> here we did see, by particular favour, the body of Queen Katherine of Valois, and had her upper part of her body in my hands. And I did kiss her mouth, reflecting upon it that I did kiss a Queen, and that this was my birthday, 36 years old, that I did first kiss a Queen.

It must have made quite a difference watching Henry kiss Katherine on stage if you had seen – and perhaps even kissed – her dead lips yourself.

Chapter Seven

Ireland: Failures in the Present

A dangerous image of Ireland

'An Englishman, an Irishman, a Scotsman and a Welshman walk into a bar . . .' We all know how the jokes begin, and how they are likely to end. Playing with, and playing up to, our national stereotypes is a long-standing staple of British humour, but Shakespeare's entry in the Four Nations banter tournament is probably the oldest version of the classic set-up that any of us is likely to encounter. It sits at the very heart of his most tub-thumpingly English play, *Henry V*, where, on the eve of battle, four captains – the English Gower, the Welsh Fluellen, the Irish Macmorris and the Scottish Jamy – bicker round the battlements:

> MACMORRIS: The day is hot, and the weather, and the wars,
> and the King, and the Dukes – it is no time to discourse,
> the town is beseeched, and the trumpet call us to the
> breach, and we talk . . .
> FLUELLEN: Captain Macmorris, I think, look you, under
> your correction, there is not many of your nation –

MACMORRIS: Of my nation? What ish my nation? Ish a villain,
and a bastard, and a knave, and a rascal. What ish my
nation? Who talks of my nation?

FLUELLEN: Look you, if you take the matter otherwise than
is meant, Captain Macmorris, peradventure I shall think
you do not use me with that affability as in discretion you
ought to use me, look you, being as good a man as
yourself . . .

MACMORRIS: I do not know you so good a man as myself.
So Chrish save me, I will cut off your head.

GOWER: Gentlemen both, you will mistake each other.

JAMY: Ah, that's a foul fault!

This scene stands out in the whole of Shakespeare's work for
one striking reason: Captain Macmorris is Shakespeare's only
Irishman. We have a Scottish play – *Macbeth* – but there is no
'Irish' play. Shakespeare gives us Welsh and Scottish charac-
ters aplenty; from Ireland, we have only our solitary Captain
Macmorris.

If Irish characters are conspicuously absent from the Shake-
spearean stage, we can, I think, be sure that they were never far
from the minds of his public. As the audience of *Henry V* were
watching Henry's fifteenth-century conquest of France, they
would have been all too aware of Elizabeth's ongoing struggle to
conquer Ireland. Captain Macmorris may be the only Irishman
who appears on stage in a Shakespeare play, but behind him, just
off stage, there are hundreds of other Irish bristling for battle:

MACMORRIS: . . . the town is beseeched, and the trumpet call
us to the breach, and we talk . . .'tis shame to stand still . . .
and there is throats to be cut . . .

The idea of a horde of unseen Irish fighters eager to start cut-
ting throats would have been shiveringly familiar to the
English theatre-goer.

In trying to reconstruct what a Shakespearean audience might have thought about the Irish, the best place to start is probably a book published in 1581 called *The Image of Ireland* by John Derricke. In a mixture of prose, verse and images, Derricke's work tells how Sir Henry Sidney, Lord Deputy of Ireland in the 1560s and 1570s, subjugated the Irish rebels. Derricke was a loyal follower of Sidney; indeed, he may well have directly witnessed Sidney's campaigning against the Irish. His book is a devoted and passionate apologia for Sidney's actions and a rancorous account of the Irish people, their wild history and barbarous ways. For all its animosity, however, the sheer detail of the twelve woodcuts – some of the most striking produced in a sixteenth-century English book – make it a leading source on the Irish experience, costume and customs in the late Tudor age. The book almost uniquely expresses Elizabethan militarism at its most hot-headed – from the minutiae of the military gear that was used to the fear and rage that the Irish rebellion generated.

The Ireland that Derricke's book describes was the setting for the great military crisis of the Elizabethan age. England in the 1590s was militarily overstretched, and the distractions of European and maritime engagements ruled out the level of action needed to bring a swift end to the Irish revolt. It was not Spain, not the Netherlands, not the high seas, but the war on England's doorstep that brought the regime perilously close to outright defeat. As Shakespeare was writing *Henry V* early in 1599, English affairs in Ireland were at crisis point. The rebels' power was growing, and the English were terrified they would join forces with the great enemy, the Spanish. Andrew Hadfield of Sussex University explains:

> If you want a comparison, it was like the Cuban Missile Crisis. You had the fear that there would be a destructive war that would engulf civilization, and the idea of Russian forces on

America's shores. That is exactly how the English felt about Ireland and the Spanish, that this was a back door into England that could result in the destruction of everything they had tried to build up over the years. So that is why in *Henry V* you have this sense of an army that is there to defend everything that everyone holds dear. The stakes are as high as they possibly could be.

Derricke's book is split into three parts. It is clearly explained that parts one and two are devoted to the evils of the rough native Irish foot-soldier, usually referred to as the wood kern: 'The Nature and qualities of the laied Wilde Wood karne, their notable aptnesse, celerity, and pronenesse to Rebellion.. also their habite and apparel, is there plainly showne.' The third section tells the story of the notorious Irish rebel Rory Oge O'More: 'The execrable life and miserable death of Rorie Roge, that famous Archtraytour to God and the Croune . . . is likewise described.' There is a dramatic illustration, in plate eleven, of Rory Oge O'More himself. The woodcut looks a little like a stage set. There is a stylized forest, with trees neatly balanced on either side. In the distance wolves prowl. And centre-stage, ready to speak, stands a bearded man with a long cloak and hood, and some of the most clumsily drawn feet in the whole of European art.

A bogeyman to the English, Rory Oge O'More was a hero – a Che Guevara – to the Irish resistance. He was one of the most successful Irish war-leaders, struggling against the Elizabethan expropriation of land from the Irish for the benefit of English settlers. In the *Annals of Loch Cé* a Gaelic chronicler wrote of him after his death: 'There was not in Ireland a greater destroyer against foreigners than that man: and he was a very great loss.' This is the kind of Irishman Shakespeare's audience truly feared – powerful, strong and a menace to the forces of the English crown.

Rory Oge O'More was not merely a fighter; he was a wood kern – the most sinister kind of Irishman of all. 'Kern' is a term we hardly know today, but to Elizabethans it was practically a household word. 'Now for our Irish wars,' says Richard II, 'We must supplant those rough rug-headed kerns, / Which live like venom where no venom else / But only they have privilege to live.' The idea of the kern was so current because these guerrilla fighters were blamed for all of England's problems in Ireland. Lightly armed, quick on their feet, kerns could melt into the countryside – they are the archetype of the nightmarishly elusive, indigenous forest-fighter. The English dream of settling Ireland was frustrated, many believed, not because the whole island was against it. The problem – it was argued – was by no means *all* the Irish people, just the awkward ones, the wild ones – the kerns. That is what Derricke's book wants us to believe, as Ciaran Brady of Trinity College Dublin sets out:

> The lesson is not that all the Irish are barbarous and uncivil, but that a certain kind of Irishman needs to be tamed; that kind of Irishman is the wood kern. These men were originally the members of the private armies of some 2,000 souls, commanded by the great feudal lords of Ireland. They were professional fighters, acculturated to violence, prepared to undertake acts of terrorism normally associated with people in organized crime. Once they were decommissioned, they had nowhere to go. Some of them went abroad, but in the majority of cases they went into the woods. And when rebellion broke out in Desmond, in Munster, in the 1580s, and most importantly in Ulster in the 1590s, they came out of the woods. And they are not the kind of people one would like to meet at three o'clock in the morning.

Uncivil, wretched, dirty and shaggy-haired – the feral nature of the wood kerns was a constant part of their image.

Shakespeare's offstage kerns unpredictably fight now on one side, now on the other. They could on occasion be fighting (for the time being at least) with the English:

MESSENGER: The Duke of York is newly come from Ireland,
　　And with a puissant and a mighty power
　　Of gallowglasses and stout kerns
　　Is marching hitherward in proud array . . .

Or they could be Irish freedom-fighters of the kind that English grandees like the Duke of York are sent to deal with:

CARDINAL: My Lord of York, try what your fortune is.
　　Th'uncivil kerns of Ireland are in arms
　　And temper clay with blood of Englishmen;
　　To Ireland will you lead a band of men,
　　Collected choicely, from each county some,
　　And try your hap against the Irishmen?

The trouble with the kerns was that you never knew whose side they were on.

Rory Oge O'More was not an ordinary kern but a chieftain and, as far as the English were concerned, a serial offender against English rule. His family was based in Leinster in the Irish Midlands, and their land was among the first seized for English settlers after the Irish colony was officially established in 1556. Rory Oge earned a reputation for gritty opposition to this policy of plantation and led two major uprisings. The first rebellion, from 1571 to 1577, ended with him accepting some land from Henry Sidney, but mutual mistrust meant there was no final settlement. After only ten months of peace, Rory Oge rebelled again in 1577–8, and this time a punitive campaign was waged against the rebels. As the conflict dragged on, massacres were carried out by both sides, and the usual rules of war broke down. Rory Oge became a demonic figure, associated, in the English mind, with witchcraft and conscienceless malevolence.

Rory Oge O'More was at the heart of a transformation in the thinking of the English elite trying to control Ireland; they began to characterize the native Irish as innately and irredeemably addicted to violence and rebellion. He was also, as far as the English were concerned, a turncoat and a traitor. Ciaran Brady again:

> Rory Oge had for a time been an ally or an agent of English government in Ireland, but he then turned and became a rebel. He had to be punished; he could not be seen to have got away with this act of treachery. What *The Image of Ireland* is trying to suggest is that, whereas you must apply the modes and processes of English law to normal subjects of the crown, the wood kern are simply beyond that, which means you need to take ruthless action. This is a kind of justification for getting really tough, for applying martial law to dangerous, demobbed soldiers.

Rory Oge was long famous for narrowly evading capture, but eventually his luck ran out, and on 30 June 1578 he was caught in a double ambush and beheaded.

The printed image of Rory Oge is a lesson not just in Irish wildness, but in English savagery: Derricke's treatment of him in print three years later was almost as gruesome as his execution. By this time, Rory Oge's head had been exhibited on a spike by Dublin Castle. Derricke makes his severed head speak to us and acknowledge his treachery:

> And here I lye groveling, poore wretch, on the ground,
> Thus God of justice, doeth traitours confounde . . .
> My hed from the bodie parted in twaine,
> Is set on the Castell, a signe to remaine.

The enemy, ambushed, defeated, executed, is now also demeaned.

*

How the beastly Irish could be subdued was not a new problem as the sixteenth century drew to its close. The action of *Richard II*, set 200 years earlier, is propelled by the crushing financial burden of his Irish wars, which set the King on the road to deposition and death.

> NORTHUMBERLAND: And then it was, when the unhappy
> King –
> Whose wrongs in us God pardon! – did set forth
> Upon his Irish expedition;
> From whence he, intercepted, did return
> To be deposed, and shortly murdered ...

Elizabeth escaped Richard's fate – although she certainly knew about it – but the Irish war was a bleak backdrop to much of her reign, and to Shakespeare's writing in the 1590s. Andrew Hadfield again:

> By the 1590s, everybody knew what was happening in Ireland. A lot of ordinary people would have been drafted into the army through the muster system. Just before *Henry V* was produced on stage, the biggest army that had ever assembled in London was ready to go over to Ireland. Many people had a connection to the army, they knew people who had been killed – it was something you could not avoid, and Shakespeare refers to Ireland, very topically and very clearly, in *Henry V*.

Though Rory Oge was by then out of the picture, rebellion against English rule broke out again in 1594, this time under the leadership of the Earl of Tyrone, Hugh O'Neill, and his allied Gaelic chieftains. So great was the concern about Ireland that Shakespeare, in what is probably his only direct reference to a topical event, compares Henry V's victory at Agincourt to Elizabeth's troops fighting the Irish:

CHORUS: Were now the general of our gracious Empress –
 As in good time he may – from Ireland coming,
 Bringing rebellion broachèd on his sword,
 How many would the peaceful city quit
 To welcome him!

Shakespeare may here be describing Elizabeth's great favourite, the Earl of Essex, sent to Ireland in 1599 with a vast force – the largest army ever assembled in London – and about to return, it was hoped, with 'rebellion broachèd' and glory shining from his sword. But Essex failed in Ireland, fell out of favour and (after a disastrously ill-judged rebellion against the Queen) was in 1601, like Rory Oge, beheaded.

What became known as the Nine Years War did conclude with victory in 1603 – the medieval plan for the conquest of Ireland was completed in the final year of Elizabeth's reign. But it was at a human cost of between 50,000 and 100,000 lives, and a financial cost of over two million pounds – more than Elizabeth spent on defence against the Armada and supporting the Dutch rebels combined. When James I inspected the documents stored at Whitehall, he exclaimed: 'We had more ado with Ireland than all the world besides!'

Chapter Eight
City Life, Urban Strife
A cap for an apprentice

One of the things most of us English speakers struggle to learn in German, French or many other languages is that there are two ways of saying 'you'. There is the friendly, informal one, and the formal, respectful one: *du* and *Sie*, *tu* and *vous*. But in Shakespeare's day English did exactly the same: as an Elizabethan, you established your social relationship to the person you were speaking to by using either a respectful 'you' or a familiar 'thou'. So the young man in the song calls his girlfriend 'thou', but her mother 'you':

> Then mother you are willing
> your daughter I shall have:
> And Susan thou art welcome
> Ile keepe thee fine and brave.

James Shapiro explains:

> In Shakespeare's day you wouldn't use the word 'you' in all circumstances. If you were speaking to somebody of a higher

social station, you would address them as 'you', and generally, when you were speaking to somebody of a lower station, you would address them as 'thee'. But if you were really angry you might address a superior, contemptuously, as 'thou'. One of the things that we have really lost is sensitivity to how that works.

In modern English we have completely lost these hierarchical nuances of 'you', 'thee' and 'thou'. The words remain, but they have lost their powers to guide us through the labyrinths of social interaction.

This cap also carries just such a lost social meaning: self-evident to an Elizabethan, but very hard for us to read today, it too was a guide to who you were, or who you were speaking to. It is an English woollen cap of the sixteenth century, a sort of flat chocolate-brown beret, and it was found about 150 years ago at Moorfields in London. Its wool has been closely knitted and felted, and it has a pleasing lived-in look. Textiles on the whole do not survive well over time; they are key pieces of physical evidence about life in the past that we often cannot recover or experience. But a relatively large number of English caps like this one have made it through the centuries, which gives us a good sense of just how many there must have been to begin with.

This hat unlocks a whole language of social difference and a whole structure of social control – both expressed through clothes. Elizabethan England had clear rules about what sort of garments could be worn by what sort of people. Between 1571 and 1597, for example, a parliamentary statute stipulated that males over the age of six had to wear a wool cap on Sundays and holidays. The law was a shrewd device for supporting the English wool industry but it was also designed to reinforce social divisions by making them visible, because in fact not *every* boy and man had to wear them – only those

who were neither noblemen nor gentlemen. The 'capped' were the lower echelons of society, and for them not to wear the cap was to break the law. Shakespeare's Uncle Henry, not quite grand enough to qualify as a gentleman, was fined in 1583 for exactly such a breach.

Everybody in Shakespeare's audience took all this for granted, and everybody in this society wore a hat of some kind as a badge of social identity; not doing so suggested that something was seriously amiss.

> OPHELIA: My lord, as I was sewing in my closet,
> Lord Hamlet, with his doublet all unbraced,
> No hat upon his head, his stockings fouled,
> Ungartered, and down-gyvèd to his ankle,
> . . . he comes before me.

As soon as Ophelia sees that Hamlet is hatless, both she and the audience are persuaded that he is probably mad or at least seriously distressed. Not that Prince Hamlet would be wearing a woollen cap, of course. Very broadly, the higher the status, the higher the hat, and a Danish prince would wear a high hat of taffeta or velvet, richly embroidered with gold or silver thread and probably a valuable hat jewel of some sort.

Our cap is what in *Love's Labour's Lost* is called a 'plain statute cap' and would have been worn by craftsmen and journeymen, servants and apprentices. Apprenticeship was a standard part of Elizabethan life. You became an apprentice around the age of fourteen and normally remained one for about seven years. In Shakespeare's London, there might have been about 20,000 apprentices – roughly 10 per cent of the city's population – and they would have come to the city from all over the country. Although apprentices were bound to a master and could not marry while their service lasted, these young men were not the downtrodden proletariat of a Victorian factory or a Dickensian workhouse. In fact, they often had

a great deal of freedom. They were a part of their masters' household; they would, in due course, one day be masters themselves; and a fair proportion of them would wind up marrying their masters' daughters. They might be wearing plain statute woollen caps, but they might well be swaggering in them too.

We can see that this particular cap was probably not an apprentice's ordinary, everyday cap. Under the brim are three lines of brown silk stitches, used to hold a silk ribbon, and there is the tiniest shred of fine tabby-weave silk still attached to the fabric. When the king in *Hamlet* calls Laertes' skill with a rapier 'a very riband in the cap of youth', a trim of stylish silk like this is what he is picturing. This velvety brown example is probably not grand enough to be a master's cap, but it does look like an apprentice's *best* cap, one that he might wear to a special event or to the theatre. So, if you were an actor looking out from the stage around 1600, you would probably have seen a sea of flat caps like this, many of them worn by apprentices standing in the open air at the Rose, the Globe or the Fortune.

Apprentices were a routine part of the audience at the public playhouses, and, needless to say, their masters complained bitterly about both their idleness and their enthusiasm for theatres and alehouses. One master carpenter, around 1600, groused about his apprentice:

[He] will work nyver but ly drinking at the ale house & romes to playes all the day longe, & at night when he comes home & if he be sheute out of dores & cannot be let in he will climb over the bricke walles & throwe downe the windowe & come in soe that theare is no body that can rule him. I would be very fayne rid of him.

It was not just the carpenter's apprentice who roamed to plays all the day long. Shakespeare's audiences included apprentices

from every trade. They stood for a penny in the pit, but they might also accompany their master or mistress to the balcony. Masters often sent an apprentice to escort their wives to the playhouse – respectable women attending the theatre needed an escort. There was uneasy humour to be had in this unsupervised relationship between mistress and apprentice, as this saucy anecdote from Henry Peacham's *The Art of Living in London* shows:

> A tradesman's wife of the Exchange, one day when her husband was following some business in the city, desired him he would give her leave to go see a play; which she had not done in seven years. He bade her take his apprentice along with her, and go, but especially to have a care of her purse . . . Sitting in a box, among some gallants and gallant wenches, and returning when the play was done, returned to her husband and told him she had lost her purse . . . Quoth her husband, 'Where did you put it?' 'Under my petticoat between that and my smock.' 'What, [quoth he] did you feel no body's hand there?' 'Yes [quoth she,] I felt one's hand there, but I did not think he had come for that.'

The theatre was an environment where the mistress was not the only one likely to get into a bit of mischief. James Shapiro of Columbia University says:

> Lots of people imagine that, like Romeo and Juliet, Shakespeare and his contemporaries married at fourteen or fifteen. In fact, they did not marry until their mid-twenties because they were apprenticed from their mid-teens to their early twenties in a trade or profession. That leaves a lot of young men who are sexually mature, working long hours and ready to relax a little bit when they are out with a crowd, ready to drink and carouse; they are defined by belonging to a particular age group as much as anything else.

Young men out on the town were bound to get into trouble, and they did. They often went particularly wild on Shrove Tuesday, when the festivities were a last chance to let off steam before the glum privations of Lent (between 1603 and 1642 there were twenty-four serious riots on Shrove Tuesdays). Sometimes, after a bit of drink, they even wrecked the theatre if they did not like the programme. In 1617 a mob of apprentices invaded and smashed up the Cockpit Theatre, apparently in retaliation after the owners transferred the resident company from the cheaper, open-air Red Bull to the indoor Cockpit, which the apprentices could not afford and where they were no longer welcome. The simple stage direction 'Enter three or four Apprentices of trades, with a pair of cudgels' from *Sir Thomas More* (a play from the 1590s in which Shakespeare may have had a hand) conveys some of the rowdy violence that apprentices could easily produce.

The disorderly behaviour of these cap-wearing young men, particularly during public holidays, sometimes became more dangerous. During the 1590s, a series of bad harvests led to demonstrations across the country about food prices. These protests frequently ran out of control. Shakespeare depicts just such a moment in *Coriolanus*: the people are hungry and are being whipped up to anger against the man blamed for the food shortage:

> FIRST CITIZEN: You are all resolved rather to die than to famish?
>
> ALL: Resolved, resolved.
>
> FIRST CITIZEN: First, you know Caius Coriolanus is chief enemy to the people?
>
> ALL: We know't, we know't.
>
> FIRST CITIZEN: Let us kill him, and we'll have corn at our own price. Is't a verdict?
>
> ALL: No more talking on't, Let it be done. Away, away!

All this would have struck a chord with the audience. But apprentices in the pit would surely not have cheered with so much gusto at the later speech by Coriolanus' friend Menenius, who must have been speaking directly to them, pointing down at them in their caps.

> MENENIUS: You are they
> That made the air unwholesome when you cast
> Your stinking greasy caps in hooting
> At Coriolanus' exile.

The hooting at Coriolanus' banishment, which threatened Rome's very existence, goes far beyond a boisterous Shrove Tuesday. There is a sense of real menace here, and Menenius, for all his condescension, has identified an aggression in the cap-wearing crowd that greatly preoccupied the English governing classes. These apprentices could, in certain circumstances, turn into a violent mob.

The cap was a tool for maintaining the social hierarchy, but, like all tools, its purpose could be redirected in unpredictable ways. The cap could come off to ask a favour – literally, cap in hand; it could be doffed to signal respect and thrown up into the air in joy, to indicate exuberant support. But, as Menenius accuses the fickle crowd, the throwing around of caps could also signal belligerence. James Shapiro explains what this tossing of caps in the air meant and why Menenius shows so much hostility to it:

> It could be an expression of wanting to throw the social order over, of regime change. The symbolism of these caps tossed in the air suggests a moment of anarchy. In plays like *Coriolanus*, Shakespeare actually writes a stage direction, 'Everybody tosses their caps in the air.' That signified a kind of threatening, rebellious, popular force that kings and theatre owners should reckon with.

In London, no less than in Coriolanus' Rome, cap-wearing mobs were a potentially frightening force. And as an emblem of the lower classes, those woollen caps could carry menacing associations – not very different from hoodies today. Shakespeare's crowd in *Coriolanus* is remarkable not just for its escalating violence, but because the caps almost acquire the status of a uniform. James Shapiro again:

> It is a way of signifying a kind of collective identity, a bunch of young men who are rowdy, or potentially easy to stir up. I think Shakespeare likes that energy. You see crowds like that in *Julius Caesar*, in *Coriolanus*. It is threatening and unpredictable. I do not think he thinks of these young men gathered together throwing their caps in the air as either good or bad in and of themselves. They are just this energetic group of people that can shift the political terrain at any point.

The relationship between the theatrical world and the apprentices was lively, close and at times uneasy. Most playing companies contained men who were also members of London livery companies, who had themselves been apprentices: Ben Jonson, the playwright and actor, was a member of the Bricklayers' Company, and Robert Armin, an actor in the King's Men, was a member of the Goldsmiths' Company. The playing companies themselves employed apprentices too – the young boys who took the female roles. More generally, if they wanted an animated audience, and plenty of pennies in their money boxes, the theatres depended on the enthusiastic attendance of apprentices, along with the porters, apple-wives, carters, butchers, serving-men and fishwives.

Suspicions about the dubious influence of the theatres on young apprentices darkened when violence broke out which seemed to implicate the players. On St Barnabas Day (11 June) 1592, celebrations took a nasty turn when the feltmakers' apprentices 'assembled themselves by occasion, & pretence of

their meeting at a play' near the Rose Theatre and, after a fracas with some of its officers, set off in an attempt to storm the Marshalsea Prison. Unsurprisingly, the theatre community tried to distance itself from such activities: the writer Thomas Nashe reported that the players 'heartily wish they might be troubled with none of their youth nor their prentices'. But in 1595 apprentices rioted seriously at Tower Hill in London. The mayor and aldermen of the City used the theatre as a scapegoat for the unrest, and as a part of the clampdown of public order the theatres were closed. In fact, this was a serious outbreak, driven by desperation arising from poor harvests and famine, and what began as a protest against rising food prices ended with martial law being declared.

Ten years on, the opening scene of *Coriolanus* dramatized exactly this sort of riot among those demanding cheap corn – 'Let us kill him, and we'll have corn at our own price.' Everyone in Shakespeare's audience would have known how threatening that could be for social order. They would also have known how dangerous it was for the apprentices themselves and that those who controlled the political terrain were always in a position to fight back. Five of the apprentices who rioted in 1595 were executed on the scaffold.

In the next chapter, we will be looking at other ways the establishment found to control an unruly world: not through martial law or statutes about clothing, but through the power of magic.

Chapter Nine

New Science, Old Magic

Dr Dee's magical mirror

From Prospero's hardworking helpers in *The Tempest* to the whimsy of Titania's midsummer fairy train and the dark spirits that Lady Macbeth summons to turn herself into a killer, Shakespeare's plays are filled with otherworldly presences, usually invisible but often a key part of the action:

PROSPERO: Spirits, which by mine art
 I have from their confines called to enact
 My present fancies.

TITANIA: I'll give thee fairies to attend on thee,
 And they shall fetch thee jewels from the deep . . .
 Peaseblossom, Cobweb, Moth, and Mustardseed!

LADY MACBETH: Come, you spirits
 That tend on mortal thoughts, unsex me here
 And fill me from the crown to the toe top-full
 Of direst cruelty.

In every case the proximity and the influence of a world of spirits are taken for granted. Gregory Doran of the Royal Shakespeare Company describes the impact of these supernatural beings in Shakespeare's era:

> This was a society that believed in ghosts, was frightened of them and was aware of the presence of the devil, and though the belief in fairies was waning, the conjuration of them on the stage would nevertheless surprise and scare people.

In the late sixteenth century, harnessing invisible spirit power was an exercise similar to harnessing the invisible power of the wind. It was unpredictable and complicated, but if you could do it – rather like improving the technology of your ship's sails – the world and its wealth were at your feet.

Reaching the spirit realm was, however, a touch more tricksy and considerably more demanding than improving navigation. One of the most effective ways of accessing the world of the spirits was through an object now housed in the British Museum. It is a round disc of highly polished black stone, about the size of a domestic side-plate but much heavier, about 880 grams. It is a mirror said to have belonged to one of the Shakespearean world's most famous practitioners of the occult arts, Dr John Dee. Made of obsidian – a black volcanic stone – that has been highly polished, it is an oddly potent artefact that one is almost nervous to pick up. It is gleaming and smooth, like something modern and industrial, but it is at least half a millennium old. There is a small bump at the top through which a hole has been pierced. With a strong cord, you could – for whatever practice – suspend this heavy, honed disc.

John Dee was particularly known for what he called his 'showstones', reflective objects in which, combining prayer with optics, he was able to conjure up and talk to angels. Dee had decided he needed to consult the angels, his 'scholemasters'

as he described them, to understand fully the natural and supernatural world. But, despite much trying, Dee found he could not access the angels directly – he needed a medium, an intermediary. The most famous of these was his assistant, the astrologer Edward Kelley – a figure now viewed as probably the real charlatan in the Dr John Dee show. With Kelley's help, the angels turned out to be beguilingly chatty, and Dee recorded their conversations in a set of 'angelic diaries'. As is the way of history, after his death Dee's angel messages were discarded and a century later were found being used to line pie dishes, but some were rescued and have survived. We can see from these surviving accounts that the whole set-up was intensely theatrical: the elaborately costumed angels, with their crowns, rods and other props, stagily declaimed mysterious messages: 'I am *Prince of the Seas*: My power is upon the water. I drowned Pharaoh . . . My name was known to Moyses. I lived in Israel. Behold *the tyme of Gods visitation*.' With visitors like this you can see why Dee became a celebrity. The consultation ended, we are told, with a black curtain being drawn within the showstone. The audience with the spirits was over.

John Dee was a celebrated mathematician and a particular expert on Euclid, the ancient Greek mathematician and father of geometry; in the 1550s he was offered lectureships in mathematics in Paris and in Oxford. But his behaviour was often that of a 'conjurer', that ambivalent word which to us suggests deception, but to an Elizabethan meant more neutrally someone who claimed the power to call up spirits. To the modern mind, this blend of science and magic disconcerts, but in Shakespeare's day there was a natural affinity between the two worlds. Professor Lisa Jardine explains the relationship:

> The term they used was a magus – this was someone who was at once a magician and a scientist, and there really was no boundary between the two. A magus was somebody who

exercised power over the natural world by some means that were unfathomable. So Dr Dee was in a very real sense a magus; in fact he was probably our only home-grown Renaissance magus. He was highly educated in mathematics, in astronomy, in languages – classical languages certainly – and he combined this intellectual training with a huge capacity and will to operate and control: he aspired to power.

Among the educated elite, John Dee had an authority similar to that of a modern celebrity scientist, whose work we admire, but can only dimly apprehend. When physicists and astronomers talk to us today of parallel universes and negative matter, few of us know enough ourselves to have any idea whether these conjectures are well founded or not. But we accept that this highly authoritative science appears to explain our world – just as Shakespeare's contemporaries accepted Dee's explanations of the workings of stars and spirits.

Elizabeth I certainly took him seriously. Dee lived at Mortlake, to the west of London, and the Queen visited him there several times, consulting him about an auspicious date for her coronation and other astrological matters. He also provided some afternoon entertainment for her, using all his scientific skills to create an optical illusion involving a mirror that, as you moved towards it, gave alarming and amusing three-dimensional reflections. Dee's cleverly contrived optical effects produced exactly the desired result: 'her Majestie's great contentment and delight'. It was a typical Dee blend of high science, high society, high-jinks and high theatre.

Dr Dee believed his angelic conversations were the crowning achievement of his career, but some of his contemporaries believed that his science was little different from sorcery. They feared he was flirting with the Devil; neighbouring children 'dreaded him because he was accounted a Conjurer'. Lisa Jardine explains what Dee did to earn such a reputation:

In his early life, Dee showed off by being very clever, often through casting horoscopes. We might think of this as simple superstition, but it involved lining up the heavenly bodies and calculating where they would be at a particular time, and, if you believe that has some control over our lives, then that could be seen as science. He also used his knowledge of mechanics to dazzle people. In a production of an Aristophanes play at Trinity College, Cambridge, he used a three-pulley arrangement to hoist a man and a scarab beetle up to the top of the theatre, and everybody fled in dismay, thinking he had performed magic.

He was also the target of serious accusations, among them formal charges of witchcraft. Like Galileo a short time later, he complained vociferously about it all in the petulant tones of the misunderstood star:

> And for these and other such like marvellous Actes and Feates, Naturally, Mathematically, and Mechanically wrought and contrived; ought any honest Student and Modest Christian Philosopher, be counted, & called a Conjurer? . . . Shall that man be (in hugger mugger) condemned as a Companion of the Hellhoundes, and a Caller, and Conjurer of wicked and damned Spirites? . . . O Brainsicke, Rashe, Spitefull, and Disdainfull Countrey men.

Dee was the prototype of the controversial celebrity, the magus that people loved to hate.

Dee's fame clearly coloured the creation of some great theatrical characters such as Christopher Marlowe's damned Dr Faustus and Shakespeare's own master of magical effects, Prospero. *The Tempest*'s 'majestic visions', a little like the magic mirror tricks laid on for Elizabeth, are high-end stagecraft: shipwrecks at sea, lavish banquets that appear and vanish in a trice – at once theatrical magic for the spectator

and the product of demanding technology. But it became possible to stage such effects only once Shakespeare's company began to use an indoor space at Blackfriars alongside the outdoor Globe theatre in around 1608. Gregory Doran explains how Shakespeare's theatre managed the magic:

> When they moved inside to the Blackfriars theatre, they had control of light, which is very important. If you can control the light, you can control the effect. In the Globe's stage, in the open air, there were no lighting effects to speak of, and with the audience wrapped all the way around, it was almost impossible to hide the strings.

Indoors at Blackfriars, stage magic reached a new pitch of sophistication in *The Tempest*. Flying beetles and other effects that had once resulted in John Dee being labelled a dangerous conjuror could now be achieved without anyone suspecting sorcery.

Prospero's magic, like Dr Dee's, is much more than light entertainment. With his superior learning, Prospero doesn't just whip up storms and banquets: he takes over the island on which *The Tempest* is set. Magic – like any mystification, if done the right way – confers authority, so we should not be surprised that Dee's skills as a magus were closely aligned to the structures of Elizabethan economic and political power. Lisa Jardine again:

> Elizabeth I was a real intellectual and sought out Dee for advice about where in the new world she might make discoveries, or significant new land claims. She did get advice on a propitious day for her coronation – he cast her horoscope to decide that – but she respected his advice on the basis of their mutual intellectual depth and understanding. Dee produced a run of documents concerned with policies on fishing rights and territorial waters, really important things that depended

on his command of geography and the extent of conquest and exploration; he had access to and engaged with matters of serious national intelligence.

This was knowledge potentially as important for national prosperity as Drake's discovery of several different routes to the Pacific (see Chapter One).

It is difficult for us now to know what to make of Dr Dee advising the Queen on colonial expansion in America. But, watching Caliban or Ariel do Prospero's bidding, the audience can never have been in any doubt that, when two worlds meet, he who has the magic holds the power. After Prospero (as the exiled Duke of Milan) arrives on the island, his knowledge – his magic – releases Ariel from the tree where a witch had imprisoned him. Ariel complains that he was promised his freedom, but Prospero spells it out clearly: 'It was mine Art that made gape the pine'. Ariel is delivered from one bondage only to be enslaved in another.

A powerful European takes over an island – is this *The Tempest*, or is it really about England and Spain making conquests in the New World? Shakespeare's audience would certainly have been reminded of recent events on the other side of the Atlantic. In the 1590s Sir Walter Raleigh's settlers had tried to establish a colony on Roanoke Island, off the coast of North Carolina, and had perished. A new English colony at Jamestown in Virginia had been established just a year or two before *The Tempest* was first performed. Nobody knew whether it would survive the combined hazards of the natives and the climate.

Encounters with indigenous people like Caliban and Ariel were always likely to be fraught. American Indians had a superior understanding of their land and its resources, but scientific knowledge like Dee's could still overwhelm them – especially if you presented your science (as Prospero does) as a secret power that only you could command. To those who

do not understand it, science often appears to be magic and can easily be used as a tool for subjugation. It was a tactic that the Spaniards had deployed to great effect in the conquest of Mexico and Peru.

It is therefore unsettling to realize that Dr Dee's mirror was almost certainly itself a piece of Spanish booty from Mexico. It turns out that this polished disc of black obsidian is in fact an Aztec mirror, painstakingly crafted in Mexico some time before the Spanish arrived. It was shaped with stone tools, and we now know – though Dee probably did not – that the high polish was achieved by long rubbing with bat excrement. The fine skeletons of the insects the bats had eaten survived the digestive journey to produce a wonderfully abrasive paste at the other end. This mirror is – entirely appropriately – fashioned with help from creatures of the night.

Aztec royalty used obsidian mirrors as symbols of their power and as a means of seeing into the future, deriving part of their authority from a god named Tezcatlipoca, 'the Lord of the Smoking Mirror'. When Spanish science (and horses and guns) overwhelmed the magic of Mexico, this magical object travelled to Europe, where it became part of another – but in some ways disconcertingly similar – structure of knowledge possessed only by a privileged, powerful few.

*

Shakespeare's Prospero is perhaps the most positive portrayal of a magus in Elizabethan and Jacobean drama – and this comes in part from the self-restraint with which he learns to use his magical powers. Having been usurped as Duke of Milan and exiled to the island by his brother partly because of his obsession with the occult, Prospero does continue to use magic. But once he has restored justice, order and happiness on the island, he sets it aside and denounces the egotism and arrogance of the magus:

PROSPERO: But this rough magic
I here abjure; and when I have required
Some heavenly music – which even now I do –
To work mine end upon their senses that
This airy charm is for, I'll break my staff,
Bury it certain fathoms in the earth,
And deeper than did ever plummet sound
I'll drown my book.

Prospero's surrender of magic has sometimes been interpreted as Shakespeare's farewell to the stage – *The Tempest*, written in about 1610, was his last play as sole author. But just as striking is Shakespeare's message about the wisdom with which some rare men choose to give up their powers: Prospero has the self-control to jettison his own supernatural strength. While in *Doctor Faustus* – Marlowe's play about the dangers of knowledge, power and greed – the terrified Faustus offers to 'burn his books' to save himself from hell, Prospero voluntarily drowns his book of magic, which he had previously called the 'volumes that I prize above my dukedom'.

Dee's later life and magical demise were less happy and less celebrated. In 1595 Elizabeth made him warden of Christ's College, Manchester, but he received no such favours from James I, whose hostile and punitive views on witchcraft were well known (see Chapter Ten). Most of Dee's family appear to have been lost to the plague in 1605, and he returned from Manchester to Mortlake with his one surviving daughter to look after him in his old age. He spent his final years in relative poverty, and his famous library – one of the largest of the age – was broken up, and many of his possessions sold.

For generations after his death, Dee was held to be a dubious character, a charlatan whose sleights of hand and gift of the gab earned him unwarranted status in a gullible age. The eighteenth-century writer and politician Horace Walpole,

who at one point acquired Dee's magic mirror for his own antiquarian collection, dismissed Dee as a 'conjuror' who used the mirror 'to deceive the mob'. Nowadays, Dee is regarded as a genuine scholar and thinker, a polymath whose interests ranged from Euclidean geometry, calendar reform and geographic exploration to astrology, alchemy and conjuring angels. He is understood as part of an intellectual continuum that stretched from outright charlatans like his sometime associate the astrologer Edward Kelley, through Tycho Brahe and Galileo, to luminaries of the Scientific Revolution like Isaac Newton – some of whose interests in alchemy and the occult had far more in common with a figure like Dee than used to be admitted.

At his peak as a magus, Dee was cultivated by ambitious rulers across Europe. From Louvain to Prague, the powerful consulted him on everything from prospecting in the Americas to predicting the future. And in due course Dee followed the path of practically every other scientist or magus of the age, from Johannes Kepler to Giordano Bruno, to the court of the other intellectual ruler, the Holy Roman Emperor Rudolf II, whom he visited in 1583. Rudolf's palace at Prague, like the lawn at Mortlake, was a place where political power paid homage to the power of spirits.

Dr Dee's spirits, like Prospero's, were usually benign (although the spirits in *The Tempest* do cause a shipwreck). Others could conjure darker, more dangerous forces. In the next chapter we shall face another (spirit-induced) storm at sea – this time with witches, trying to drown the King and Queen of Scotland.

Chapter Ten
Toil and Trouble
Model of a bewitched ship

For centuries, Scottish ships set sail from Leith pier near Edinburgh to make the perilous journey over the North Sea to the European mainland and to the wider world beyond; it was from Leith pier that Scotland faced the world. In the autumn of 1589, a young Scot undertook the dangerous voyage from Leith to Norway and Denmark, returning the following spring. This young man was James VI, King of Scotland, and his ship was beset by such terrible storms that it nearly perished. James came to believe that the storms were more than just the usual bad Scottish weather. They were the work of evil Scottish witches.

ALL: Double, double, toil and trouble;
　　Fire burn, and cauldron bubble.

ALL: Fair is foul, and foul is fair.
　　Hover through the fog and filthy air.

Shakespeare opens *Macbeth* by bringing us face to face with three extremely dangerous Scottish witches. Throughout the

play these Weird Sisters cause mayhem on land and sea, and it was probably this kind of malevolent witchly chaos that lay behind the building of a finely crafted ship put on display in Leith towards the end of the sixteenth century, and now kept in the National Museum of Scotland.

It is a model ship, just 65 centimetres high. Made of wood, its hull is thickly painted in red and gold. The figurehead is a boldly carved gold lion, and on the sides hefty white mermaids clutch their tails, while sea gods wave their tridents. At first glance you might think it was a toy, but it was not made for the amusement of children: this was an offering to God. Ship models now usually serve as records of actual vessels, but the purpose of this model was apparently to give thanks – for survival at sea, and for delivering the ship's passengers and their cargo from the clutches of tempest-brewing witches.

For modern audiences it can be hard to grasp why Macbeth, who was a successful practical soldier and king in eleventh-century Scotland, pays so much attention to what the witches tell him. But Shakespeare's public would most definitely have understood. For many, witchcraft was part of the fabric of daily life, as the historian Keith Thomas explains:

> To ordinary villagers, labourers, small farmers, shopkeepers, witchcraft was the power to work physical effects by some supernatural means. Witches were divided into good witches, white witches, and bad ones, black witches. The good witches healed people by charms or prayers or some other form of mysterious activity. The black witches were people who did harm through their occult powers, typically by injuring people's animals, their livestock, or worse by injuring or killing children, men or women. Out of the fear of witchcraft, there grew a huge literature of learned demonology, which described how black witches flew through the air to black masses, where they conducted obscene rituals, had sexual

intercourse with the devil and, most important, made a contract with the devil. In other words they were heretics. They had renounced God for the devil. The Reformation was immediately followed by witchcraft prosecution at a fairly intensive level and a concerted drive on the part of everyone, Catholics as well as Protestants, to complete the Christianization of the population at large. In the process, that sharpened the eye for any heresy. So if people turned to charmers and cunning folk, something had to be done about them. This was particularly the case in countries where the clergy were very influential, Scotland being a very good example of that.

Witchcraft became prohibited by statute for the first time in England only in 1542. In 1562, another Act against 'conjurations and witchcraftes' made the 'invocation and conjuration of evil spirits' felonies. But only the use of witchcraft to kill was punishable by death: injuring persons or cattle, treasure-hunting through magic and provoking unlawful love were punished merely by a combination of prison or the pillory.

Not everyone agreed that it was possible or desirable to punish witches. Reginald Scot's *The Discoverie of Witchcraft* of 1584 was a forthright and angry attack on the folly and injustice of witchcraft persecutions:

And because it may appeare unto the world what treacherous and faithless dealing, what extreame and intolerable tyranie, what grosse and fond absurdities, what unnaturall and uncivil discourtesie, what cancred and spiteful malice, what outrageous and barbarous crueltie, what lewd and false packing, what cunning and craftie intercepting, what bald and peevish interpretations, what abominable and devilish inventions, and what flat and plain knaveries is practised against these old women; I will set downe the whole order of the inquisition, to the everlasting, inexcusable, and apparent shame of all witchmongers.

Such sceptical and humane voices, always a minority, were even less likely to be heard once James became King of England. His interest in witchcraft was well known on both sides of the border through his book *Daemonologie*, which was published in 1597 and reprinted in London in 1603, the year he acceded to the English throne. *Daemonologie* had in part been intended as a rejection of Reginald Scot's arguments, and one of James's first acts as King of England was to order all copies of Scot's work be destroyed. The next English witchcraft law, enacted a year later, stiffened the penalties and made more crimes punishable by death; possession of a 'familiar', an animal accomplice in witchcraft, became a felony for the first time, as did grave-robbing to find body parts for spells. James does nonetheless seem to have become gradually more cautious about witchcraft during his reign, and in England he generally refrained from involving himself actively in the trials, unlike his behaviour when he was still in Scotland.

But then Scottish witches were in one crucial respect different from their English sisters. English witches by and large worked at local level – municipal mischief, you might call it – causing cattle to abort, children to come out in rashes, cream to curdle and so on. Scottish witches on the other hand had a taste for high politics and were more likely to be involved in treason and regime change than mere local malfeasance. Trying to sink the King's ship is exactly what you would expect a Scottish witch to do. So it is not at all surprising that in *Macbeth*, a play focused on the high Scottish politics of power, Shakespeare puts witches centre-stage. And in doing so he created what has become the definitive image of the witch across the entire English-speaking world. No Hallowe'en night is now complete without some 'secret, black and midnight hags' stirring cauldrons and chanting spells.

Witches are for the most part foul-weather friends. Macbeth's trio will meet in thunder, lightning and rain, but it rarely

seems to occur to them to go out in the sun. When they do go out they raise storms, flatten crops, kill swine. They are 'posters of the sea and land', making all ports, Leith among them, dangerously 'tempest tost'. Only witches could raise winds so violent as to blow an anointed King off course – and almost to his death – just such a storm as led to the creation of this model ship. Such votive ships, offered to churches in thanksgiving, are rare in Britain, and this is one of the few to survive; but they were very common in Denmark, where around 1,300 examples are still known. That gives us a useful clue, because carved into the ship is a large gold letter C enclosing the number Four – the monogram of the sixteenth-century Danish king Christian IV. This model is in fact a Danish warship, bristling with cannon, and the reason it is now in Scotland is that, when the young James sailed home over the stormy North Sea in that spring of 1590, he was with his new bride, Christian IV's sister Anne, Princess of Denmark.

On 20 August 1589 James and Anne had been married by proxy at the castle of Elsinore, on whose ramparts Hamlet would later encounter his father's ghost. It was clearly a place where many disturbed spirits were at work. The whole business of the marriage eventually took nearly ten months, from this first ceremony to the pair's eventual arrival in Scotland. Terrible weather repeatedly buffeted Anne's ship and escort, driving them to Norway; instead of the expected five-day voyage to Scotland, it took her fifty days to get to Oslo, where it was decided her journey could not be resumed until spring. On hearing this, in perhaps the most reckless act of his life, James himself set sail from Leith on 20 October, despite postponements due to yet more storms. He reached Oslo on 19 November, and the couple were married in person on 23 November. There was now no question of risking a return voyage, and the couple travelled to Denmark for the winter, finally setting sail for Scotland on 21 April 1590. The storms that beset the Scottish royal

couple were immediately interpreted by the Danes as the result of witchcraft: six Danish witches were tried and executed.

Back in Scotland, the terrifying storms that nearly sank the royal ship off Leith were also assumed to have the same cause. Investigations – witchhunts – were set in train, and in November 1590 Agnes Sampson from North Berwick near Edinburgh made a shocking confession before the King at Holyrood. A coven of Scottish witches had indeed conspired against him in a contract made with Satan. Under torture, she spelled out just what she had done:

> at the time when his Maiestie was in Denmarke, she . . . tooke a Cat and christened it, and afterward bound to each parte of that Cat, the cheefest partes of a dead man, and seuerall ioints of his bodie, and that in the night following the saide Cat was counveied into the midst of the sea by all these witches sayling in their riddles or sieves . . . and so left the saide Cat right before the Towne of Leith in Scotland. This done, there did arise such a tempest in the Sea, as a greater hath not beene seene; which tempest was the cause of the perishing of a Boate . . . It is confessed, that the said christened Cat was the cause that the Kinges Maiesties Ship at his coming forrth of Denmarke, had a contrary winde to the rest of his Ships . . .

During her trial Agnes Sampson declared that James and Anne were saved from being drowned by their Christian faith, which alone had been able to thwart the witches. 'His Maiestie had neuer come safelye from the Sea,' she confessed, 'if his faith had not prevailed above their ententions.'

And this is the most probable explanation for our model ship: a Danish-style offering made for the Protestant church in Leith, put there to thank God for the safe deliverance from storm and spell of the Scottish king and his new Danish queen. To reinforce the point, the church in which the ship was displayed was not far from where the self-confessed witch Agnes

Sampson admitted that she had tossed the christened cat into the sea. An anti-witch ship ornamented with naked mermaids is not your usual Scottish kirk furnishing: but it is intended not to decorate, but to proclaim God's victory over magic. We can still see how potent its appearance must have been, suspended from the roof of that church in Leith. We can also see that it must have been hung high: the upper details and the rigging are out of proportion to the bottom, showing that it was designed to be viewed from below. Gaudily painted, gilded to catch the eye in the church's candle-lit interior, it must almost have seemed a magical object in its own right.

After a trial at which James VI was present, Agnes Sampson was convicted, garrotted and then burned on the esplanade in front of Edinburgh Castle on 28 January 1591; her execution cost £6 8s 10d Scots. Julian Goodare of Edinburgh University, who has made a special study of Scottish witchcraft, explains the circumstances of this celebrity execution:

> It takes several hours to reduce a body to ashes, and it is a very dramatic event. We know that crowds gathered at these executions. The North Berwick trials weren't the first Scottish witch trials or even the first panic, but they were the first to be a media event. They involved the King and that attracted attention. A pamphlet was written called *Newes from Scotland*, published in London in order to impress the English and in order to show the English that the King is serious about witches.

A quick glance at *Newes from Scotland* shows that sensational tabloid journalism is an old British tradition. Here was news of a doctor in league with the devil, burned at the stake. And the luridly worded cover promised its readers more: it would reveal how certain ladies of North Berwick 'pretended to bewitch and drowne his Majesty in the sea coming from Denmark, with such other wonderfull matters as the like hath not been heard at any time.'

Inside there are pictures too. On a page with a ship going down in the background, you can see four witches stirring a cauldron. For all its shrillness, James had good reason to arrange for this tabloid account of the witches' trial to be published in England, as Julian Goodare explains:

> One of the things that *Newes from Scotland* says is that the witches asked the devil why he is conspiring against James of Scotland. And the devil answers because the King is the greatest enemy that I have on earth, which is arguably quite a flattering statement. This is politically important to James in the 1590s because he wants to be seen as a credible successor to Queen Elizabeth and he wants to impress the English.

So when the English welcomed James as their king in 1603, one of the things they knew about him was that he was a man for whom even the devil had a healthy respect. And many watching *Macbeth* for the first time – it was probably written sometime after 1605 – would have known the contents of *Newes from Scotland* at first or second hand. When *Macbeth*'s audience heard of seafaring witches travelling to Aleppo in a sieve or consorting with cats and assembling dead body parts, I think we may be certain that at least some of them would have associated such behaviour with witches from Scotland.

FIRST WITCH: Here I have a pilot's thumb,
 Wracked as homeward he did come.

THIRD WITCH: Liver of blaspheming Jew,
 Gall of goat, and slips of yew
 Silvered in the moon's eclipse,
 Nose of Turk, and Tartar's lips,
 Finger of birth-strangled babe,
 Ditch-delivered by a drab,
 Make the gruel thick and slab.

ALL: Double, double, toil and trouble;
 Fire burn, and cauldron bubble.
SECOND WITCH: Cool it with a baboon's blood;
 Then the charm is firm and good.

James survived plotting by witches, but a further threat lay in store, which has, by a strange coincidence, also become part of our national folklore. In the next chapter, James confronts not Satanic drowning, but a plot with gunpowder.

Chapter Eleven

Treason and Plots

A manual for murder

From the beginning to the end of Shakespeare's career, the murder of the monarch is both the supreme crime and an abiding political conundrum. Richard II is killed on stage. By stabbing and drowning his own brother Clarence, and then smothering the young king and his brother in the tower, hunchbacked Richard of Gloucester becomes Richard III. And in *The Tempest*, Prospero, Duke of Milan, ends up on his island because his usurping brother has plotted to drown both him and his daughter Miranda (see Chapter Nine). Royal murder is at once catastrophe and commonplace. Shakespeare's great lyrical improviser on this theme is Richard II:

> KING RICHARD: For God's sake let us sit upon the ground
> And tell sad stories of the death of kings –
> How some have been deposed, some slain in war,
> Some haunted by the ghosts they have deposed,
> Some poisoned by their wives, some sleeping killed,

All murdered. For within the hollow crown
That rounds the mortal temples of a king
Keeps death his court; and there the antic sits,
Scoffing his state and grinning at his pomp,
Allowing him a breath, a little scene,
To monarchize, be feared, and kill with looks,
Infusing him with self and vain conceit,
As if this flesh which walls about our life
Were brass impregnable; and humoured thus,
Comes at the last, and with a little pin
Bores through his castle wall, and – farewell, king!

No one can come away from a Shakespeare play thinking life at the top is easy.

Rulers are always at risk. In our democratic age they may simply be ousted by votes. But through much of history and in much of the world, people who want to change rulers kill them. The death of a ruler is never just a personal tragedy: as it is a matter of national security, the whole state is affected. In Shakespeare's *Richard II*, the Bishop of Carlisle spells out very clearly what will happen to England if the usurper Bolingbroke succeeds (as he does) in driving God's chosen monarch, King Richard, off the throne:

BISHOP OF CARLISLE: let me prophesy
The blood of English shall manure the ground,
And future ages groan for this foul act.
Peace shall go sleep with Turks and infidels,
And in this seat of peace tumultuous wars
Shall kin with kin, and kind with kind, confound.
Disorder, horror, fear, and mutiny
Shall here inhabit, and this land be called
The field of Golgotha and dead men's skulls.
O, if you raise this house against this house
It will the woefullest division prove

That ever fell upon this cursèd earth.
Prevent it; resist it; let it not be so,
Lest child, child's children, cry against you woe.

In the world beyond the theatre, the subjects of Elizabeth I were also eloquently, and frequently, reminded of the dangers of political violence by regular reports of the crown in peril and the state in danger. Throughout Elizabeth's reign, conspiracy followed conspiracy, with the Ridolfi plot of 1570 (see Chapter Four), the Throckmorton plot of 1583, the Babington plot of 1586 and the Lopez plot of 1594. In an era before modern media, news of these conspiracies was murkier, harder to be sure of, and so all the more potent. It circulated through pamphlets and woodcuts, broadside ballads and sermons, pedlars' tales and, of course, rumour.

Shakespeare does not mention any of the plots that his audience must sometimes have discussed on their way to the theatre, but a contemporary of his, born a few years before him, wrote an entire book about them. He was another prophesying bishop, keen to remind his readers just how close England was to 'disorder, horror, fear and mutiny' and to becoming that field of 'dead men's skulls'. His book captures the mindset of the governing class during the decades in which Shakespeare was writing – suspicious to the point of paranoia, and always ready to retaliate with savagery.

The book was compiled by George Carleton, Bishop of Chichester, and was first published in 1624, a few years after Shakespeare's death. The title page shows an ample female figure holding a large cloth on which is written 'A Thankfull Remembrance of God's Mercie by G. C. . . .' It goes on: 'An Historicall Collection of the great and merciful Deliverances of the Church and State of ENGLAND, since the Gospel beganne here to flourish, from the beginning of Queene Elizabeth.' The title says it all, and Carleton's best-selling book

does indeed deliver exactly what it promises on the cover. In eighteen chapters he frightens and thrills his readers with fifty years of conspiracies, intrigues and assassination attempts.

The book is a tabloid history of England during Shakespeare's lifetime, told entirely through plots to murder the monarch. Take, for example, the Lopez conspiracy of 1594, which he presents as 'a most dangerous and desperate treason. The point of conspiracy was Her Mat[ies] death. . . . The manner was poison.'

Throughout his book, the adversaries that Carleton describes are, as well as being mainly Catholic, also mainly foreign. They are the agents of the Kings of France and Spain and they are, more particularly, agents of the Pope: 'But he was _drunke_ with the cup of _Rome_; for who would run such courses but drunken men? It may teach others to beware of those, that bring such poisoned and intoxicating cups from Rome.' On and on, in high fulmination, Carleton goes, telling one rattling good yarn after another about evil Catholics and their dastardly acts. Time after time wicked people, aided by even more wicked and Catholic foreigners, set out to assassinate the monarch. Time after time they are foiled by loyal Englishmen and the grace of God. This is not about the divine right of kings, but the divine protection given to the Protestant rulers of England: Carleton seeks to show that without question God has been on 'our' – English, Protestant – side. Ultimately, the message of the book is triumphant, because all these plots against the King and Queen of England failed. Carleton's stories are like a horror movie, danger watched (and tremulously enjoyed) from a place of safety. Strangers are concealed and in disguise. Foreigners lurk in the alleyway. As the tension mounts, the danger could not be greater.

Although none of these real plots features in Shakespeare, both the fact and the fear of conspiracy inhabit his work. Before he can set off for battle, Henry V has to deal with a

group of noblemen found to be secretly in league with the King of France. Brutus and Cassius conspiring against Julius Caesar are, for Shakespeare's audience, secret plotters of the sort they have been warned about, and, even more shocking, they are successful assassins. *Julius Caesar* is in many ways the archetypal assassination play, and in it Mark Antony describes the pain felt by the whole body politic when the ruler is murdered:

> ANTONY: O, what a fall was there, my countrymen!
> Then I, and you, and all of us fell down,
> Whilst bloody treason flourished over us.
> O, now you weep, and I perceive you feel
> The dint of pity. These are gracious drops.
> Kind souls, what weep you when you but behold
> Our Caesar's vesture wounded? Look you here,
> Here is himself, marred, as you see, with traitors.

Shakespeare's audiences could have told their own sad stories of the death of kings. Across Europe rulers fell before the dagger, the bullet, the cup of poison. Erik XIV of Sweden, enthusiastic suitor of Elizabeth, was poisoned in 1577. The Protestant Prince of Orange was shot in the chest in 1584. France lost so many kings to the knife that it began to look like carelessness: Henri III stabbed in 1589, Henri IV stabbed in 1610. And everyone would know of the killing in England itself of two queens in particular: Anne Boleyn, Elizabeth's mother, sent to the scaffold by Henry VIII, Elizabeth's father, in 1536; and James's mother, Mary Queen of Scots, executed on the orders of her cousin Elizabeth in 1587. In each case, the killing followed sustained reports of a treasonable conspiracy.

How would news of the conspiracies Carleton describes have circulated? Moira Goff, Curator of Printed Historical Sources at the British Library, describes how he did his research:

He would have acquired his material from a variety of sources. Quite a lot of it would have been word of mouth, and some of it privileged word of mouth. His information would also have come from printed pamphlets or from manuscript newsletters, which would later be replaced by the printed newspapers then in their infancy. Shakespeare's audiences were drawing on the same range of sources. The groundlings would have been much more reliant on the oral – *have you heard the latest news?* People further up the social hierarchy would have also been getting manuscript newsletters on a regular basis. For men of business, news was a staple of their work.

Anyone hearing rumours or reading pamphlets in the 1590s – newsletters of the sort Carleton later gathered together – would have recognized in Richard II's catalogue of killed kings not the remote history of 200 years earlier, but something uncomfortably close to current affairs.

To the modern eye, Carleton's lurid terrors can easily seem absurd. Yet if we look behind the bluster, his anthology makes disturbing reading, because Elizabeth and James were in fact frequent, one might almost say constant, targets of assassination. And had they been killed, the consequences for every person in the land would have been grave. Reading Carleton's *Remembrance*, we can see there was a great deal to be frightened about.

The book was enlivened by illustrations, twenty-one shockingly bad and crude woodcuts. We can watch William Parry, frozen with fear, finding himself unable to go through with his assassination attempt on a terrifying-looking Queen Elizabeth. Here are the Babington plotters, conspiring with Mary Queen of Scots against Elizabeth, blithely unaware of a grim execution taking place behind them – the fate that will soon be theirs. The pictures systematically underline the message of the text: Catholic traitors are everywhere, and they are plotting to destroy us.

The most sensational plot of the 1590s was the Lopez conspiracy, to which Carleton gives particular prominence. The mixture of political intrigue, paranoia about Spain, court gossip and xenophobia which lie behind the downfall of Roderigo Lopez reveals how powerful a force conspiracy anxiety had become in Elizabethan England. Lopez was a second-generation Portuguese immigrant, the son of a forcibly converted Jew. He was a wealthy and successful physician, serving the Queen as well as the Earl of Essex, one of Elizabeth's favourites (see Chapter Seven). From about 1590 Lopez was in informal discussion with the Spanish ambassador to France, with a view to opening peace negotiations between England and Spain, but he seems to have gone well beyond his authority, enraging Essex by gossiping about his health and his political future. This was a serious mistake: when Essex came across evidence of Lopez's unauthorized conversations, he claimed that his sources implicated Lopez in 'a most dangerous and desperate treason' to poison the Queen. The motive alleged was greed – a promised bribe of 50,000 crowns. Essex's investigation was unremitting and ended with Lopez's conviction and public execution. He was hanged, drawn and quartered at Tyburn on 7 June 1594.

Lopez was in fact probably innocent: it appears that even the Queen had serious doubts about his guilt. But the case was hopelessly muddied by confusion, paranoia and double agents; and the momentum of events, and Essex's determination to pursue a cause that so effectively heightened his own prestige, made Lopez's fate inescapable.

Carleton, in his account of the plot, describes the alien – the Jewish – nature of the traitor's behaviour: 'Lopez, like a Iew, did utterly with great oaths and execrations denie all the points, articles, and particularities of the accusation.' But fascinatingly, Carleton feels the need to insist that behind Lopez's Jewishness lies the even more alien, more threatening, power

of the Catholic church: 'This practise of poisoning ... was brought into the Church by Popes, and reckoned among the sinnes of the Anti-christian Synagogue, and taught for Doctrine by the Romish Rabbies.' Jews in league with the Pope: the ultimate Axis of Evil.

Susan Doran assesses Carleton's constant focus on the Catholics as the main threat to the English state:

> He was responding to a particular political circumstance of his time. The Catholics were considered to be the agents of the Antichrist. It had started with the way that the burnings of Mary's reign were being presented in England: Catholics were disloyal, they were erroneous, they were idolatrous, and if they were ever to get to power again, the Protestants would be in danger of their lives because they burned people. And the Saint Bartholomew massacre in 1572 in France again confirmed that impression. So there was an anxiety – almost like Islamophobia today, or at least as it was at the time of the Twin Towers – that there was an international conspiracy to overturn Protestantism, the true church, as well as the true monarch.

*

Carleton's climax is the Gunpowder Plot – that famous attempt in 1605 by a handful of Catholic conspirators to blow up parliament and kill the King. He calls it a 'blow to root out Religion, to destroy the state [and] the Father of our Country'. So outraged is Carleton, so potent is the event in his and his readers' memories, that for once he does not limit himself to the usual suspects – generally the Spanish, intermittently the French, always the Pope. So hellish is the attempt to blow up parliament that this Gunpowder Plot can have come only from 'the deepnesse of Satan' himself.

Carleton aims to plant a fear of terrorism so all-pervasive

that if the news he reports is true, England is like Hamlet's Denmark, a kingdom on the cusp of dissolution – where foreign armies are about to invade, everyone is spying on everyone else, and a purloined letter can either save a man's life, or send Babington and Lopez, or Rosencrantz and Guildenstern, to their deaths.

To most of us today, episodes like the defeat of the Armada, the Lopez incident and the thwarting of the Gunpowder Plot appear separate, distinct events. But Carleton knew they were all connected, all part of a sinister plot masterminded overseas and set in motion at home by covert enemy agents. For Shakespeare's audience, these were the news stories they had heard endlessly repeated and discussed, the formative public events of their lifetime. In every Bolingbroke and every Brutus you saw not just a character from history whose motive you might ponder, but a rebel and a murderer of the sort that might any day turn your own world upside down. And in the great anonymous melting pot of the theatre, one of those secret agents, one of those covert assassins, might be standing right beside you – or even selling you an oyster.

Chapter Twelve

Sex and the City

A goblet from Venice

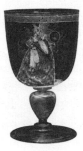

Every age has its own fantasy of the great city, where glamour and pleasure not only abound, but are easily available. For the twentieth-century world, New York was that city of the world's imagining: rich and welcoming, hedonistic, sophisticated and spectacular. In Shakespeare's day it was Venice, the shopping capital of Europe, home of true luxury and style, one of the globe's busiest crossroads, a place where travellers and traders, merchants and moneylenders watched greedily as Venetian gold ducats – the dollars of the day – changed hands in huge quantities. All this wealth ultimately rested on one thing: shipping.

> SHYLOCK: Ho no, no, no, no! My meaning in saying he is a
> good man is to have you understand me that he is sufficient.
> Yet his means are in supposition. He hath an argosy
> bound to Tripolis, another to the Indies; I understand,
> moreover, upon the Rialto, he hath a third at Mexico, a
> fourth for England, and other ventures he hath squandered

abroad. But ships are but boards, sailors but men; there
be land rats and water rats, water thieves and land thieves,
I mean pirates; and then there is the peril of the waters,
winds, and rocks. The man is, notwithstanding, sufficient.
Three thousand ducats; I think I may take his bond.

Cosmopolitan and multicultural, Venice was the model of the
great maritime trading city – a model that London was not
merely aspiring to, but just beginning to realize that it could
conceivably rival. The Englishman Thomas Coryate brilliantly
evokes the allure of the place in his travel guide:

> Truely such is the stupendious (to use a strange Epitheton for
> so strange and rare a place as this) glory of it, that at my first
> entrance thereof it did even amaze or rather ravish my senses.
> For here is the greatest magnificence of architecture to be
> seene, that any place under the sunne doth yeelde. Here you
> may both see all manner of fashions of attire, and heare all the
> languages of Christendome besides those that are spoken by
> the barbarous Ethnickes.

Coryate's description of the city is designed to excite the English
reader. Venice is, in his unforgettable new word, 'stupendious':
Venice is wealthy, fashionable, pleasurable, a potent and dan-
gerous mix of many different peoples. With its 'barbarous
Ethnickes' from all over Europe, Africa and the Middle East,
Venice is Babylon, where you encounter not just the babble of
tongues, but stylish strangers, looser laws and the chance of
boundless pleasure.

An object which speaks to all this fantasy is this large
400-year-old Venetian glass goblet. The upper part fits into
the hand like a pint glass of beer, but the shape as a whole is
different. The wide bowl will hold a great deal of wine, and it
perches on a heart-shaped stem with a round base. Just below
the rim is a showy band of gold that would touch the drinker's

lips at every sip. Beneath this gold band stands a blonde-haired woman in a billowy blue dress patterned with giant snow-flakes, who looks ready to have – and to give – a very good time. This is a glass that to anybody in Shakespeare's audience would speak of Venice and the sophisticated pleasures that it, and only it, could offer. Dora Thornton, curator of Renaissance collections at the British Museum, has made a particular study of the luxury goods of Italy:

> In the mid-fifteenth century Venetian glass workers perfected a wonderful new medium, Cristallo glass. It was given this name because it has the clarity of rock crystal. But, unlike rock crystal, it can be moulded and blown into fantastic forms and shapes and it can be decorated with beautiful, brightly coloured enamels and gilding. The making of Cristallo was a very closely guarded trade secret. It needed plant ash imported from Syria and a special kind of river pebble that comes from northern Italy. The striking cobalt blue is likely to come from the Erzgebirge region on the German–Czech border. The white, which is made from tin oxide, is made using tin that has probably come from Cornwall or Brittany. And the gold, heavily used all over the rim and for touching up details and for the arms, is probably from Africa.

Glassware as stylish and clear as this, dependent on so many networks of transport and trade, was sought after all over Europe. Only the rich could afford Venetian glass, with its lavish decorations of gold and brilliant colour. These were objects literally fit for a king. When Shakespeare's Richard II renounces the crown and the privileges and possessions that go with it, he mournfully puts aside goblets that sound very much like ours:

KING RICHARD: I'll give my jewels for a set of beads,
My gorgeous palace for a hermitage,
My gay apparel for an almsman's gown,
My figured goblets for a dish of wood . . .

When Antonio's argosy of richly laden ships sailed for London, it would certainly have carried Venetian glassware, along with many other extravagances to fuel the fantasies of Shakespeare's audience. Across the whole of Europe, there was such demand for Venetian glass that the glassmakers themselves were enticed to work abroad – glasses like the one discussed here may in fact have been made outside Venice, in Germany, France or England by *émigré* Venetian glassmakers, who came bringing their trade secrets with them. What was called Venetian glass and sold at Venetian prices was in fact a global brand, like a must-have designer handbag today, conceived in Italy or France, but possibly manufactured in the Far East.

The power behind the brand dwelt at the epicentre of banking, brokering and insurance in sixteenth-century Venice: the Rialto, the city's business district. This was where shopping and shipping came together; the point at which news from all over the world about ships, shipwrecks and losses was announced. This is where Shylock would have heard the news that Antonio's English argosy had been wrecked on the Goodwin Sands:

> SALERIO: Why, yet it lives there unchecked that Antonio
> hath a ship of rich lading wracked on the narrow seas, the
> Goodwins I think they call the place, a very dangerous
> flat, and fatal, where the carcasses of many a tall ship lie
> buried as they say, if my gossip Report be an honest
> woman of her word.

Luca Molá of the European University Institute in Florence is an expert on the economy and law of sixteenth-century Venice:

> By the late sixteenth century the Rialto was frequented by merchants from all over the world. There were Turks, Persians, Jews, Armenians, Germans, Flemish and English merchants,

and ships coming from as far as Mexico and India would bring news of international markets. This complex system was well organized by the government, in some cases using the ideas they had learned from the Islamic world, confining the merchants in places where they could trade with brokers and translators, but also giving them privileges and religious and political freedom. So even in Padua, which is the city where the Venetians had their university, they accepted Lutheran students without problems. There was an Ottoman community at the Rialto in the late sixteenth century. And while officially these people were not supposed to be practising Muslims, they were given a warehouse in 1621, where they were allowed to have a mosque inside. And there were many synagogues in the ghetto; there were something like four synagogues open to the public between the sixteenth and seventeenth centuries.

Shakespeare's London was a more cosmopolitan city than it had ever been before, but it was still nothing compared to Venice. One of the many differences between the two was that in London there were no synagogues, no visible Jewish community. The Jews had been expelled from England about 300 years earlier, so virtually no Englishman would ever have seen a practising Jew when they came to watch *The Merchant of Venice*. Venice, by contrast, had a whole quarter reserved for its Jewish inhabitants. In principle, Jews were supposed to be confined to the Ghetto, and theoretically they were locked in there every night, but the reality was much freer, and Venice's reputation for tolerant government (especially to people of different religions) was well deserved. Shakespeare drew upon this reputation. Shylock, for example, complains that he has been the butt of Antonio's anti-Jewish abuse, but when both of them come into court, Shylock and Antonio stand before the law on exactly the same footing, as Antonio himself makes clear:

ANTONIO: The Duke cannot deny the course of law,
 For the commodity that strangers have
 With us in Venice, if it be denied,
 Will much impeach the justice of the state,
 Since that the trade and profit of the city
 Consisteth of all nations.

This was a city that treated its immigrants well and fairly; it understood that prosperity depended on having lots of foreigners living happily together. And to ensure this, it guaranteed them all equal treatment under the law – the essential pre-condition of successful easy commerce in Venice, as it would later be in London. As a city-state Venice's model of government was much commented on and highly regarded.

The great poet Edmund Spenser praised Venice as successor to Babylon and Rome, superior in laws and justice:

Fayre Venice, flower of the last worlds delight;
And next to them in beauty draweth neare,
But farre exceedes in policie of right.

*

If you look at the back of our glass, there is a riotously florid coat of arms in red, blue and gold, topped by a saucy, very Venetian lion poking out its long red tongue. It is not, however, a Venetian coat of arms. It is almost certainly German, and this glass was probably one of a set made in Venice specifically for the very large German export market. Looking at the coat of arms on a glass like this, we should not be surprised that one of the few references to a drinking glass actually being used in Shakespeare involves a German – or that it comes in *The Merchant of Venice*. When the suitors are competing to marry the wealthy heiress Portia, the unwelcome German candidate is, inevitably, caricatured as a heavy drinker. So Portia, declaring she would as soon be married to

a sponge, plans to decoy him to the wrong casket with 'a deep glass of Rhenish wine'. We can be pretty certain that she served it in a glass like ours.

Interestingly, Shakespeare makes Venice even more tolerant than it actually was, a place where Christians and Jews could mingle in a way unimaginable in any other part of Europe. Venice for Shakespeare and his public is not just a rich Italian city, it is a laboratory of new social possibilities that were only being hinted at in contemporary London. Venice becomes the place of the audience's imagining – rich and cosmopolitan, free and enticing; a happy vision of London's freewheeling commercial future, perhaps, but also a place where the rules that govern society are alarmingly fluid. In *Othello*, Shakespeare's other great play about Venice, the city offers the ideal setting in which the boundaries of belonging can be tested and uncomfortable ideas of race and religion explored at a safe distance. Here, in Venice, a Jewish girl might well elope with a Christian, and a successful black general could marry the daughter of a white Venetian nobleman.

Venice's reputation for relaxing the rules went much further than mixed marriages. For Shakespeare's audience, it is the place where anything goes, and commerce and cosmopolitanism were only a part of what made it such a dizzying site of fantasy. Beauty and seduction were potently associated with the city – both its buildings and its inhabitants – especially, perhaps, in the collective mind of the more puritanical, post-Reformation parts of Europe. If the coat of arms and the gold band along the top tell a story of a Venice aristocratic and commercial, the lady on our goblet plays to the darker side of the city's allure. Her thick yellow hair is teased up provocatively into two towering horns, and her racy outfit highlights a considerable cleavage. She also carries a circular black fan and – strikingly – a white handkerchief. Looking at her, it is hard not to think of another rich Venetian lady, Desdemona,

with the fateful handkerchief that will be brandished as evidence of her sexual infidelity.

Intriguingly, it is not at all obvious from looking at this glass whether the woman painted on it is a patrician or a prostitute, *grande dame* or *grande horizontale*. Lots of seventeenth-century tourists found a similar ambiguity about Venetian women – even women as irreproachably pure as Desdemona – that suggested all kinds of possibilities and pleasurable deceits. Venetian courtesans were brilliant at what Iago calls 'a seeming', which meant emulating respectable women in their dress and manner to attract and deceive potential customers. These are the very uncertainties which unsettle and finally undo Othello.

For a theatre-goer in a London playhouse audience watching *Othello*, this idea of beautiful women and questionable virtue was something indissolubly associated with the city. Sixteenth-century Venice was famous across Europe for its prostitutes, something to which Thomas Coryate, again, refers: 'So infinite are the allurements of the most famous Calypsos, that the fame of them hath drawn many to Venice from some of the remotest parts of Christendom, to contemplate their beauties, and enjoy their pleasing dalliances.' The risky entrepreneurship that flourished in Venice's red light district was merely another dimension of Venetian freedom. This was the city of swiftly shifting values and easily manipulated stereotypes, where young Desdemona, entirely chaste, could wind up being accused by Othello, her own husband, of being 'that cunning whore of Venice'.

Beneath the admiration for the watery city, there was the suspicion of corruption, dangerous sensuality and, like the rest of Italy, poison. In 1616 the translator and writer Robert Johnson described the corruption he saw behind the beauty of Venice: 'It surpasseth for Cities, buildings and outward magnificence; yet when you come to examine particulers, you shall

finde it like a rotten post gilded on the outside.' Already in Shakespearean England we can detect the later stereotype of a sinister, decadent Venice, what in Otway's 1682 play *Venice Preserved* was called the 'Adriatique whore'.

Othello and *The Merchant of Venice* could not have worked, could not have been imagined, if they had been set in London. Venice then, as now, was the city of dreams, a place where the limits of the possible were endlessly extendable, the metropolis of intoxicating potentiality.

Chapter Thirteen
From London to Marrakesh
African treasure

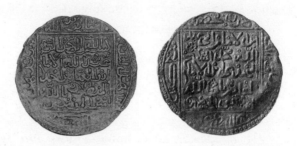

Elizabeth I was a monarch of many names – Good Queen Bess, Gloriana, the Virgin Queen and occasionally something much more exotic: 'The Sultana Isabel, who has high position and majestic glory, constancy and steadiness, a rank which all her co-religionists, far and near, recognise, whose stature among the Christian people continues to be mighty and lofty'. The Sultana Isabel is, of course, Queen Elizabeth I as seen from far away – from Africa in 1600. This flattering description of her majestic glory, constancy and steadiness was given by one of her new allies on the world stage, Sharif Ahmad al-Mansur, the wealthy King of Morocco – far richer than Elizabeth herself – and a force to be reckoned with in both the Mediterranean and the Atlantic.

Sharif al-Mansur's comment on their Queen is a reminder that English play-goers in Shakespeare's time were just beginning to be global citizens. They were proud of Francis Drake's circumnavigation of the earth, credulous, willing listeners to tall stories of the sort of lands filled with 'cannibals that each

other eat / the Anthropophagi and men whose heads / do grow beneath their shoulders', and eager readers of a new genre of thriller – traveller's tales like Sir Walter Raleigh's book of 1596, *The Discovery of Guiana*, possibly Shakespeare's source for Othello's stories.

This curiosity about an expanding, unsettling world was played out in the theatre. In *The Merchant of Venice*, a richly dressed, exotic figure sweeps on to the stage to woo the Italian heiress, Portia.

> MOROCCO: Mislike me not for my complexion,
>> The shadowed livery of the burnished sun,
>> To whom I am a neighbour and near bred.

This eloquent sun-burnished man is the Prince of Morocco. He is the first of Shakespeare's noble Moors and, what is more, the first non-villainous Moor to appear on the English stage. Even more surprising than his skin colour is that this man, whom Portia calls a 'gentle' Moor, is totally at ease with English currency:

> MOROCCO: They have in England
>> A coin that bears the figure of an angel
>> Stampèd in gold – but that's insculped upon;
>> But here an angel in a golden bed
>> Lies all within. Deliver me the key.
>> Here do I choose, and thrive I as I may!

Shakespeare reassuringly suggests that, even if the English know little of Morocco, this sympathetic prince already knows something about England – and quite a lot about its money.

This prince was a character entirely of Shakespeare's invention – he does not appear in any of the earlier material that *The Merchant of Venice* drew on – and was probably inspired by England's intensifying trading relations with

Morocco in the 1590s. The divide between Christianity and Islam would have made his marriage to Portia unthinkable in the real world of sixteenth-century Europe, but on Shakespeare's stage, Moorish royalty is associated not so much with an alien or hostile faith as with luxury and exotic riches: sugar, the finest horses and dizzying quantities of gold.

Nobody watching *The Merchant of Venice* would be the least bit surprised that the Prince of Morocco, asked to choose one of three caskets to win Portia's hand in marriage, would go for the gold. West Africa was, as everybody knew, quite simply where gold came from: it was the source of pretty well every gold coin minted in England. Sharif al-Mansur controlled access to these huge gold supplies. From Timbuktu alone he took 600 kilograms of gold a year: predictably, he was dubbed *al-dhahabi*, the Golden One, and it was reported that 'fourteen thousand hammers continuously struck coins at his palace gate'. While this is clearly a poetic exaggeration, one can nonetheless almost hear in that phrase the sound of al-Mansur's money being minted.

This particular coin of al-Mansur's, now in the British Museum, is almost exactly the same size as a modern twopence piece, although it is thinner and is, of course, made of solid gold. Both sides are covered with beautifully calligraphed Arabic script: 'In the name of God, the Merciful, the Compassionate,' the central panel begins, then describes al-Mansur as 'Commander of the Faithful'. The coin tells us both the place and the Islamic year of issue: 'Struck in the city of Marrakesh, may God protect it, in the year one thousand and eight.' That is the year we call 1600, by which time *The Merchant of Venice* had been playing for about five years.

Morocco was rich in saltpetre, the main raw material of gunpowder, as well as in sugar and gold, and in 1585 London merchants had established the Barbary Company to trade in north Africa. By the 1620s the English immigrant community

in Morocco and neighbouring lands was substantial. English merchants and artisans took advantage of the region's wealth and global trade links to make a good living, and there was a growing flow of people and goods going both ways between north Africa and England. But it was an unequal relationship: England paid more attention to rich Morocco than Morocco to England. Sharif al-Mansur began to take English power seriously only after the defeat of the Spanish Armada in 1588. Morocco also was in a state of more or less permanent war with Spain, and England had suddenly emerged as a useful ally: to celebrate the Queen's victory over their common enemy, the Sharif encouraged the English residents of Morocco to light festive bonfires.

To foster the new alliance between the two countries, al-Mansur also sent emissaries to England. Londoners were particularly struck by the splendid processions of the Moroccan ambassador, Abd al-Wahid bin Masoud bin Muhammad al-Annuri, and his retinue in 1600. For many it would have been their first glimpse not just of Africa, but of Islam. Kate Lowe, Renaissance historian at Queen Mary, University of London, explains:

> That 1600 embassy was the first time that lots of Londoners would have seen Muslims in a group behaving as Muslims. It must have created an enormous impetus to understand more. There would have been a difference too between popular opinion and the official foreign policy line held at Court, because these people were allies against Spain. So at Court there was an acceptance of them, probably in a way that the people in the street did not see.

The street was potentially a great deal less friendly to foreigners, and treatment of Moors in England could be hostile – for there were some Moors on the London street. In 1595, English and Moroccan forces together had rescued north African

galley-slaves from Spanish ships. Some were sent home to Morocco, but others were allowed to come to England. Despite the Queen's interest in protecting her Moorish allies, Londoners protested, and the Moors eventually had to be expelled.

Shakespeare never actually uses the words Moroccan or Muslim. The standard Elizabethan word for a north African is 'Moor'. Kate Lowe explains:

> The word Moor sounds impressive, but it actually signifies very little. Originally it was the classical word to describe somebody that lived in Mauritania, the Roman province across the top of north Africa. After that it gained other meanings, one of which was black. It also later gained the meaning of a Muslim, but when it is used in Elizabethan England it is imprecise. That is in itself one of the reasons why that term 'the Moor' is used so much: it has resonance but not much substance, and you can hang so much off it.

One of the things you could easily hang off it was the popular xenophobic hostility that forced Elizabeth to expel the Moroccan galley-slaves, and Shakespeare does not shy away from this kind of racial antagonism. In *Othello*, not for the first time, he explores a contemporary London phenomenon by setting it in Venice. The villain Iago and the angry father of Desdemona – Othello's white Venetian bride – indeed anyone hostile to Othello, use racial insults against the Moor: 'thick-lips', 'barbarian' and 'sooty'. These still shock today, as they were surely meant to then. Iago does not mince his words. Here he is telling Desdemona's father that his daughter has eloped with Othello:

> IAGO: Even now, now, very now, an old black ram
> Is tupping your white ewe. Arise, arise,
> Awake the snorting citizens with the bell,
> Or else the devil will make a grandsire of you.

For Iago, Othello is not just black and oversexed, but diabolical, and, as the play goes on, Shakespeare accentuates Othello's blackness. Yet for all the times he is associated with darkness, Othello is also praised: this general is 'brave', 'noble', 'valiant'. The blacker his antagonists paint him, the more Shakespeare forces his audience to acknowledge Othello's honour and integrity.

Desdemona falls for Othello as he is telling exotic stories of his African youth. One episode is particularly designed to win the young girl's sympathy:

> OTHELLO: Wherein I spake of most disastrous chances,
> Of moving accidents by flood and field,
> Of hair-breadth scapes i'th'imminent deadly breach,
> Of being taken by the insolent foe,
> And sold to slavery . . .

Othello, the great and valiant leader, was once himself a slave, sold after being taken prisoner. His story reminds us of something commonplace to the Elizabethans: the Mediterranean was a dangerous place of warfare, piracy, slavery and shipwreck, as the ships of the different seafaring powers – Venetian and Turkish, Genoese and Moroccan – fought for supremacy. And we know that one of these ships, passing from Morocco to northern Europe, carried this gold coin of Sharif al-Mansur – because it was found not in Morocco, but twelve miles off the coast of Devon, one of a hoard of 450 Moroccan gold coins found in Salcombe Bay in 1994. The South-West Archaeological Group, a team of amateur marine archaeologists and semi-professional divers, uncovered this astonishing treasure in a treacherous area of seabed, beset with strong currents and deep gullies. They found large quantities of sixteenth-century coins, gold ingots, earrings and pendants – all from Morocco – along with other artefacts and debris: lead weights, pewter tableware, ceramic fragments and decomposing iron. Apart

from the coins, it is hard to tell what the many different pieces of gold are. Among the mass of 400-year-old Moroccan jewellery, there are no complete pieces. These are emphatically not jeweller's goods for sale; rather they are chopped-up bullion, bits of gold intended to be melted down and reused. But the gold coins give us important information. Their inscriptions tell us that they were struck by several members of the Sa'did dynasty – of which al-Mansur was the most significant figure – that ruled Morocco from the mid-sixteenth to the mid-seventeenth centuries. The latest coin that we can date was issued by Sharif Al-Walid, who ruled until 1636, so the shipwreck probably occurred shortly after that.

This is inscrutable wreckage. There is not much about it that we know for certain: there are none of the usual signs of a boat that has gone down; no rudder, timber, deadeyes have been found, and there are no records of any ship lost in the area. Was this a trading ship on the way home from north Africa? Or was it perhaps a pirate ship? We know there were many such ships around – both English and Moroccan. Barbary pirates, in particular, took captives from ships on the high seas and from fishing vessels close to the English coast. Now and then they raided the mainland, sometimes literally dragging people from their beds and either enslaving them or holding them to ransom. In 1584, Richard Hakluyt reported that ships from Guernsey, Plymouth, Southampton and London were taken and their crews enslaved. The practice continued for decades. In 1631, 107 men, women and children were taken in Ireland; 20 per cent vanished – died or converted – before they could be ransomed.

When we think of pirates in stories, we tend to think of Long John Silver rather than anything more sinister. But for Shakespeare's audience pirates were much closer to the murderous hijackers of our day, and piracy off the coast of England was a frightening, much-publicized possibility. The terrifying

activities of these corsairs spawned a new literary genre in sixteenth- and seventeenth-century England, known now as the captivity narrative: hair-raising and sword-rattling tales of English victims seized by north African pirates. The mournfully and lengthily titled ballad of 1623, *The Lamentable Cries of at least 500 Christians: Most of them Being Englishmen (Now Prisoners in Algiers Under the Turks) Begging God's Hand That He Would Open the Eyes of All Christian Kings and Princes to Commiserate the Wretched Estate of So Many Christian Captives,* gives a compelling taste of the dangers at sea:

> Being boarded so, and robbed then are they tied
> On chains and dragged t'Argiers [i.e. Algiers] to feed the pride
> Of a Mahumetan dog (eight in a row).
> Each eighth man to the Argier king must go
> And th'eighth part of what's ta'en is still his prize;
> What men he leaves are anyone's who buys
> And bids for them, for they then are led
> To market and like beast sold by the head,
> Their masters having liberty by law
> To strike, kick, starve them, yet make them draw
> In yokes, like oxen, and if dead they beat them

These captivity narratives told of attack, incarceration, derring-do and breathtaking escape. The stories of forced conversions and bestial savagery fed the xenophobia and religious hostility that coexisted, in the English popular mind, with hunger for the valuable and exotic goods of north Africa.

Pirates never took centre-stage for Shakespeare – he was, after all, a man from landlocked Warwickshire who seems never to have travelled abroad – but they are part of the elemental backdrop to sea travel in his plays. Pirates attack Hamlet en route to England, forcing him to return to Denmark, or they dash in and seize Marina in *Pericles*, leaving no doubt about their reputation for casual violence:

[*Enter Pirates*]

FIRST PIRATE: [*to Leonine*] Hold, villain! [*Leonine flees*]

SECOND PIRATE: [*seizing Marina*] A prize, a prize.

THIRD PIRATE: Half-part, mates, half-part. Come, let's have her
aboard suddenly.

[*Exeunt*]

[*Enter Leonine*]

LEONINE: These roguing thieves serve the great pirate Valdes,
And they have seized Marina. Let her go.
There's no hope she will return; I'll swear she's dead
And thrown into the sea. But I'll see further:
Perhaps they will but please themselves upon her,
Not carry her aboard. If she remain,
Whom they have ravished must by me be slain.

Pericles is one of Shakespeare's later plays – one that he co-
wrote in about 1607 or 1608. This scene is, perhaps, an
acknowledgement of the dramatic upsurge of piracy that was
sparked by the chaos and civil war in north Africa caused by
the death of al-Mansur from plague in 1603. The seas were
never more awash with Barbary pirates than during the first
half of the seventeenth century.

Despite the heightened activity of corsairs in these decades,
Kate Lowe thinks that the African treasure found in Salcombe
Bay is unlikely to have been pirate gold:

I think it is far more likely to be trade. Morocco and England
were only in contact because they were both united as being
enemies of Spain. The English are sending timber so the
Moroccans can build ships to fight against Spain, they are
sending cannonballs, and sending guns. And the Moroccans
are sending saltpetre to make gunpowder. They were probably
trading in arms, and I suspect that the Moroccans had not got
enough that the English wanted so they probably had to pay
in bullion, and that is why some of it is broken up; it is just bits

of jewellery and so on to get the required amount to buy the arms.

Whatever its precise history, the African treasure is evidence that England, like every other part of Europe, was now in economic, political and military terms unquestionably part of a global system. And Venice, as we saw in the last chapter, was one of its nerve centres. It is striking that in *Othello* the characters speak over thirty times of the 'world'.

The Salcombe Bay treasure was a part of this new world system of sometimes violent exchange, and its gold coins show that *Othello* is much closer to the practical realities of Elizabethan life than we might think. Like Shylock or Cleopatra, Othello is not the distant outsider, but an example of the many encounters between the English and Africans, Arabs and others. A surprisingly large number of people around 1600 would have thought of Good Queen Bess as the mighty and lofty Sultana Isabel.

Chapter Fourteen
Disguise and Deception
Pedlar's trunk

When *As You Like It* was first performed, a boy actor got dressed up as a girl to play Rosalind, the romantic lead. In the course of the play, Rosalind then pretends to be a boy, who then goes on to impersonate a girl. By the time the epilogue comes up, we no longer know who this character speaking to us actually is – and he/she knows it too:

> ROSALIND: If I were a woman, I would kiss as many of you
> as had beards that pleased me, complexions that liked me,
> and breaths that I defied not; and, I am sure, as many as
> have good beards, or good faces, or sweet breaths, will,
> for my kind offer, when I make curtsy, bid me farewell.

And with that she – or should that be he? – ends the play. You can see why Puritan critics of the theatre found the whole enterprise dangerous and unwholesome.

At the heart of it all is disguise: both as a theatrical convention – dictated by the fact that women were not allowed to perform on stage – and as an important element of the plots

themselves. Clothes need to be changed to keep the dramatic action going. Edgar, banished by the bad sisters in *King Lear*, finds that disguise as a beggar is the only way to save his life. Portia becomes a male lawyer to rescue Antonio in court. To escape danger when she and her friend Celia flee to the woods, Rosalind dresses up not just as a man, but as a bloke's bloke.

ROSALIND: Were it not better,
 Because that I am more than common tall,
 That I did suit me all points like a man?
 A gallant curtle-axe upon my thigh,
 A boar-spear in my hand, and in my heart
 Lie there what hidden woman's fear there will,
 We'll have a swashing and a martial outside,
 As many other mannish cowards have
 That do outface it with their semblances.

Changing identities like this took no more than just changing costumes. For a boy to become 'some squeaking Cleopatra' required only his skill as an actor and the accoutrements of femininity: dresses and gowns, bonnets and shoes, embroidered linens and brightly coloured silks. It was a simple trick and easy to pull off, as long as the audience was willing to play along.

The object in this chapter has disguise and trickery at its heart. It promises happy endings and sudden revelations, but it also suggests darker notes of danger and potential tragedy. On the surface it is solid and straightforward: an Elizabethan trunk of clothes. From the outside it looks pretty robust: it is about the size of a bag you might use to carry sports kit around in and it is fairly heavy to lift. It is made of wood, probably pine, and it has been covered with animal hide, most likely pony, to keep the water out. Inside, the trunk is jam-packed with pieces of fabric. There is straightforward plain white linen. There are also embroidered linens, silks and damasks – brown, red, gold, green, white, some of them heavily worked. There is

a ring, and some beads. And on top of everything is a fetching pink silk-lined bonnet. These, you might imagine, are the sorts of things that any Elizabethan housewife might want to buy. On the outside of the trunk are leather loops; this box was carried around on a horse. It has all the appearances of a pedlar's trunk.

Pedlars were generally welcome arrivals in the towns and villages of Shakespeare's England. They catered primarily to women, supplying them with their buttons and thread, bows and brocade. In a world where practically all clothes were home-made, a little piece of damask or lace would add a touch of metropolitan chic. Margaret Spufford has uncovered much of what we now know about Elizabethan pedlars:

> The pedlar is a very elusive figure indeed, not only because he is peripatetic, but also because he or she – there were women pedlars too – lived near the edge of society, on the vagrant fringe. They were essentially salesmen, the travelling legs of the markets. They circulated very widely, travelling on foot and on horseback. Before the village shop was very common, these people filled in the gaps. Pedlars were also entertainers: they often earned their night's lodging by singing, telling stories or the latest news.

Like Autolycus in *The Winter's Tale*, many pedlars had a good line in promotional jingles:

AUTOLYCUS: Will you buy any tape,
 Or lace for your cape,
 My dainty duck, my dear-a?
 Any silk, any thread,
 Any toys for your head,
 Of the new'st and fin'st, fin'st wear-a?
 Come to the pedlar:
 Money's a meddler
 That doth utter all men's ware-a.

However useful for the promotion of their wares, the pedlars' reputation for fast talking and their constant moving around made them figures of suspicion. There were all sorts of people travelling the roads: there were respectable pedlars – chapmen or tradesmen who journeyed with horse and pack following an established route on a mental map dotted with overnight stopping places – and there were those who blended into the transient, criminal margins, little more than tramps or petty thieves. Autolycus is a typically tricky character from this netherworld of travellers and 'rag and bone' men. When he boasts that he is a 'snapper-up of unconsider'd trifles', what he really means is that he steals sheets from washing lines in one town to sell on in the next.

Pedlars of both these kinds were a sort of Elizabethan Twitter feed; they carried news quickly, spread it widely, and their relationship to the truth was similarly easy-going. In 1604 it was said of the loose-tongued Alice Bennet of Oxfordshire that she 'goeth abroad to sell sope and candels from towne to towne to get her lyving, and she useth to carrie tales between neighboures'. Travelling about the country as they did, pedlars were unfailing sources of news, rumour, gossip – and, on occasion, sedition.

Not surprisingly, this shifting, ever-present underclass was almost impossible to pin down or control. Like Shakespeare's disguised characters, it was hard to tell just how honest or genuine a pedlar was, or what he might be up to. Goods as innocent as linen and lace could mask more covert activities, from thievery to espionage. In the 1590s, new legislation was introduced to crack down on the 'jugglers, tinkers, peddlars', who were seen as undesirable vagrants. Pedlars could be dubious characters, and the contents of their trunks were not always what they seemed either. Which is the case here – for the linen, silk and damask in this particular pedlar's trunk are not bits of material waiting to be transformed into smart

clothes for a young Elizabethan woman. They have already been made into the illegal vestments of a clandestine Roman Catholic priest.

The pedlar's trunk is now in the collection of Stonyhurst, the Jesuit school in Lancashire, originally founded in 1593 in France to provide a Catholic education abroad for English boys. Jan Graffius, curator at Stonyhurst, explains its contents:

> The pieces of fabric are the stoles that the priest would wear around his neck. Beneath them are long, decorated braids: this is the girdle that he would tie around his waist. Fabric like damasks and silks were extraordinarily expensive, so we think that these were made from Sunday dresses which pious Catholic women sewed into vestments for priests; it was such women who largely kept the Catholic faith alive in England. It was not possible to acquire these vestments or the fabric for them openly, but women could sew at home without arousing suspicion. The beads in this trunk are disguised rosary beads; there is also an altar stone, which has relics set into it. This was needed for the priest to say mass, as the consecration of the bread and the wine takes place on top of an altar stone. For the central ceremony of the mass there is even a pewter drinking cup, a chalice. It is just an ordinary Elizabethan drinking cup that could be found in houses and inns, but what is unusual is that there is also what looks like a little drinks coaster, made out of pewter – it is a paten, and it sits on top of the chalice. It is to cover the wine during the consecration to preserve the mystery.

This box contains everything required for a Catholic priest to say mass. This pedlar's trunk is a secret, portable church.

The trunk was found in the mid-nineteenth century, walled up in a country house, Samlesbury Hall in Lancashire, about seven miles from Stonyhurst. Samlesbury was the home of the Southworth family, prominent English recusants – people

who refused to give up their Catholic faith – of whom three members in one generation became Catholic priests. The compartment in which the trunk was found may have been created by Nicholas Owen, a carpenter and Jesuit lay brother who specialized in the creation of 'priest-holes' and secret stores to hide Catholic equipment and who died under torture in 1606 following the Gunpowder Plot (see Chapters Eleven and Nineteen). Father John Gerard, a leading Jesuit priest of the time, described Owen's work:

> his chief employment was in making of secret places to hide priests and church stuff ... in all shires and in the chiefest Catholic houses of England ... of several fashions in several places, that one being taken might give no light to the discovery of another.

Seen as emissaries of the Pope who had relieved English Catholics of their allegiance to the Queen, and as supporters of the arch-enemy Spain, in 1585 Catholic priests were prohibited even from coming to England, let alone actively practising their vocation. In order to minister to those who persisted in Catholic worship, they had to come covertly, and risk death. In the process, they created a new sort of church, secret and hidden. A small minority of them were involved in various ways with Catholic conspiracies and attempts at rebellion and assassination; most of them were simply trying to keep the old faith alive. But in the public mind, all of them were associated with treason, violence and deception: 'Those Snakes that do naturally sting, as soone as they get warmth, may not be harboured in the bosome of the Commonwealth: But all popish priests professe rebellions, as soone as they can presume of their strength.' To avoid discovery and certain death, these, then, were the necessary strategies of survival for an undercover priest: false and rapidly changing identities, costumes and names; forged documents; secret assemblies;

hidden chambers; codes and concealment. And such subterfuges, born out of the repression and rancour faced by practising Catholics, in turn further inflamed the suspicions of Protestants and the governing elite.

Most notorious, and most hated, of these survival strategies was the Jesuit practice of 'equivocation' – juggling with words to mislead or evade answering under oath, but with unspoken mental reservations. 'Equivocation' drew special condemnation for its dishonesty and slipperiness. In *Macbeth*, written around the time of the Gunpowder Plot, the Porter voices the popular view of the treacherous Jesuit priest:

> PORTER: Faith, here's an equivocator that could swear in
> both the scales against either scale, who committed
> treason enough for God's sake, yet could not equivocate
> to heaven. O, come in, equivocator.

In Shakespeare, while disguise is often a frivolous affair, the idea of dissembling – hiding or misleading one's real character or purpose, leading the innocent to trust the untrustworthy – is the hallmark of the true villains, from Richard III to Iago in *Othello* and Edmund in *King Lear*:

> RICHARD: I'll play the orator as well as Nestor,
> Deceive more slily than Ulysses could,
> And, like a Sinon, take another Troy.
> I can add colours to the chameleon,
> Change shapes with Proteus for advantages,
> And set the murderous Machiavel to school.

For undercover Catholic priests, however, deception was essential for self-preservation and for moving around the country. Disguised as itinerant salesmen, they would have effectively had freedom to travel anywhere. The fabrics and furbelows in the trunk, as well as the beads and an everyday pewter cup, could easily be mistaken for legitimate goods.

The pink bonnet found at the top of the pile may have been placed there to mislead whoever opened the trunk.

Shakespeare's audience were well aware of this closet religious practice, and everyone would have recognized the pattern of disguise, constant movement and equally constant fear. Gloucester's son Edgar in *King Lear* is in flight because, if caught, he will be killed:

> EDGAR: I heard myself proclaimed,
> And by the happy hollow of a tree
> Escaped the hunt. No port is free, no place
> That guard and most unusual vigilance
> Does not attend my taking.

He decides that the only safe way forward is to disguise himself as a wandering beggar:

> EDGAR: Whiles I may 'scape
> I will preserve myself; and am bethought
> To take the basest and most poorest shape
> That ever penury, in contempt of man,
> Brought near to beast. My face I'll grime with filth,
> Blanket my loins, elf all my hair in knots,
> And with presented nakedness outface
> The winds and persecutions of the sky.

Persecuted, endangered, travelling under a false identity in order to do good for his blinded father – Edgar is a striking parallel of an outlaw Catholic priest, disguised and on the run.

The unmasking of disguise in Shakespeare's plays is usually a cause for delight: Viola is reunited with her brother Sebastian; Portia and Nerissa are restored to their astonished husbands; Rosalind at last revealed to her lover Orlando. If you were a Roman Catholic in England around 1600 and your pedlar unexpectedly turned out to be a priest, it must

have been a moment of similar intense rejoicing – despite the risks associated with discovery. Thanks to a trunk like this one, what you believed could now be celebrated in the ritual of the mass that was at the heart of your faith – forbidden by law, but now miraculously possible. In your own home, a room could become a church, where with these vestments, this plate and cup, family and friends could gather in a rare forbidden communion.

In the next chapter we examine another group of people that many Elizabethans viewed with suspicion – not Roman Catholics, but what Shakespeare in *Henry V* called 'the weasel Scot'.

Chapter Fifteen

The Flag That Failed

Flags for Great Britain

On the night of 26 March 1603 Sir Robert Carey galloped up to the front of Holyrood Palace in Edinburgh with eagerly awaited news. He had ridden straight from London, where, two days before, at three in the morning, Queen Elizabeth had died. It was the event that everyone in England had long been dreading.

> CRANMER: She shall be, to the happiness of England,
> An agèd princess; many days shall see her,
> And yet no day without a deed to crown it.
> Would I had known no more! but she must die –
> She must, the saints must have her – yet a virgin;
> A most unspotted lily shall she pass
> To th'ground, and all the world shall mourn her.

But while all the world was mourning, English politicians had to act. An hour or so after Elizabeth's death, James VI of Scotland was proclaimed her successor by the Privy Council, led

by Sir Robert Cecil. At 10 o'clock the next morning Cecil again proclaimed James I King of England, France and Ireland, this time openly at Whitehall. At Holyrood in Edinburgh, the news was received with rapture. Elizabeth had proved very un-Tudor in her longevity, and James had had a long, uncertain wait. Now, after just eight days to prepare and pack, he left Holyrood on 4 April 1603 to claim his new and much richer crown in England.

Ten years later, in their jointly authored play *Henry VIII*, William Shakespeare and his collaborator John Fletcher looked back at the pivotal moment when James had succeeded Elizabeth, and the hopes that surrounded the new king.

> CRANMER: So shall she leave her blessèdness to come –
> When heaven shall call her from this cloud of darkness –
> Who from the sacred ashes of her honour
> Shall star-like rise, as great in fame as she was,
> And so stand fixed. Peace, plenty, love, truth, terror,
> That were the servants to this chosen infant,
> Shall then be his, and like a vine grow to him.

For the first time in history, the whole island of Britain was under one rule – something that even the Romans had failed to achieve. Everybody knew that with James as King of England and King of Scotland a new political world had been born. But it was not at all clear how things were going to change. Shakespeare and Fletcher's Archbishop Cranmer predicts that:

> CRANMER: Wherever the bright sun of heaven shall shine,
> His honour and the greatness of his name
> Shall be, and make new nations. He shall flourish,
> And like a mountain cedar reach his branches
> To all the plains about him; our children's children
> Shall see this, and bless heaven.

But making a new nation turned out to be very difficult. For many of the previous 300 years England and Scotland had been at war; they had very different political and legal systems, a different established church, different currencies, separate parliaments and a long history of intense dislike and deep suspicion. James's central ambition was to make these two very foreign countries into one new state, with a new name – Great Britain.

The succession of James VI of Scotland to the English throne in 1603 created a dynastic union, and a personal union of political authority, but it did not create a union of the crowns in constitutional, legal, ecclesiastical or economic terms. Forging such a union was James's paramount aim. In some ways, it was not a bad time for an ambitious project of nation-building. It followed half a century of unbroken peace between Scotland and England (give or take the usual Border skirmishings) and a growing sense that, in spite of a bloody history, England and Scotland shared a common language and a common Protestant faith.

In 1604 James set out the framework for a legal and political union, including a certain amount of free trade, the abolition of the special laws governing the Scottish Borders (to be renamed 'the Middle Shires') and the naturalization of Scottish subjects living in England. John Morrill of the University of Cambridge explains:

> Initially James pushed for all-out union: political union, an economic union and a religious union. But very quickly he saw that the scale of the opposition was too great, so instead he proposed what he called the 'union of hearts and minds'. The problem was the English wanted to create common institutions covering the whole of the island, so there would be one parliament, one system of law and one church. Whereas the Scots preferred a federal structure in which both countries

retained independent institutions but ones which would work together, using some new mechanisms for increased cooperation. In a sense the Scots would always prefer devolution to integration. They would always like to have their law and their particular style of Protestantism protected.

The full union James dreamed of was impossible without legislation, and this required parliamentary approval. The negotiated proposals for union were passed by the Scottish parliament in 1607 (the Scottish parliament was a single-chamber assembly consisting overwhelmingly of royal tenants-in-chief and usually obedient to the king), but that decision was conditional on the agreement of the English parliament. The Scottish king quickly discovered that the less subservient English parliament was having none of it, and the Treaty failed.

Yet some things James could alter without parliament. He could use his prerogative powers to make the union at least a symbolic reality, what were called 'outward marks of government'. He issued a new £1 coin and called it the 'Unite'. He changed his title to King of Great Britain – some of his supporters even urged that he should call himself 'Emperor of Great Britain', although he declined to go that far. He famously began his great project to create a new version of the Bible in English that would be used in both kingdoms. And he set about designing a new *British* flag.

In the National Library of Scotland, there is now housed a set of flag designs made around 1604 – the earliest designs for James's new flag. They are drawn on a piece of paper about the size of a large placemat, and on it six flags are flying. They look a bit like pictures in a child's colouring book, all outlined very simply in ink and then brightly coloured in – there are six red, white and blue variations on how you combine the Scottish cross of St Andrew and the English cross of St George, annotated in almost illegible seventeenth-century writing. They

are a strikingly straightforward attempt at visual propaganda. Each design sought to capture what James optimistically, if rather naively, called 'this happy marriage'. Here, the flags say, are not two nations, but one; no longer England and Scotland, but now Britain.

As well as the parliamentary and personal programme, there was a major campaign in print and on the public stage in 1603–6 in support of James's project. In 1605 the Lord Mayor's pageant presented Antony Munday's *Triumphes of Re-united Britannia*, in which the three kings Locrine of England, Camber of Wales and Albanact of Scotland resign their crowns to Empress Britannia ('I yielded long ago,' says Camber wistfully). William Herbert's *Lamentation of Britaine*, published the following year, urging the English to become British, begins:

> Oh where is Britaine? Britaine where is shee?
> What? Smothered in forgetful sepulcher?
> Exilde from mans reviving memorie?
> Oh no, let England like a childe prefer
> That well knowne title of her ancester.
> I know the neighbour sisters of this Ile
> Will greatly glory in so good a stile

This revival of Britain was not a new idea; it moved forward behind a phalanx of historical writings and previous political manoeuvrings, and it also rested on James's bloodline. He was, of course, Scottish, but also English and Welsh through the Tudors – and thus impeccably, predestinedly British. He could even, by several ancestral routes, lay claim as heir to Cadwallader, last of the British kings (a tentative and insecure claim, but one which still made for good propaganda). And his coins explicitly made the link between James and Henry VII, his direct ancestor: 'HENRICVS ROSAS REGNA IACOBVS' they read. James was uniting the thrones of

Scotland and England just as Henry, combining the red and white roses, united the Houses of Lancaster and York.

Looking at the flag designs, you can see the intractable politics of union being played out in graphic form. All the designs stumble on the one key problem facing James's project: how do you combine two kingdoms, but allow each to retain equal status? Crudely put, which national cross gets to be on top, St George or St Andrew? And does size matter?

If you have never seen the Union Flag that we have all grown up with, it is surprisingly difficult to come up with an even-handed solution to this problem. The six designs of 1604 tackled it in different ways. Two of them put the Scottish cross unequivocally on top of the English cross, but they make the Scottish cross much smaller. In two others, the English cross hogs most of the flag, but a smaller, Scottish cross gets the coveted 'pole position' in the upper left-hand corner. So these four proposals all offer the same compromise: the English cross is bigger, but the Scottish cross holds the position of honour.

The last two designs are much more ingenious. One has four small Scottish crosses, white on blue, filling each of the quarters around a large red English cross. The last design is perhaps the simplest of all. It just quietly sets the two crosses side-by-side, fifty-fifty, English to the left, the Scottish to the right. It might seem to be the obvious solution, but it is conspicuously ugly. Perhaps inevitably it was the one that the Earl of Nottingham, as Earl Marshal and responsible for supervising heraldry, recommended to the King. In a note that Nottingham wrote on the drawing itself, he explained why he thought it a happy conceit, an unimpeded marriage of true minds expressed in flag form: 'In my poor opinion, this will be the most fittest, for this is like man and wife without blemish one to other.' But in heraldic terms, there was a problem with this design, because in this seventeenth-century flag couple,

England is very much the man, on the privileged position on the inside of the flag. Scotland, as the wife, is relegated to the outside.

The matrimonial metaphor was much in the air. James himself used it with evident relish when addressing the English parliament in 1604:

> What God has conjoined then let no man separate. I am the husband, and all the whole Isle is my lawfull Wife. I am the head and it is my body; I am the shepherd and all the whole isle is my flock ... I hope therefore no man will be so unreasonable as to think that I that am a Christian king under the Gospel, should be a Polygamist and husband to two wives.

But the two wives – Scotland and England – were never going to agree, which is why the flag issue was so telling. The Scots wanted absolute parity; the English wanted acknowledgement of their longer history, greater resources and (in their eyes) inherent pre-eminence. Neither side would give way.

These early years of James's reign were the background against which Shakespeare wrote *Macbeth*, in which England and Scotland are separate but friendly. Despite the intense royal propaganda for full union, Shakespeare on the whole evades the question of Britain. In *King Lear*, written around the same time, he draws on a little-known anonymous play, published in 1605, in which a mythical King of Britain breaks up his united realm with devastating consequences. In his source, Britain is mentioned over twenty times, but in Shakespeare's version, Lear's kingdom strikingly has no name, and the word 'Britain' does not appear once. Shakespeare, like everybody else, must have known James's views. Jonathan Bate says:

> Shakespeare always keeps his own cards very close to his chest. One of the things that makes his plays so endlessly open

to new interpretations and performances in new cultural contexts is the fact that they set up questions, big questions about politics, the state, the relationship between the individual and the state, between the present and the past. They don't propose answers, they are not propaganda. You can look at some of the other dramatic works of the period, for instance the court masques written specifically for King James by Shakespeare's friend Ben Jonson, and they are overtly propagandistic, celebrating the triumphs of Britannia. Shakespeare doesn't do that – he is too subtle a writer – but there is no doubt that we can see him cutting his cloth according to the concerns of the new king. I think the thing to remember about King James is that he loves debates . . . He sees himself as a real intellectual king. So the fact that Shakespeare's plays present questions, political, philosophical, but don't actually give propagandistic answers, in a way I think James would have found that very attractive.

Shakespeare's early history plays written under Elizabeth had taken a very pro-Tudor line, presenting the Queen's own view of what England was, and the court rewarded him. And he did eventually furnish a 'British' play for James, his new patron (Shakespeare's company, the Chamberlain's Men, was renamed the King's Men in very short order after the arrival of James in London). Jonathan Bate explains:

Shakespeare's most overt engagement with this British question is the play called *Cymbeline King of Britain*. Set during the time of the Roman Empire when Julius Caesar has landed in Britain and the British tribes are having to pay tribute to Rome, it is a play about British identity, about what it is to be British and to fight against a powerful European empire. Obviously to some extent ancient Rome represents the modern Roman Catholic lands, dominated by Spain. King James had been very concerned to bring peace to Europe, to reconcile

the Roman and the Protestant nations. What seems to happen in *Cymbeline* is that by the end of the play you get a reconciliation between the Roman Empire and this new British kingdom. There is a lot of language associated with the idea of the King of Britain bringing peace, that it is the King of Britain who is able to put an end to the divisions that have racked Europe, and this is exactly the role in which James saw himself.

Cymbeline concludes with a victorious Britain and a chastened Rome – entirely a fiction of Shakespeare's creation – and ironically it ends with Cymbeline calling for the hoisting of a British flag:

CYMBELINE: let
 A Roman and a British ensign wave
 Friendly together. So through Lud's Town march,
 And in the temple of great Jupiter
 Our peace we'll ratify, seal it with feasts.
 Set on there. Never was a war did cease,
 Ere bloody hands were washed, with such a peace.

The audiences would all have known that the very idea of a 'British ensign' was still acrimonious and unresolved. By the time Shakespeare wrote *Cymbeline* in 1610, the English parliament had killed James's union project dead. It would be another hundred years before the formal Act of Union united Scotland and England into one state of Great Britain.

James eventually decided not to use any of the six designs we see here and opted instead for a much simpler solution, with the English cross of St George superimposed on the Scottish cross of St Andrew. Needless to say, the Scots immediately protested, and an unofficial Scottish version with the cross of St Andrew supreme quickly began to be used on Scottish ships. Eventually the puzzle of how to design a union flag

would be solved, but it took a very long time, and the arguments that lay behind it – arguments first tackled 400 years ago in these drawings of six simple combinations of crosses – have never truly gone away. Usually today, outside St Giles' cathedral in the heart of Edinburgh, there are two or three blue and white saltires, the old Scottish flag of St Andrew, flying – and not a Union Jack to be seen anywhere.

Chapter Sixteen
A Time of Change,
a Change of Time
A striking musical clock

We take time for granted, or perhaps we just accept its tyranny, as we rush from one place to another or hurry to take our seats in the theatre. But how did Shakespeare's audiences know when a performance was going to start, and how did they think about time? It is an important issue in many of the plays, and, like so much of life for Shakespeare's contemporaries, even time itself had been recently changed by new ideas and new inventions. Richard II, imprisoned by his cousin and awaiting death in his cell, thinks of himself as quite literally 'doing time', but he does so in a very modern way:

> RICHARD: For now hath time made me his numbering clock.
> My thoughts are minutes, and with sighs they jar
> Their watches on unto mine eyes, the outward watch
> Whereto my finger, like a dial's point,
> Is pointing still in cleansing them from tears.

The 'jar' or ticking of a domestic clock as it marked the minutes was a new feature of Elizabethan England, and not a sound

that Shakespeare's parents would have known. For them, minutes would have been merely an idea, and the noise of time would have been almost exclusively the chimes of a public clock.

> RICHARD: Now, sir, the sound that tells what hour it is
> Are clamorous groans which strike upon my heart,
> Which is the bell.

We are used to kings being compared to the sun, to lions, even to gods. But here, startlingly and poignantly, King Richard likens himself to a timepiece. And this is not the only moment in Shakespeare where a character will be compared to a clock. It is a device that works just as well in comedy:

> BEROWNE: I seek a wife?
> A woman, that is like a German clock,
> Still a-repairing, ever out of frame,
> And never going aright . . .

For Berowne in *Love's Labour's Lost*, wives, like German clocks, are high-maintenance and unreliable. To get a sense of how fresh this insult must have seemed, we need to look at a real clock, one made in 1598, just after Shakespeare wrote *Love's Labour's Lost*.

The clock here is not strictly German, but it is not English either. Its maker, Nicholas Vallin, was a Flemish Protestant who came to England in the 1580s to escape the religious persecution which followed Spanish repression in the Low Countries. He and his father settled in Blackfriars in London, where, towards the end of his career, he made this clock. The creation of a timepiece like this was an impressive feat. It stands nearly two feet tall (excluding the weights and ropes) and looks like a small, square classical temple. The main storey has four Doric columns, one at each corner, framing the clock itself. Above that, four smaller columns carry gilded triangular

pediments and house a miniature belfry, and, over the top, squatting like the dome of the British Museum Reading Room, is a giant bell. This is a (barely) portable classical bell tower made for use in the home. Nicholas Vallin has proudly engraved his name on the front and dated it 1598.

Behind the clockface, the workings are exposed to view, a marvel of mechanical skill, and above them we can see thirteen small bells. It is quite clear that Vallin wanted people not just to use this clock but also to admire its workings. In *The Winter's Tale*, when the Queen tells Leontes that she loves him 'not a jar o'th'clock' less than any lady loves her husband, she is protesting an affection as reliable as clockwork, like these minutely precise, unfailingly regular flywheels.

Berowne was absolutely right in stating that a clock like this demands – indeed commands – a great deal of attention. Mounted on a bracket high on the wall, our clock would have held a prominent position in its wealthy owner's house, probably in a reception room or hall. One feature of Vallin's clock would particularly have impressed contemporaries: it has two hands, one for hours and one for minutes. Before 1600, the great majority of clocks had just a single hour hand, and the divisions of the hour were judged approximately; so what now looks to us like a conventional clock was in 1598 (as for Richard II) cutting-edge technology. It would be another fifty years before minute hands became standard.

This clock also plays music – every quarter-hour. That, the quarter-hour, rather than the minute, was the unit of time that dominated how people thought. Here is William Harrison in his cheerily chatty *Description of England* in 1577:

> In most places they descend no lower than the half or quarter
> of the hour, and from whence they proceed unto the hour, to
> wit the four and twentieth part of that which we call the
> common and natural day.

No one, or virtually no one, then thought in terms of seconds, a unit of time not mentioned anywhere in Shakespeare. In the late sixteenth century, only astronomers and scientists like John Dee or Tycho Brahe would have even tried to get time-pieces that were accurate to the second. Seconds then were a little like nanoseconds to us today – we know they exist, but we have no need of them, and wouldn't know how to use them in our daily lives.

The smaller bells on Vallin's clock sounded a different melody every quarter, while the big bell at the top announced the hour to the whole household – a private domestic echo of public municipal time. This clock is in fact an indoor version of the large clocks displayed in churches or civic buildings, which regulated public life throughout England. The medieval tradition, like the Roman, had divided the day into unequal hours, subdividing the daylight and night-time periods into twelve equal segments, which varied with the length of the day. The idea of officially calibrated time-keeping regulated by clocks – our modern idea of 'telling the time' – was a routine thing to do in Shakespeare's age, but in historical terms it was a fairly recent innovation. In 1400, there were only twenty-five public clocks in the whole of England that we know about. In Shakespeare's London there were dozens of them, and their chimes and bells were keeping time more accurately than ever before. Watches, for example – personal, mobile timekeeping – were an even more avant-garde technology. They had been invented in the sixteenth century, but were reliable only to the half-hour. Worn around the neck on a ribbon or a chain, they were a rich man's toy, a prop in Malvolio's daydream about the leisured, insouciant superiority with which he will treat Sir Toby once he is married to the Lady Olivia:

MALVOLIO: Seven of my people, with an obedient start,
 make out for him. I frown the while, and perchance wind up

my watch, or play with my [*fingering his steward's chain of office*] – some rich jewel. Toby approaches, curtesies there to me . . .

Clocks and watches are both emphatically urban objects. 'There's no clock in the forest,' says Orlando in *As You Like It*. But in the busy city environment, gates had to be opened, council meetings convened, markets regulated, alehouse hours supervised and public theatres opened at the time announced. Dr Paul Glennie of the University of Bristol has studied the history of timekeeping in England:

> The thing about towns, at least large towns, is the density of clocks. In London, for example, there are 110 or so parishes, of which in Shakespeare's time, somewhere around half or just over have clocks that are striking the hour. One of the great things about timekeeping with bells as opposed to looking at a clock dial is that information is being spread over quite a wide area. They may not be exactly in time with each other, but broadly there is a kind of big audible pulse broadcasting to the atmosphere, into the landscape.

It is also the sound you would have heard as you hurried (perhaps a little late) to a two o'clock performance at the Globe. Reliable public timekeeping was essential for the commercial theatre. The public had to get there in time, pay their admission and buy their refreshments. What Shakespeare called the 'two hours' traffic of the stage' depended on a punctual start. The authorities liked to get people home before dark to avoid disorderly behaviour, so depending on how close to midsummer it was, plays started at either 2 or 3 p.m. In 1594, the Lord Chamberlain assured the Lord Mayor of London that: 'Where heretofore they began not their Plaies till towards fower a clock, they will now begin at two, & have done between fower and five.'

Since afternoon church services also started at 2 p.m., this fuelled the antagonism between church and playhouse. Many Londoners must have reacted to the mid-day church bells by setting out – for the theatre.

*

Of all his plays, *The Winter's Tale* is perhaps Shakespeare's greatest meditation on time. When a man sees a statue of his dead wife and it miraculously comes to life, it is as if we can turn back time, and every human loss – grief, guilt, even death – can somehow, at least within the romance of the play, be restored. There is even an extraordinary moment when Time himself becomes flesh and walks centre-stage, from where – as well as helpfully explaining a lapse of sixteen years in the plot – he contemplates his inexorable reach over restless, ever-shifting human lives:

> [*Enter Time, the Chorus*]
> TIME: I that please some, try all; both joy and terror
> Of good and bad; that makes and unfolds error,
> Now take upon me, in the name of Time,
> To use my wings. Impute it not a crime
> To me or my swift passage that I slide
> O'er sixteen years, and leave the growth untried
> Of that wide gap, since it is in my power
> To o'erthrow law, and in one self-born hour
> To plant and o'erwhelm custom.

Even when Time himself is not on stage, musing and philosophizing, there is hardly a Shakespearean sonnet or scene that does not take up the theme of time. Nicholas Hytner of the National Theatre says:

> The passage of time and the effects of time come up over and over again in his plays. 'Tomorrow and tomorrow and

tomorrow, / Creeps in this petty pace from day to day / To the last syllable of recorded time.' That 'syllable of recorded time' is an image which could probably only have emerged after the invention of the clock. The idea that time passes in tiny increments and 'all our yesterdays have lighted fools the way to dusty death', the idea that Macbeth is trapped in a vast ticking mechanism, that the human race is stuck in the middle of a slowly ticking clock which is just going to go on ticking away the syllables, ticking away the seconds until the world ends – that is an extraordinarily potent image.

Older forms of timekeeping – hourglasses and sundials – do still crop up. Mercutio tells Juliet's nurse, surely with a heavy wink: 'the bawdy hand of the dial is now upon the prick of noon'. But clocks appear more frequently – their sound effects explicitly required by stage directions and commented on by characters. The striking of the clock propels the comic plot in *The Comedy of Errors* and *Merry Wives of Windsor* and ratchets up the tension, Hitchcock-style, in the histories and tragedies. Even ancient Rome is awarded its own prematurely invented clock as a dramatic device: in *Julius Caesar*, while the conspiracy is being hatched, we hear the clock strike 3 a.m.

TREBONIUS: There is no fear in him; let him not die;
 For he will live, and laugh at this hereafter.
 [*A clock strikes*]
BRUTUS: Peace, count the clock.
CASSIUS: The clock hath stricken three.
TREBONIUS: 'Tis time to part.

As the assassins wait to betray their friend and leader, the clock relentlessly punctuates the plot: we are told it has just struck eight in the morning when Caesar sets off to the Capitol, and when Portia asks for news at nine, we know that Caesar will soon be dead.

Theatrical tension was one by-product of the mechanical march of time, but it wasn't only in the theatre that clocks spread a sense of menace. In the workplace also they were often seen as instruments of oppression, as Paul Glennie explains:

There is plenty of complaining about the volume and the intensity of work and hard taskmasters before time discipline comes in, so it is very easy to blame time, to blame the clock. Anyone who supposes that life in the pre-industrial country-side was an idyllic kind of existence does not have a sense of how urgent it was to get the harvest in before it rained, for example. But it is certainly true that expectations about how hard people work, how regularly people work and how inten-sively their output is monitored do relate quite closely to the way in which clocks can be used to record that much more closely. It becomes a way of inspecting.

Consequently it was not just clocks that the London work-force disliked – they also resented the clockmakers. Skilled Protestant refugees like Vallin were welcomed by Elizabeth's government, but they did not always have an easy time of it – asylum-seekers rarely do. The Flemings and French were the two groups of 'strangers', as they were called, that drew the most persistent antagonism from London apprentices and journeymen, whose hostility was backed by Sir Walter Raleigh, among others, at Court. In 1593 a series of hostile 'libels' were pinned up on the walls of the Dutch church in Austin Friars, where Vallin had married three years earlier:

Doth not the world see, that you, beastly brutes, the Belgians or rather drunken drones, and fainthearted Flemings; and you, fraudulent father, Frenchmen, by your cowardly flight from your own natural countries, have abandoned the same into the hands of your proud, cowardly enemies, and have, by a feigned hypocrisy and counterfeit show of religion, placed yourselves

here in a most fertile soil, under a most gracious and merciful prince, who hath contented to the great prejudice of her own natural subjects, to suffer you to live in better care and more freedom than her own people? Be it known to all Flemings and Frenchmen that which follows: for that there shall be many a sore stripe. Apprentices will rise to the number 2336. And all apprentices and journeymen will down the Flemings and strangers.

Was this menacing rant, worthy of the most unashamed racist, anything more than xenophobic graffiti? There is no record of an attack by 2,336 apprentices on Flemish migrant craftsmen, nor do we know that Nicholas Vallin himself ever suffered any assault. But it is the world in which he worked, and in which our clock was made – Shakespeare's world. In any case, Vallin did not live long after he made this clock: he died in the great plague outbreak of 1603 along with his father, two of his three daughters and two journeyman clockmakers who were working for him at the time: an entire household virtually obliterated.

Amidst all this human mortality, Queen Elizabeth, so long on the throne, seemed to many the very image of timelessness. In a poem sometimes attributed to Shakespeare and perhaps spoken by him as an epilogue to a play performed at court on Shrove Tuesday 1599, he addresses the elderly Queen, now well into her sixties. He compares her to a clock, like Richard II – or rather, to a clockface, unchanging herself, and the constant background against which the lives of her transient subjects were played out, like ever-moving hands:

> As the dial hand tells o'er
> The same hours it had before,
> Still beginning in the ending,
> Circular account still lending,
> So, most mighty Queen we pray,
> Like the dial day by day

You may lead the seasons on,
Making new when old are gone,
That the babe which now is young
And hath yet no use of tongue
Many a Shrovetide here may bow
To that empress I do now,
That the children of these lords,
Sitting at your council boards,
May be grave and aged seen
Of her that was their fathers' queen.
Once I wish this wish again,
Heaven subscribe it with 'Amen'.

Elizabeth was lucky. She survived into old age. Many of her subjects did not, victims of that most terrifying of Elizabethan diseases, which we will be looking at in the next chapter – the plague.

Chapter Seventeen

Plague and the Playhouse

Plague proclamations

In 1564, as we saw in Chapter Two, a quarter of the population of Stratford-upon-Avon died of the plague. One of those who escaped was the infant William Shakespeare – though on the street where he was born, in April that year, one family lost all four of their children to the disease. Shakespeare's life was marked by plague: his career was shaped by it, his audiences feared it, and many of them died of it. But there is no great play about it, by Shakespeare or any of his contemporaries. Its absence is one of the puzzles of Shakespearean scholarship.

Yet if plague never appears on stage, it can rarely have been far from the thoughts of the audience and the players. And never more so than in 1603, a year which the playwright Thomas Dekker commemorated in a pamphlet called quite simply *The Wonderfull Yeare*. What Dekker calls wonderful – by which he means full of wonders – was, for most Londoners, more appropriately described as terrifying.

On 24 March, Queen Elizabeth died.

To report of her death (like a thunder-clap) was able to kill thousands, it took away hearts from millions: for having brought up (even under her wing) a nation that was almost begotten and born under her; that never shouted any other *Ave* than for her name, never saw the face of any Prince but herself, never understood what that strange outlandish word *Change* signified: how was it possible, but that her sickness should throw abroad an universal fear and her death an astonishment?

Though Elizabeth's death had been long anticipated, the long security of a forty-five-year reign suddenly evaporated. Nobody knew what her successor, her foreign cousin James of Scotland, was likely to do. But the fears surrounding James's succession were overtaken a few months later by the most frightening of all the year's events:

23 June 1603: Forasmuch as the infection of the plague is at this present greatly increased and dispersed as well in the Cities of London and Westminster, as also in the Suburbs thereof, the King's Most Excellent Majesty considering that great peril and danger might ensue not only unto his Royal person, the Queen's Majesty, the Prince, and Princess, the Honourable Ambassadors from sundry foreign Princes, the Lords and others of his Majesty's Honourable Privy Counsel, the Nobles of this Realm, and other his Majesty's loving Subjects, if the people of all sorts, and out of all parts of this Realm, should resort or continue together for their Suits and Causes.

James's reign began in a cruelly testing way: not with processions of rejoicing citizens, but in pestilence. In the British Library there sits the evidence of how the new king tried to manage this totally unmanageable situation. It is a run of royal proclamations, each one issued separately on one or two large

sheets roughly the size of a modern tabloid newspaper. Such proclamations were the equivalent of today's rolling news:

> LOVELL: I hear of none but the new proclamation
> That's clapped upon the court gate.

> KING HENRY: These things indeed you have articulate,
> Proclaimed at market crosses, read in churches.

These proclamations were intended for mass distribution across the country, to be read out and then pinned up in public view. The royal arms appear at the top, and they all begin with the words 'By the king'. The first letter of the proclamation itself is a large decorated initial, and the proclamation is printed in a dense typeface used specifically for authoritative public documents.

Mass communication by print was one of the few instruments the authorities had to try to control the spread of disease. In 1574, following one particularly severe outbreak, a set of orders had been printed and fixed upon posts containing, probably for the first time, instructions on how people should conduct themselves in the face of an epidemic. In 1583 a more elaborate list of commands was set up in parish churches and on posts through London. This became the standard response to all future plague outbreaks, right up to the gradual waning of the disease following the great plague of 1665. After a particularly severe outbreak in 1592, the authorities also began to publish London Bills of Mortality: these listed deaths parish by parish and could be bought at the cost of a penny (the price of entrance to the Globe Theatre). When the pestilence was at its peak in 1603, Bills of Mortality were published every week in large print-runs, providing an ever-changing plague map of London, which you could check to find out where the infection was raging and where you might hope for relative safety.

6 July 1603: Forasmuch as we find that the Infection within our City of London doth daily increase, and is like (to our grief) rather to augment than diminish, as well by reason of the season of the year, as by the great Concourse of people to our said City against the time of our Coronation, some to do their duties in such necessary services, as to them belongeth at that Solemnity, and some for comfort they take in the sight of our Person, of the Queen our dear wife, and of our children.

As you leaf through James's 1603 proclamations, which attempted to contain the disaster, and which were issued at a steadily growing distance from the infectious capital, you get a strong impression of a king on the run: 'Given at our Manor of Greenwich', 'Given at our Castle of Windsor', 'Given at our Honour of Hampton', and then on to Southampton, Winchester and Wilton. It was a wretched beginning to a reign – but the wisest thing to do in the face of plague was indeed to run. Richard Barnett is a medical historian:

> Governments and states in Shakespeare's time are a little worried about people running away from the plague. On the one hand, if you are an aristocrat and you have a country estate, or if you are a priest or a physician and you have a college at Cambridge or Oxford that you can retreat to, of course that is what you want to do. But there are great fears in this period that people running away will spread disease much more quickly, so this is why governments and states start to jump in with new regulations about quarantine and confinement and restricting movement.

Those who were not in a position to run away – people like the groundlings who paid a penny to stand in the theatre – were the ones likely to suffer most, and suffer they did, as Richard Barnett describes:

The most common kind of plague and the kind most associated with historical plague is bubonic plague. The bacterium gets into the body, it goes to the lymph nodes; you generally find these in the neck and the shoulder, the armpit, the groin: they swell up, they go black, in some cases they sort of burst open, and you get really nasty abscesses. With bubonic plague you fall into a deep fever, you get multiple organ failure, your body just starts to shut down.

Bubonic plague – the Black Death – had been endemic in Britain since the fourteenth century. Spread by fleas from the black rat, it was one of the hazards of hot summers. When it arrived, plague was fast and fatal and so disrupted the ordinary life of the city that even the busiest of streets sprung weeds and grass. During the outbreak in London in 1592, when one Londoner in twelve died, Shakespeare was lucky once again. The authorities closed the theatres, and the promising young playwright turned to love poetry. He acquired a patron – the Earl of Southampton – and wrote his long poems *The Rape of Lucrece* and *Venus and Adonis*, which made him a star among the literati. But even Venus seems to be conscious of what is going on in the real world as she whispers this startling compliment about her lover's lips:

> Long may they kiss each other, for this cure!
> O, never let their crimson liveries wear!
> And as they last, their verdure still endure,
> To drive infection from the dangerous year:
> That the star-gazers having writ on death,
> May say, the plague is banish'd by thy breath.

Whatever his prowess as a lover, and however accident-prone as a huntsman, Adonis is clearly a sound choice in an epidemic.

Shakespeare's early career is largely a mystery: the details of his life in the theatre before the closure of the playhouses in

1592 are largely lost to us. But he emerged out of the disruption and reconfiguration of the theatres as a senior member and resident dramatist of the new Lord Chamberlain's Men, one of London's two authorized playing companies. For the rest of the 1590s bad weather – the cool, wet summers that made for riot-inducing bad harvests – kept the city more or less free of plague: crowds gathered, theatres boomed, and Shakespeare was able to return to writing plays and making his fortune.

All this changed once more with the plague of 1603. As the Queen lay dying in March, the first victims began to fall. Soon after Elizabeth's funeral on 28 April, it was all too obvious that London was caught up in another major outbreak. King James arrived in the capital on 7 May, but on the 29th he ordered the gentlemen and nobles already assembling for his coronation in July to return home until closer to the time. Over that summer, as far as possible, the city was shut down:

> 11 July 1603: The care we have to prevent all occasions of dispersing the Infection amongst our people doeth sufficiently appear by our former Proclamations, and for that cause we are contented to forebear at our Coronation all such ceremonies of honour and pomp used by our progenitors, as may draw over great confluence of people to our City.

The 1603 outbreak was first noted in the theatre district of Southwark, and the authorities began the standard measures to prevent it spreading. Infected houses would have been easy to spot, as Hazel Forsyth of the Museum of London explains:

> Families who were affected by plague were quarantined, usually for a period of a month. There were also measures to identify properties that contained victims: a pole had to be suspended above the door or from the window with a bundle of straw attached to it. Then gradually printed or painted

paper signs were fixed to posts and sometimes to door lintels and the door itself with the words 'Lord have mercy on us'. Sometimes also a painted cross on paper was used, and then the symbol that we perhaps most identify with plague today became the current one: the red cross. One foot two inches high, its size was very particular; it was painted in oil, presumably because it was much more difficult for people to remove.

Quarantine and those frightening large red crosses painted on the doors were something everyone knew about, and many would have encountered.

> OTHELLO: By heaven, I would most gladly have forgot it!
> Thou said'st – O, it comes o'er my memory
> As doth the raven o'er the infected house,
> Boding to all! – he had my handkerchief.

To enforce the policy of quarantine, new lines of work opened up: two 'honest and discreet matrons', who lived apart and received a fee of fourpence or sixpence for each body, would stalk the parish in search of signs of infection; 'searchers' were appointed to enter the isolated houses and reclaim the bodies of those lost to the plague. At a critical turning point in *Romeo and Juliet*, Friar Laurence is told why his crucial letter could not be delivered to Romeo:

> JOHN: the searchers of the town,
> Suspecting that we both were in a house
> Where the infectious pestilence did reign,
> Sealed up the doors, and would not let us forth . . .

Everyone in Shakespeare's audience would have shared the fear of being sealed up in a house in this way and not let forth. But this is the only time plague plays any significant part in the plot of a Shakespearean play, as near as it gets to coming on stage.

*

Over the summer of 1603, the number of plague deaths surged. The coronation went ahead on 25 July, but the new King's procession into London was cancelled.

> 29 July 1603: The infection of the Plague spreadeth and scattereth itself into diverse places of the Realm, and is like further to increase, if by the presence and care of such as are in authority and credit amongst our people, they be not contained in some good course, for the preventing of that contagion ... We have thought it good to publish to all other good subjects of this realm, that our pleasure is, and we command that all such as are not our servants in ordinary, or be not bound to attendance about our court by express commandment of Us, or our Council, shall immediately depart home to their countries.

The next day, 30 July, James issued national Plague Orders, effectively declaring a state of emergency. These Orders are a little like the civil defence pamphlets of the Cold War period, giving explicit instructions to every citizen on how to cope with an outbreak of plague. Organizing committees were to meet in safe places, people were to be appointed to count the infected and the dead and to conduct burials; local taxes were to be levied to cover the costs. The 1603 Plague Orders contain detailed advice, with recommendations for possible remedies and tonics that sound suspiciously like advertisements:

> For the Poore take *Aloes* the weight of sixepence, put in the pappe of an Apple: and for the richer *Pilles* of *Rufus* to be had in every good Apothecaries shop. After letting of blood and purging (as shall bee needfull) some of the forenamed Cordials are to be used.

You can't help wondering how much the manufacturers of the Pilles of Rufus had paid the printer.

The Orders also included a kind of plague recipe book, instructing you how to brew up rosemary, juniper, figs, sorrel,

cinnamon and saffron to make a variety of remedies. One of the most surprising antidotes advocated – though not in the Orders – was a noxious new herb from Virginia recently popularized by Sir Walter Raleigh. Hazel Forsyth says:

> Tobacconists made an absolute killing at the time. This was the period when tobacco really begins to become extremely popular. Realizing that people could create a sort of haze of smoke around them, the tobacconists profited by suggesting that people might have perfumed tobacco which they could buy expressly to protect them against plague. There were also extraordinary recipes for plague protection in the form of treacle and gunpowder, which was supposed to provoke a sweat.

One remedy that was not available was to cheer yourself up by going to the theatre. Playhouses were closed during plague outbreaks because controlling the assembly of crowds was one of the few effective ways of keeping the death toll down.

> 8 August 1603: ... And we do charge and enjoin to all Citizens and inhabitants of our City of London, that none of them shall repair to any Fairs held within any part of this Realm, until it shall please God to cease the Infection now reigning amongst them.

By late summer, it was not just the King and his young family who were moving progressively further from the capital. The London acting companies also headed for the provinces, the plague effectively forcing Shakespeare's company to develop what we might now call a national outreach strategy. Unable to play in London, they visited Richmond, Bath, Coventry and Shrewsbury, where they would have performed well-tried favourites such as *Romeo and Juliet*. It is worth wondering how those audiences in that 'wonderful' year of 1603 reacted to Mercutio's dying curse: 'A plague a both your houses'.

Around one in five of London's inhabitants died in 1603, at least 25,000 people. It was the worst single outbreak of plague that England suffered for sixty years. Although the epidemic waned in 1604, restrictions on the theatres remained sporadically in place until 1610 – between July 1606 and the beginning of 1610, for example, there was only one brief reopening in the spring of 1608. For much of this time – the period of *Othello*, *King Lear*, *Antony and Cleopatra*, *Coriolanus* and *Cymbeline* – Shakespeare probably retired to Stratford. He had previously been writing two new plays a year, but now his creative output slowed; perhaps there was no point in producing new works when the theatres could not put them on. Profits – and Shakespeare's income – must have been badly hit by this freezing of the theatres, in spite of the occasional royal payments to compensate the playing companies for their losses. As a leading member of a company, however, Shakespeare would have been far less vulnerable than the independent playwrights dependent on piecework. (Dekker's account of 1603, *The Wonderfull Yeare*, was written in part to make up for earnings he would normally have hoped for as a playwright.) Shakespeare was, of course, lucky to have survived the plague, but he was also lucky to have made his name and his fortune as a playwright in the 1590s – a window of booming activity in London's theatre-land when the audiences of the still-bustling playhouses craved new work.

As the year 1603 closed, life began to return to normal, and the Court organized its traditional Christmas festivities. The King's Men performed at Hampton Court for a fee of £103 and were given an extra £30 in compensation for loss of income due to the plague. Dekker, appropriately given his circumstances, likened the plague to a figure in the theatre: 'Death ... (like stalking Tamberlaine) hath pitcht his tents ... in the sinfully-polluted Suburbes: the Plague is Muster-maister and Marshall of the field.' One of those sinfully polluted

suburbs was Southwark. On 9 April 1604, the Globe and the other public theatres there reopened, for the time being. Actors and audiences must have noticed that quite a few of the old regulars, especially among the groundlings, were no longer there.

It was the last restriction on public gatherings to be lifted. Three weeks before, James had finally made his triumphal procession through the streets of London. We will be looking at this supremely theatrical spectacle, unforgettable to everyone who saw it, in the next chapter.

Chapter Eighteen

London Becomes Rome

London's triumphal arches

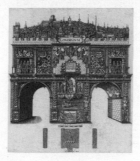

Julius Caesar, as we all learned at school, was one of Rome's greatest generals, and a ruler murdered by his friends. Few of us consider him one of London's earliest architects. But for Shakespeare's audience, that is what he was – and the London they were living in thought of itself, physically and intellectually, as the living heir of ancient Rome.

The Tower of London is to us one of the great monuments of medieval England, perhaps the defining symbol of the Norman Conquest. In Shakespeare's day, people believed the Tower was built not by William, but by a different, even more celebrated conqueror:

> PRINCE EDWARD: I do not like the Tower, of any place.
> Did Julius Caesar build that place, my lord?
> BUCKINGHAM: He did, my gracious lord, begin that place,
> Which, since, succeeding ages have re-edified.
> PRINCE EDWARD: Is it upon record, or else reported
> Successively from age to age, he built it?

BUCKINGHAM: Upon record, my gracious lord.

PRINCE EDWARD: But say, my lord, it were not registered,
 Methinks the truth should live from age to age,
 As 'twere retailed to all posterity,
 Even to the general all-ending day.

RICHARD [*Aside*]: So wise so young, they say, do never live long.

It is not just the young princes in the Tower who knew that this was a Roman building. The Queen in Shakespeare's *Richard II* also shudders at the 'flint bosom' of what she calls 'Julius Caesar's ill-erected tower'.

Prison or palace, Roman or not Roman, the Tower has always been a dominant presence in the city. This was where kings, the day before their coronation, set out on a triumphal procession through London to show themselves to the citizens, who would flock to welcome them. This ritual of the royal entry was modelled on an ancient Roman tradition – so where better for a king to begin his triumph than from what everybody knew was Julius Caesar's tower?

On 15 March 1604 it was James I's turn to make his ceremonial entry into his new capital. He had been crowned almost a year earlier, but, as we saw in the previous chapter, the pre-coronation procession had been cancelled because of the great plague of 1603. Now that the disease had abated and the city was safe for crowds to gather, some 250 joiners and carpenters, painters and carvers, dressmakers, actors and musicians set to work.

They made seven triumphal arches, cobbled together out of wood and plaster, coloured and gilded, decorated with statues and paintings, the largest of them ninety feet high and seventy feet across, which spanned the City streets at various points along James's processional route from the Tower to the Strand. At each stage, the King would stop to admire the arch itself, and there would be a performance, combining music, dancing,

pageants and songs – the words mostly written by the play-wrights Thomas Dekker and Ben Jonson. It was just the sort of citywide street party imagined in *Henry V*:

CHORUS: But now behold,
In the quick forge and working-house of thought,
How London doth pour out her citizens:
The Mayor and all his brethren in best sort,
Like to the senators of th'antique Rome,
With the plebeians swarming at their heels,
Go forth and fetch their conquering Caesar in.

For the whole of that day, 15 March 1604, real-life London fantasized that it was ancient Rome, and James its 'conquering Caesar' guaranteeing peace and prosperity.

The seven arches were demolished and recycled immediately after the procession, but we know what they looked like because the designs were published as a set of splendid engravings in a souvenir guide (available for purchase at the print-sellers 'at the White Horse' in Pope's Head Alley). Thomas Dekker, dismissed as a cheap hack by his co-writer and rival Ben Jonson, but always quick to spot a publishing opportunity, rushed out a written account, which was sold in pamphlet form and which has left us with a detailed description of the day.

The first arch, which stood at Fenchurch Street, set the tone. The print shows a roughly classical, more or less Roman arch, with on top of it a huge model of the City of London. Old St Paul's is surrounded by gothic spires, but the whole confection is proudly, classically labelled LONDINIVM. Modern London is once again a Roman city, and the city on the Thames is the equal of her sister on the Tiber. Pretentious? Of course. Ambitious? Certainly. But it was central to how London wanted to see itself.

Like all the arches, this first one is full of classical symbols and Latin mottoes. As James approached, various actors appeared – some on the arch itself – to address the King, including a deified embodiment of the Thames, who to modern eyes seems a bizarre confluence of classical paganism with Protestant London's totemic river. Renaissance scholar Professor Elizabeth McGrath describes the scene:

> There are various figures on it, allegorical figures, personifications of virtues; in fact they were people dressed up to be these figures. The River God Thames raises himself up – ancient river gods generally lie down; they are also naked, but in fact we know that the boy who represented the river was dressed in a skin-tight leather suit to simulate nudity, painted blue because he should be blue for water (although of course the Thames then, even more than now, was never blue).

Next up was 'the Genius of the City', played by Edward Alleyn, the greatest actor of the age and leader of the Prince's Men. His address, Dekker tells us, was 'delivered with excellent Action and a well tun'de audible voice'. With stars like Alleyn taking part, the whole spectacle must have been like a Jacobean street-theatre version of a Royal Variety Performance – and, as always, the most important person present did not stay long enough. Dekker tells us that the crowd was disappointed that King James moved on so quickly, as they had been 'glewed there together so many houres to behold him'. But a few hundred yards further, at Gracechurch Street – or as it was then called, 'Gracious Street' – a second arch was waiting for him: the arch of the Italians.

Needless to say, the classical theme continues at 'this great Italian Theater'. At its base, the Roman sea gods Neptune and Amphitrite frolic in the waves just off the coast of Kent. There are Latin inscriptions, allegorical figures and, in the centre, a

painting of James arriving on horseback like a Roman emperor. The Italian merchants who had paid for the arch were seated in galleries and greeted the King with more speeches, this time in Latin. Such orations were not as daunting as they would be to us, and the spectators might well have understood quite a lot. Jonathan Bate explains:

> The study of the classics, and in particular of ancient Rome, was the absolute centre of education at this time. They did not study English history, they studied classical history. They read works like Livy's *History of Ancient Rome*, Plutarch's *Lives of the Noble Grecians and Romans*. Also crucial was the study of the great political texts, particularly Cicero – they did not study Chaucer, or texts in the English language, they studied Latin literature: Virgil, Ovid, Horace. We can see from Shakespeare's works that he knew those poets very well.

And Shakespeare's characters let us know that they too have studied Horace, Virgil and Ovid. In *Titus Andronicus* young Lucius appears with a book tucked under his arm and diligently announces:

> YOUNG LUCIUS: Grandsire, 'tis Ovid's *Metamorphoses*;
> My mother gave it me.

It was not just boys who studied the writers of ancient Rome: many girls were taught classical languages too. In *The Taming of the Shrew*, Bianca is booked in for her weekly Latin lesson. Who could be duller and less threatening than a Latin tutor? So her father can leave her safely alone with him. But translating the classical texts – when your Latin teacher turns out to be your suitor in disguise – can be a lot of fun:

> BIANCA: Where left we last?
> LUCENTIO: Here, madam.
> [*He reads*]

> '*Hic ibat Simois, hic est Sigeia tellus,*
> *Hic steterat Priami regia celsa senis.*'

BIANCA: Construe them.

LUCENTIO: '*Hic ibat*', as I told you before – '*Simois*', I am
 Lucentio – '*hic est*', son unto Vincentio of Pisa – '*Sigeia*
 tellus', disguised thus to get your love – '*Hic steterat*', and
 that Lucentio that comes a-wooing – '*Priami*', is my man
 Tranio – '*regia*', bearing my port – '*celsa senis*', that we
 might beguile the old pantaloon.

An audience that could laugh at teenagers flirting in Latin
would have been quite capable of reading a few short phrases
on a triumphal arch and understanding at least the gist of a
Latin speech.

The rest of James's progress was a kind of world tour. The
Italian arch was followed by the arch of the Dutch and Bel-
gian merchants. Then a lively Danish march played in honour
of James's wife, Anne of Denmark, accompanied the royal
couple to Cheapside, where a fourth arch stood, near a foun-
tain running with wine. This arch was entitled the New Arabia.
Somewhat surprisingly, Britannia was the theme here – but a
Britain of a very exotic kind. Topped by a minaret and flanked
by oriental towers, the arch presents to the viewer Arabia Bri-
tannica, a happy land made fertile by the presence of its new
king, and inhabited by figures representing Fame, Brightness,
Youthfulness and Cheerfulness, all intent on telling the King
how thrilled his subjects are to be his subjects.

It was pure theatre: classical arches as a seamless backdrop
to classical pageantry. It is no surprise that at this point a fig-
ure stepped forward to announce James's own descent not
just from a mere Tudor king of England, Henry VII, but from
a prince of ancient Troy, Brutus, who after sailing round the
Mediterranean had, it seems, eventually landed at Totnes a
couple of thousand years before:

> Great monarch of the West, whose glorious stem
> Doth now support a triple Diadem
> Weighing more than that of thy grand Grandsire Brute.

James would have loved this. Even today, if you visit Holyrood Palace in Edinburgh, a line of portraits depicts the ancestors of our present queen. The first of them is Brutus of Troy.

After this confirmation of James's prodigious ancestry, the royal party processed on to the Garden of Plenty, arch number five, in Cheapside. The sixth arch, in Fleet Street, was the enormous New World, ninety feet high and fifty feet wide, whose centrepiece was a moving globe with personifications of the Four Cardinal Virtues and James's four kingdoms (England, Scotland, France and Ireland), with Envy standing by, powerless and miserable.

The procession finished in a total fusion of London and ancient Rome. Temple Bar had been transformed into the Temple of Janus, Roman god of beginnings and endings, and inhabited by yet another impressive troupe of nymphs – Peace and Liberty, Safety and Felicity – together with that most important of all Jacobean virtues, Wealth. Here, the Genius of the City stepped forward again to acknowledge the perhaps rather embarrassing scheduling of the procession for one of the most inauspicious days in the Roman calendar, the Ides of March, on which, famously, Julius Caesar had been assassinated. As James was about to pass from the City into the Strand, the Genius spoke lines by the classically educated Ben Jonson:

> Begin our Spring, and with our Spring the Prime,
> And first accompt of Years, of Months, of Time.
> And may these *Ides* as fortunate appear
> To thee, as they to *Cæsar* fatal were.
> Be all thy Thoughts born perfect, and thy Hopes

In their events still crown'd beyond their Scopes.
Let not wide Heav'n that secret Blessing know
To give, which she on thee will not bestow.

The whole day was a riot of pyramids and columns, divinities and personifications, music, songs, tableaux and endless Latin orations. Some of these, as Dekker notes, were left unspoken or cut short – 'a regard being had that his Majestie should not be wearied with teadious speeches'. It was all created with a royal audience of one in mind, and only the King, with his accompanying family and Court, would have been able to make much sense of it all (provided he could keep his concentration up). The watching crowds, however much they might have tried to follow the procession round, would have had only a pretty hazy idea of what was going on. In truth, many of them must have been there principally to see the King and his entourage, eat the free food and drink the free wine, rather than to follow the pageants and listen to the speeches. The gold and glitter of the royal costumes were surely at least as much the attraction as the choirboys from St Paul's kitted out as Ceres and Pomona.

We do not know what role Shakespeare and the King's Men played in the day. They must have done something, but Dekker mentions only the Prince's Men, for whom he often worked – Edward Alleyn, their leader, was a good friend who had helped extract him from the debtors' prison. When the day was over, the whole show was dismantled as quickly as it went up. Like Prospero's towers and palaces, the structures simply disappeared. But in their ornate, ephemeral glory, the arches were making an explicit point: London was not just the inheritor of Rome, James I was the bestower of a new classical order and authority. An illusion of timeless legitimacy was conjured through the fleeting medium of street theatre.

*

This transformation of modern life into ancient Rome worked both ways. If Fleet Street could become the Forum for a day, then the Forum could now and then be Whitehall. In all the Roman plays – *Julius Caesar*, *Coriolanus*, *Antony and Cleopatra* – ancient Roman history stands in for English domestic politics – as everyone in the audience could have seen. Jonathan Bate again:

> Towards the end of Queen Elizabeth's life, people began to look at the example of ancient Rome and to get very worried that if there is uncertainty over your succession or system of government, there might be civil war. *Julius Caesar*, which Shakespeare wrote in 1599, is a play that addresses exactly this sort of question. What sort of state are you going to have? Are you going to have a monarch or an emperor or a more republican system? When King James came to the throne in 1603 he began to project an image of himself as being like the ancient Roman Emperor Augustus, who after a long period of civil war brought Rome to unity. James sees himself bringing peace, bringing greatness to the nation, and that is why, in establishing this new image of the king in London, he makes sure that, when he arrives in London and when his coronation is celebrated, the Roman imperial idea is invoked through the triumphal arches.

Like James's procession, Shakespeare's Roman plays are an intoxicating mixture of ancient and modern, Roman and British. And so in its way was the Globe Theatre itself. The very idea of a theatre is a classical one, and the shape of the new London theatres was derived from surviving Roman models in France and Italy. Shakespeare's Roman plays were performed in front of what was in effect a permanent temporary triumphal arch, on which people appeared and made speeches – the Globe's own stage. In the reconstructed modern

Globe you can still admire the painted columns and classical details very much as they would have been on James's triumphal arches. And just as the arches embraced the whole world – Britain, Arabia, the Americas – so the theatre too aimed to hold the entire globe in one – ultimately classical – embrace.

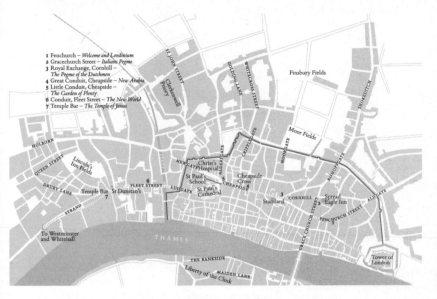

1 Fenchurch – *Welcome and Londinium*
2 Gracechurch Street – *Italians Pegme*
3 Royal Exchange, Cornhill –
 The Pegme of the Dutchmen
4 Great Conduit, Cheapside – *New Arabia*
5 Little Conduit, Cheapside –
 The Garden of Plenty
6 Conduit, Fleet Street – *The New World*
7 Temple Bar – *The Temple of Janus*

The route of James I's royal entry, 1604.

Chapter Nineteen

The Theatres of Cruelty

Eye relic of the Blessed Edward Oldcorne

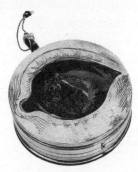

Enter King Henry VI with a supplication, and the Queen with
Suffolk's head.
Re-enter one with the heads.
Enter Iden, with Cade's head.
Throwing down Somerset's head.
Enter Lovel and Ratcliff, with Hastings' head.
Enter the Bastard, with Austria's head.
Re-enter MacDuff, with Macbeth's head.
Re-enter Guiderius, with Cloten's head.

The most gruesome lines of Shakespeare's plays are often not in the text itself, but in the stage directions. Time after time, especially in the history plays, the heads of major characters reappear on stage without their bodies attached. The price of political failure – or in some cases simply of weakness – has been an excruciating death. This is in a very real sense the theatre of public cruelty, and it is controlled by instructions

that are occasionally spine-chilling: '*Enter Lavinia, ravished, her hands cut off and her tongue cut out*', and sometimes comically gruesome: '*Enter Messenger with two heads and a hand*' – both from *Titus Andronicus*.

By modern standards, this sort of material is what we would call strictly post-watershed, and definitely not family entertainment. But around 1600 in London's theatres, mutilation, dismemberment and execution were matinée fare. In Shakespeare's world, human butchery was a part of life. Strolling across London Bridge to see a play at the Globe or the Rose, you would sometimes pass rows of traitors' heads impaled on spikes. The execution of criminals was, if not exactly public entertainment, certainly popular public spectacle. You might well go to Tyburn in the morning to witness a public hanging and then move on to the theatre after lunch to watch Macbeth lose his head or the Earl of Gloucester both his eyes. Making the suffering of criminals and traitors public was a key part of the judicial system, and, like the theatre, executions drew a large and socially very diverse audience.

Amongst the collection of historical artefacts and records held by Stonyhurst College, the Jesuit school in Lancashire, there sits a small, circular box, inscribed with four short lines of Latin. As you turn it over in your hand, you can see a little window in the shape of an eye, and on the silver mount around it are engraved some short, curled lashes and a few wrinkles. Peering through the glass reveals a small, brownish lump, a bit like a shrivelled prune. It is a human eye, and, as the Latin inscription explains, it is the right eye, the *oculus dexter*, of the Jesuit Edward Oldcorne. This silver box is the reliquary of an English Catholic martyr.

Jan Graffius, curator of the Stonyhurst collection, explains the background:

Edward Oldcorne was a missionary priest in the late sixteenth and early seventeenth centuries. He was quietly successful, spending about seventeen years hiding and working in amongst the Catholics of Worcestershire. He was a very gentle person but had the great misfortune to be caught up in the aftermath of the Gunpowder Plot – despite having nothing to do with it at all. Because of the safety of the house where he was living, other Jesuits who were being hotly pursued came to him for sanctuary, and they were all caught at the same time. And although Father Oldcorne had absolutely no knowledge or complicity in the plot, as a Catholic priest and a Jesuit, which was illegal in itself, he was tortured and then hanged, drawn and quartered.

The Gunpowder Plot of 1605, when Guy Fawkes very nearly blew up James I inside the Houses of Parliament, shook public opinion in much the same way as the destruction of the Twin Towers did the modern world. The plot was immediately seen as a traitorous Catholic conspiracy in which the Jesuits, the Pope and the King of Spain were all implicated. Jesuits and clandestine Catholic priests were hunted down and sentenced to brutal exemplary punishment. Among them was Edward Oldcorne, executed near Worcester on 7 April 1606. Traitors like him were hanged, cut down while still alive – sometimes still conscious – and disembowelled; then their bodies were quartered, literally hacked into separate pieces. The flavour of such occasions is captured in a description of the execution in 1586 of John Ballard, another alleged priestly plotter:

> Ballard the priest, who was the first broacher of this treason, as the first that was hanged, who being cut down (according to judgement) was dismembered, his belly ripped up, his bowels and traitorous heart taken out and thrown into the fire, his head also (severed from his shoulders) was set upon a short

stake upon the top of the gallows, and the trunk of his body quartered and imbrued in his own blood, wherewith the executioner's hands were bathed, and some of the standers by (but to their great loathing, as not to be able for their lives to avoid it, such was the throng) besprinkled . . . Now when these venomous vipers were thus hewn in pieces, their tigers hearts burned in the fire and the sentence of law satisfied: their heads and quarters were conveyed away in baskets, to be fixed upon poles and set over the gates of London, that all the world might behold the just reward of traitors.

These violent executions were meant to deter potential traitors, but inevitably they also inspired fellow Catholics. Somehow, after Oldcorne's execution, a sympathizer must have been able to secure his eye as a relic. To the authorities Oldcorne was a traitor: to fellow Catholics he was a martyr, whose remains must be gathered and honoured. By the time of the Gunpowder Plot, the authorities were actively taking steps to prevent Catholics from picking up clothes or body parts that would commemorate the execution of priests. Their bodies were destroyed. Jan Graffius explains what such a relic would mean to the faithful:

> It would be testament to the bravery of those priests who were working in England undercover, a powerful inspiration: Jesuit priests who served in England and came back to Europe without having been caught often described themselves as too unworthy to share the crown of martyrdom. So while it was not something they sought, martyrdom was considered a huge honour.

Stonyhurst College has other relics relating to the English martyrs of the seventeenth century. There is, for instance, a late sixteenth-century beaded box, the outer decoration of which gives no clue as to what is inside. It contains, as Jan Graffius tells us:

a human shoulder bone; you can see where the knife has sliced through it, a very sharp knife. This is from the quartering. The brownish material clinging to the bone is human flesh, the skin and muscle of one of four young men who trained for the priesthood in France, landed in Durham and were unlucky. They were not disguised and were very inexperienced and within a matter of weeks they were arrested and executed. Then somebody was brave enough either to bribe the executioners for a part or to notice where the bodies were buried, often in dung heaps, and dig a piece up.

Despite the best efforts of the authorities, relics were acquired, preserved and treasured. The theatre of horror was now and then subverted by the very people who were supposed to be intimidated by it.

*

Public executions were, in a very real sense, performances. The executioner's scaffold built for the likes of Edward Oldcorne and the Gunpowder Plotters was a kind of stage – little different in construction and purpose from a theatre stage. The crowds forming the audience expected the condemned to make a speech before dying; and they usually did, mostly admitting their guilt, asserting their loyalty and asking for forgiveness.

The very word scaffold had a double meaning. In *Henry V* the theatre stage is memorably described by the Chorus as an 'unworthy scaffold to bring forth / so great an object'. But in *Richard III* it is more expectedly the place of public execution, 'where men march up to some scaffold, there to lose their heads'. Bloody spectacles could be witnessed on both. In George Peele's play *The Battle of Alcazar* (which appeared around 1590, just as Shakespeare was beginning to write) three men are disembowelled, and the staging required for each one of them three separate vials of blood and a set of sheep's entrails.

Such executions and torture were part of the fabric of public life; in Shakespeare's plays, torture and torturers are mentioned no fewer than forty-five times. In *The Winter's Tale*, Paulina reproaches the paranoid king Leontes:

> PAULINA: What studied torments, tyrant, hast for me?
> What wheels? Racks? Fires? What flaying? Boiling
> In leads or oils? What old or newer torture
> Must I receive, whose every word deserves
> To taste of thy most worst?

State violence did not just share the stage of public life with London's theatres; occasionally the two collided. The playwright Thomas Kyd, author of the revolutionary *Spanish Tragedy*, was tortured for information about Christopher Marlowe's alleged treasons, and the mystery surrounding Marlowe's death in 1593 – officially in a drunken brawl, but ten days after being questioned for blasphemy – has lingered to this day.

Tom Piper is a set designer with the Royal Shakespeare Company, and he explains the practical difficulties of staging Shakespeare's theatre of cruelty – the beheadings, eye-squelchings and other gory scenes:

> There's a gruesome bit at the end of *Richard II* when all the heads of all the people who've fought against [Bolingbroke, the future] Henry IV are brought in one after another, and so about eight of them in sacks are dropped on the stage and they have to not bounce – it is obviously a comedy moment when one of your heads bounces across the stage – so quite often they are weighed down with a lot of buckshot. Another problem is blood. First of all there is what we call our sticky blood, which, acoustically, is just like strawberry jam: it is sort of sticky and stretchy, and you can use it for congealing wounds. Actors love it, they just get completely carried away. There is another

sort of blood, which is kept in a blood bag. It is runnier, because it has to seep through a costume and spread quite quickly. Eyes are also a particular problem. For eyes, we basically use lychees, which you can fill with blood. They are the right size, they are white and they are cheap, and they come in tins, so you can bring them with you wherever you're going around the world.

Today these bloody bits of stage business can often seem contrived, artificial or half-hearted, but in Shakespeare's time, they were disconcertingly close to the real brutality that the audience might witness for themselves in public executions.

Contemplating the removal of Edward Oldcorne's eye, it is hard not to think of what is probably the most unsettling stage violence in the whole of Shakespeare: the blinding of Gloucester in *King Lear*, written around the time that Oldcorne suffered his fate.

CORNWALL: Fellows, hold the chair.
 Upon these eyes of thine I'll set my foot.
GLOUCESTER: He that will think to live till he be old
 Give me some help! – O, cruel! O, you gods!
REGAN: One side will mock another. Th'other too!
CORNWALL: If you see Vengeance –
FIRST SERVANT: Hold your hand, my lord!
 I have served you ever since I was a child;
 But better service have I never done you
 Than now to bid you hold.
REGAN: How now, you dog!
FIRST SERVANT: If you did wear a beard upon your chin
 I'd shake it on this quarrel.
 [*Cornwall draws his sword*]
 What do you mean?
CORNWALL: My villain!
 [*He lunges at him*]

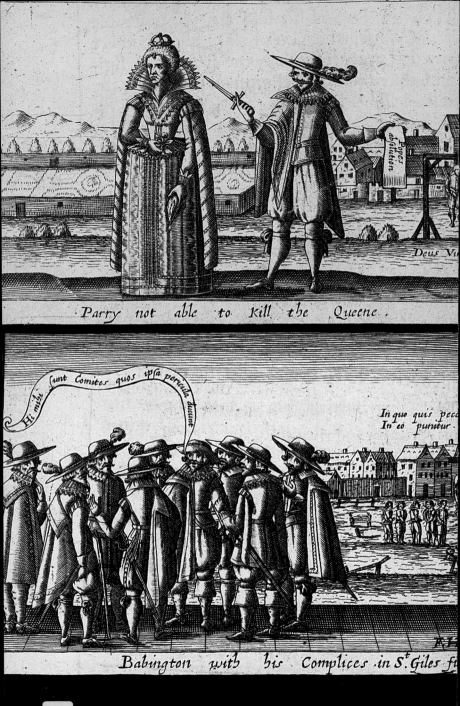

Parry not able to Kill the Queene.

Babington with his Complices in S.t Giles fi

II

1600

ABDVLGVAHID .

ÆTATIS:42 .

LEGATVS REGIS BARBA
IN ANGLIAM .

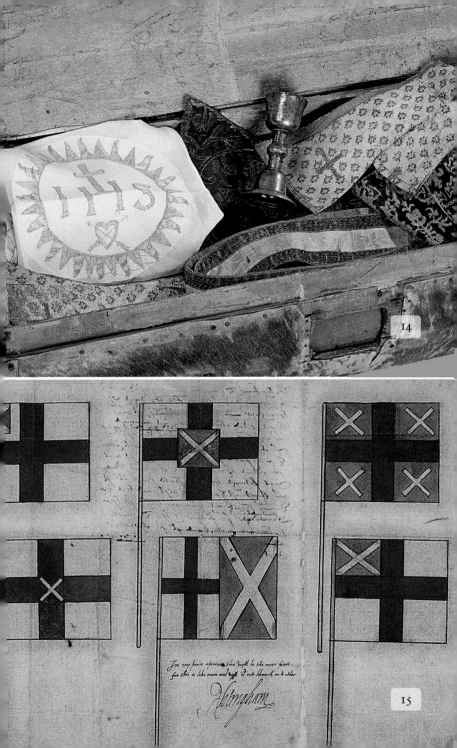

14

15

❧ By the King.

THe Solemnities of our Coronation being now performed according to the vsages and customes of this our Realme of England, and with mutuall contentment, aswell of vs in the zeale and loue of our people at the performance thereof expressed, as of them in the expectation of our gouernment; We haue entred into consideration of the state of the seuerall parts of the body of our Realme, And therein do finde, that the absence of the Noblemen and Gentlemen which are vsed to reside there in seuerall quarters, is accompanied with great inconuenience, aswell in the want of reliefe which the poorer sort did receiue by their ordinary Hospitalitie, as also chiefly in the defect of Gouernment, whereby besides other inconueniences, through lacke of order, the infection of the Plague spreadeth and scattereth it selfe into diuers places of the Realme, and is like further to increase, if by the presence and care of such as are in authoritie and credit amongst our people, they be not contained in some good course, for the preuenting of that contagion.

Wherefore hauing taken order for the returning home into their Countreys of diuers of the Nobilitie of our Nation of Scotland, and others also, who to do vs honour at our Coronation, haue attended here since the entring of vs and the Queene our deare wife into this Kingdome: We haue thought good also to publish to all other good Subiects of this Realme, that our Pleasure is, and we command that all such as are not our Seruants in Ordinary, or be not bound to attendance about our Court by expresse commandement of vs, or our Councell, shall immediatly depart home into their Countreys; Specially all Deputy Lieutenants, and all such as are in Commission of the Peace, there to attend their seuerall charges, & chiefly to preuent by all good meanes the spreading of this Contagion of the Plague. For seeing now there is no necessary cause why any man should abide either about our Citie of London, or about our Court, who is not our ordinary Seruant, we shal haue iust cause to be offended with such, as shall contrary to this our Pleasure, voluntarily absent themselues from the places where their dueties doe require they should abide.

And whereas We are giuen to vnderstand, That notwithstanding our former Proclamation, there doe continu-

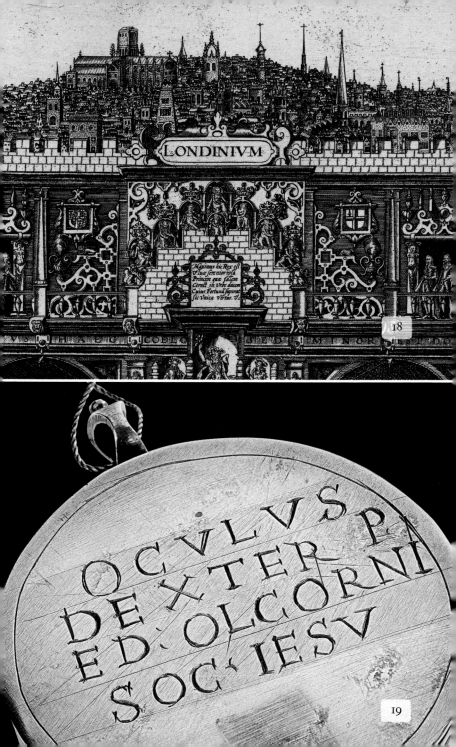

LONDINIVM

Maximus hic Rex est
Vivæ serenior ipsa
Princeps quæ talem
Cernit in Urbe ducem
Cuius Fortuna superat
sic Unica Virtus. V:

18

OCVLVS P.
DEXTER
ED·OLCORNI
SOC·IESV

19

Fierce fiery warriors fight upon the clou(
In ranks and squadrons and right form
 war,
Which drizzled blood upon the Capitol ;
The noise of battle hurtled in the air ;
Horses did neigh, and dying men did groa
And ghosts did shriek and squeal about t
 streets.
O Cæsar, these things are beyond all use,
And I do fear them !
 Cæs. What can be avoid(
Whose end is purpos'd by the mighty god
Yet Cæsar shall go forth ; for th(
 predictions
Are to the world in general as to Cæsar.
 Cal. When beggars die there are
 comets seen :
The heavens themselves blaze forth t
 death of princes.
 Cæs. Cowards die many times bef(
 their deaths :
The valiant never taste of death but on
Of all the wonders that I yet have heard
It seems to me most strange that m
 should fear,
Seeing that death, a necessary end,
Will come when it will come.

FIRST SERVANT: [*drawing his sword*] Nay then, come on, and
take the chance of anger.
[*He wounds Cornwall*]
REGAN: Give me thy sword. A peasant stand up thus!
[*She takes a sword and runs at him behind.*]
FIRST SERVANT: O, I am slain! My lord, you have one eye left
To see some mischief on him. O! [*He dies.*]
CORNWALL: Lest it see more, prevent it. Out, vile jelly!
Where is thy lustre now?

The squelching of Gloucester's eye is always a terrifying
moment in the theatre. We wait for it; we turn away. We
simply cannot look.

But were Shakespeare's audiences shockable in this way? It
seems unlikely: the blood-soaked plays were very popular,
and real-life executions attracted thronging crowds jockey-
ing for the best views. The executioners, many of whom
normally worked as butchers, regularly handled bits of bodies
in front of the crowd, as part of the performance. Standing as
a groundling at the foot of the stage must have been very like
jostling among the crowd pressed around the foot of the scaf-
fold. Holinshed's chronicle describes how:

There is no question whether there wanted people at this pub-
lic spectacle . . . For there was no lane, street, alley or house in
London, in the suburbs of the same, or in the hamlets or bor-
dering towns near the city . . . out of which there issued not
some of each age and sex; so much so that the ways were pes-
tered with people so multiplied, and they thronged and
overran one another for haste, contending to the place of
death for the advantage of the ground where to stand, see, and
hear what was said and done.

Contemplating the small silver box, I find I am haunted by
the thought of the last thing that Edward Oldcorne saw with

this right eye. He had been hanged and cut down while still alive, so his last sight was almost certainly of a crowd of men and women, pushing and shoving, trying to get a better view. And then, finally, the hangman approaching with his knife to disembowel him.

Chapter Twenty

Shakespeare Goes Global

The plays in print

On 22 July 1942, the German SS announced that all the Jews in Warsaw would, in the euphemism of the day, be 'resettled' to the camp at Treblinka. It was effectively a death sentence. There were, however, six groups of people who were to be exempted from the resettlement. The twenty-two-year-old Marcel Reich-Ranicki was one of those exemptions. Now over ninety years old and Germany's leading literary critic, he told his story to the German parliament in January 2012:

> These included all able-bodied Jews of working age, all persons employed by German public authorities or in German production facilities or those who were on the staff of the Judenrat and the Jewish hospitals. One sentence suddenly set me thinking: the wives and children of the people in these categories were not to be resettled either.

A German-Polish Jew, he was working for the Judenrat, the Council of Jews set up by the Nazis. He had no wife or children,

but he was engaged, and he realized that, if he acted straight-away, he could prevent his fiancée from being 'resettled'. He must marry her at once:

> Immediately after dictating the order I sent a messenger to Teofila, asking her to come right away and to bring her birth certificate. She came immediately and was quite agitated because the panic in the streets was contagious. I quickly went with her to the ground floor, where a theologian worked in the historical records department of the Judenrat. I had already discussed the matter with him. When I told Teofila we would be married she was only mildly surprised and nodded in agree-ment. A theologian was authorized to perform the duties of a rabbi and raised no objections. Two officials who were working in the next room served as witnesses. The ceremony did not last long. I cannot recall whether in all the rush and excitement I actually kissed Teofila, I don't know. But I well remember the feeling that engulfed us, a feeling of fear, fear of what would happen in the coming days. And I still remember the Shake-spearean line that occurred to me at the time: 'Ward je in dieser Laun' ein Weib gefreit?'

'Ward je in dieser Laun' ein Weib gefreit?': 'Was ever woman in this humour wooed?' It is a quotation from the celebrated German translation of Shakespeare's *Richard III* and it is an astonishing thing for a young German Pole to think of at such a moment. At the point of supreme agitation, the words that came to Marcel Reich-Ranicki were Shakespeare's.

In this book we have been looking at how Shakespeare's plays were crafted to speak to a particular audience and the uncertain, restless world which that audience inhabited. We have focused on what Shakespeare's words meant to a public that was not listening to the world's most famous playwright, but hearing for the first time the latest play by a successful writer for the com-mercial London stage. In this last chapter, we shall look instead

at the many things that Shakespeare's plays have come to mean to the whole world. For hundreds of years now, people like Marcel Reich-Ranicki have found in Shakespeare the words to express their own deepest feelings. How has this supremely public writer become the private companion of so many, his words the stuff that their hopes, fears and dreams are made on? How did this very English playwright go global?

The simple answer lies in the form of a book: *Mr. William Shakespeares Comedies, Histories, & Tragedies* – often referred to simply as the 'First Folio'. It is a big book, about the size of a packet of cornflakes, and its 900 or so pages contain thirty-six plays. The First Folio was advertised for the Frankfurt Book Fair of 1622, six years after Shakespeare had died, but, as often happens, the publishers ran a little late, and it appeared only in 1623. At the time, it was rare for plays in English by a single author to be gathered and published like this, a tribute usually reserved for the great writers in Latin. If it had been up to Shakespeare himself, it is likely that the book would not exist – for whatever reason, he seems to have had little or no interest in getting his plays published (unlike his friend Ben Jonson, who carefully produced his own *Collected Workes* and was in some quarters roundly mocked for doing so). It was not, however, left up to Shakespeare. The two men who began the Shakespeare industry were his long-time colleagues John Heminges and Henry Condell, fellow members of the King's Men. Thanks to their energy and inspiration we have the First Folio, a volume of Shakespeare's collected plays pulled together from the King's Men's archives and other varied sources. They describe their motivation in the dedication: 'onely to keepe the memory of so worthy a Friend, & Fellow alive'.

Looking at the title page and contents gives us a sense of what we owe to Heminges and Condell. Thirty-six plays are listed, with only *Pericles* and *The Two Noble Kinsmen* omitted. The Folio is the only good source we have for about twenty of

the plays. Without it, we would not have *Twelfth Night* or *As You Like It*, *The Tempest* or *The Winter's Tale*, *Julius Caesar* or *Antony and Cleopatra*, *Coriolanus* or *Macbeth* – and so most of Shakespeare's great female roles would be unknown to us. In an alternative universe without the First Folio, Shakespeare would be known principally as a writer of history plays, with a tranche of early comedies and an impressive but smaller run of great tragedies – *Romeo and Juliet*, *Hamlet*, *King Lear*, *Othello* – and there would be relatively little 'Jacobean' Shakespeare for us to read. Would this alternative Shakespeare hold the dominant position he holds for us today? Or would he merely be part of an Elizabethan triumvirate, his much smaller *Collected Works* sitting between those of Marlowe and Jonson?

The book contains the early apparatus for building the cult of the celebrity writer: the famous woodcut portrait of Shakespeare, the dedication and letter to the reader and the celebratory poems lauding his genius: Shakespeare as 'happy imitator of Nature', the 'Soul of the Age', 'Fresh to all Ages': these are all phrases coined by his contemporary admirers and included in the Folio. In their opening letter Heminges and Condell address the reader with a eulogy of Shakespeare:

> Who, as he was a happie imitator of Nature, was a most gentle expresser of it. His mind and hand went together: And what he thought, he uttered with that easinesse, that wee have scarse received from him a blot in his papers. But it is not our province, who onely gather his works, and give them you, to praise him. It is yours that reade him. And there we hope, to your divers capacities, you will finde enough, both to draw, and hold you : for his wit can no more lie hid, then it could be lost. Reade him, therefore; and againe, and againe.

With this book, people everywhere, people who had never seen Shakespeare played in the theatre, could make his works

part of their lives, as Heminges and Condell exhort. They could read him again and again. And, from the beginning, we know that they did.

The First Folio allowed Shakespeare to travel out of the theatre and into the world. One copy that has survived belonged to a William Johnstoune, who lived in Dumfriesshire in Scotland. Written in the margins are observations (presumably Johnstoune's own) on the text of the plays, and when we look at them we are peering over the shoulder of one of Shakespeare's earliest readers, alone in his study in Dumfriesshire in the 1620s, underlining phrases that interest him and commenting on them in the margin. Looking at these notes, we are watching Shakespeare become part of William Johnstoune's world. He marks Lady Macbeth's sleepwalking, 'The distracted queene goes writes & talkes sleeping', and he observes 'unnaturall deedes trouble the mind unnaturallie'. Reading *Richard II*, Johnstoune raises a very Scottish eyebrow at John of Gaunt's speech about 'this scepter'd isle . . . This precious stone set in a silver sea', and you can almost see his lips purse as he scribbles in the margin 'extreame high praise England'.

Sitting hundreds of miles from the jostling crowds of the Bankside theatres, shelling their oysters and flaunting their rapiers, Johnstoune is a founder member of a new kind of audience for Shakespeare: a worldwide public composed of anybody who can read the plays and make them their own. When Shakespeare was turned into a book, the man behind the Globe became a global figure.

And that means global in the most up-to-date sense: Johnstoune's copy of the First Folio is now in Meisei University in Tokyo, but I can read it in London on my smartphone. In fact anybody can read it pretty well anywhere. In *A Midsummer Night's Dream*, as we saw right at the beginning, Puck puts a girdle round the earth in forty minutes; but in the world of modern magic, online Shakespeare circles the globe instantly,

and on every circling the words mean something new. In 2012, the very new state of South Sudan found echoes of its post-conflict recovery in an officially sponsored production of *Cymbeline*, performed in Juba Arabic. A hundred years earlier, a New York film studio had reimagined *Romeo and Juliet* with a star-crossed Huron brave and a Mohican princess. It was love. It was doomed. It was America. It was a new medium. But Shakespeare, as always, was there.

Memorably he was there too on Robben Island, the infamous South African jail, where in the 1970s leaders of the African National Congress were imprisoned during the struggle against apartheid. Sonny Venkatrathnam was one of them:

> When I got to Robben Island we had no access to a library or any other reading material. I applied to buy some books and the reply came that I am allowed only one book. Eventually I decided the only book that would keep me going for some time would be *The Complete Works of Shakespeare* – well I knew they wouldn't allow me to have the *Das Kapital* or something.

In order to keep his mass-produced copy of Shakespeare with him in his cell, Sonny Venkatrathnam disguised it by sticking Hindu cards sent to him for Diwali over the covers. The Robben Island 'Bible', as it has become known, is now part of the legend of the battle against apartheid:

> About six months before my due release date, I circulated *The Complete Works of Shakespeare* and asked my comrades there to select a line or a passage that appealed to them and sign it. All of them chose lines or passages that inspired them and strengthened the resolve for the struggle.

On 16 December 1977, the disguised Robben Island Shakespeare reached Nelson Mandela. He signed his name beside this passage on courage and death from *Julius Caesar*:

CAESAR: Cowards die many times before their deaths:
 The valiant never taste of death but once.
 Of all the wonders that I yet have heard,
 It seems to me most strange that men should fear,
 Seeing that death, a necessary end,
 Will come when it will come.

The same passage had moved William Johnstoune in Scotland 350 years earlier: 'Death a necessarie end will come when it will come and is not to be forefeared.'

The prisoner Walter Sisulu, pondering racial injustice in South Africa, fascinatingly did not choose as his passage words spoken by Othello, the Moor of Venice, and victim of many racist slurs. He chose instead the Venetian Jew, Shylock:

SHYLOCK: You call me misbeliever, cut-throat dog,
 And spit upon my Jewish gaberdine,
 And all for use of that which is mine own.
 Well then, it now appears you need my help.
 Go to then. You come to me and you say
 'Shylock, we would have moneys' – you say so,
 You that did void your rheum upon my beard,
 And foot me as you spurn a stranger cur
 Over your threshold. Moneys is your suit.
 What should I say to you? Should I not say,
 'Hath a dog money? Is it possible
 A cur can lend three thousand ducats? Or
 Shall I bend low and in a bondman's key,
 With bated breath and whispering humbleness,
 Say this:
 'Fair sir, you spat on me on Wednesday last,
 You spurned me such a day, another time
 You called me dog . . .'

Imagining Sisulu reading these lines is to imagine Shakespeare conjuring the humiliations of apartheid South Africa. The Robben Island Bible resoundingly vindicates the great truth that everyone can see in Shakespeare the mirror of their own predicament.

In the First Folio, his contemporary Ben Jonson paradoxically described Shakespeare as the 'soul of the age', but also as 'not of an age, but for all time'. Jonathan Bate says:

> I think the key to Shakespeare's endurance, and the fact that in every culture and every age he seemed to speak to the present, comes from that paradox. On the one hand he was the 'soul of the age', all the great conflicts and innovations of the age, the sense of the discovery of new worlds, new ways of looking at the world, it all is there in Shakespeare. He was the soul of the age, but at the same time he never confined himself to the particularities of his historical moment, and that meant that, because he sort of plugged into the fundamental questions about human society and human life, he speaks to every age. Shakespeare is always our contemporary.

Shakespeare's plays were written for a new medium, the public theatre of Elizabethan London. In the 1920s, Shakespeare took to another new medium: radio, an 'airy nothing', where, as in a theatre like the Globe, with little scenery and few props, words alone have to spark the imagination. When the BBC's new building, Broadcasting House, opened in 1932, the architects, searching for an emblem to symbolize world broadcasting, turned of course to Shakespeare. And so over the door of BBC Broadcasting House are two sculptures by Eric Gill: a young naked boy stands on a globe protected by an older bearded man – Ariel, the invisible spirit of the air, who serves Prospero in *The Tempest*. The actor who originally played Ariel would have required wires to fly over the theatre stage, but the wireless – still in its infancy – would

finally set Ariel free and carry Shakespeare himself across the globe.

PROSPERO: These our actors,
 As I foretold you, were all spirits, and
 Are melted into air, into thin air;
 And, like the baseless fabric of this vision,
 The cloud-capped towers, the gorgeous palaces,
 The solemn temples, the great globe itself,
 Yea, all which it inherit, shall dissolve,
 And like this insubstantial pageant faded,
 Leave not a rack behind. We are such stuff
 As dreams are made on.

Shakespeare began as a purveyor of what was considered by many a vulgar form of popular entertainment, describing the world he and his audience inhabited in linguistic Technicolor; he deployed tormented ghosts and spectacular swordplay, clowns and caricatures, and he made lots of jokes – good, bad and rude. He wrote song and dance into his plays and he set his words to the great popular hits of the day. And yet, centuries later, in the Warsaw ghetto or in a South African prison, Shakespeare almost uniquely speaks to the unsettled condition of modern times. For those living the dark moments of history, as for those exploring the wilder or the sweeter shores of love, Shakespeare's words console, inspire, illuminate and question. More simply, they capture for us the essence of what it is to be restlessly human in a constantly restless world.

List of Lead Objects

Dimension: H: 128cm and H: 46.3cm
Inventory No.: IX.1494 A and X.1764

CHAPTER SIX
Europe: Triumphs of the Past

Object: Funeral Achievements of
 Henry V
Location: Westminster Abbey

Helmet
Dimensions: H: 42.5cm / W: 25.4cm /
 D: 32.4cm
Inventory No.: 839

Sword
Dimensions: H: 89.5cm
Inventory No.: 840

Shield
Dimensions: H: 61cm / W: 39.4cm
Inventory No.: 838

Saddle
Dimensions: H: 39.3cm / W: 54.6cm /
 d: 67.3cm
Inventory No.: 837

CHAPTER SEVEN
Ireland: Failures in the Present

Object: Derricke's *The Image of
 Irelande: with a discouerie of
 vvoodkarne*
Location: Edinburgh University
 Library
Dimensions: H: 20.5cm / W: 32cm
Inventory No.: De.3.76 no.11

CHAPTER EIGHT
City Life, Urban Strife

Object: woollen cap
Location: British Museum
Dimensions: H: 6.3cm / W: 25cm
Inventory No.: 1856,0701.1882

CHAPTER NINE
New Science, Old Magic

Object: obsidian mirror
Location: British Museum
Dimensions: H: 22.4cm / W: 18.6cm /
 D: 1.3cm
Inventory No.: 1966,1001.1

CHAPTER TEN
Toil and Trouble

Object: wooden ship model
Location: National Museum of
 Scotland
Dimensions: H: 65cm / W: 64.5cm /
 D: 29cm
Inventory No.: H 1993.666

CHAPTER ELEVEN
Treason and Plots

Object: Carleton's *A Thankfull
 Remembrance*
Location: British Library
Dimensions: H: 20cm / W: 15.4cm /
 D: 3cm
Inventory No.: 807.c.22.

CHAPTER TWELVE
Sex and the City

Object: glass goblet
Location: British Museum
Dimensions: H: 22.1cm / W: 12.6cm
Inventory No.: S.853

CHAPTER THIRTEEN
From London to Marrakesh

Objects: gold objects from Salcombe
 hoard
Location: British Museum
Dimensions: H: 2.85cm / W: 2.85cm
Inventory No.: 1999, 1207. 30

CHAPTER FOURTEEN
Disguise and Deception

Object: pedlar's trunk and contents
Location: Stonyhurst College
Dimensions: H: 34.5cm / W: 85cm /
 D: 37cm
Inventory No.: N/A

CHAPTER FIFTEEN
The Flag That Failed

Object: Union flag designs
Location: National Library of
 Scotland
Dimensions: H: 29cm / W: 42.5cm /
 D: cm
Inventory No.: MS.2517 f.67

CHAPTER SIXTEEN
*A Time of Change, a Change
of Time*

Object: clock
Location: British Museum
Dimensions: H: 59cm / W: 26cm /
 D: 23.3cm
Inventory No.: 1958,1006.2139

CHAPTER SEVENTEEN
Plague and Playhouse

Object: proclamation issued by
 James I

Location: British Library
Dimensions: H: 384mm / W: 283 mm
Inventory No.: C.112.h.1. (23.)

CHAPTER EIGHTEEN
London Becomes Rome

Object: Print from *The Arches of
 Triumph*, Stephen Harrison,
 London 1604
Location: British Museum

Londinium
Dimensions: H: 26.8cm /
 W: 23.1cm
Inventory No.: 1880,1113.5777

CHAPTER NINETEEN
The Theatres of Cruelty

Object: eye relic mounted in silver
Location: Stonyhurst College
Dimensions: H: 6.2cm / W: 4.6cm /
 D: 1.7cm
Inventory No.: N/A

CHAPTER TWENTY
Shakespeare Goes Global

Object: Robben Island Bible
Owned by Sonny Venkatrathnam
Dimensions: H: 21.5cm / W: 15cm /
 D: 5.5cm
Inventory No.: N/A

Bibliography

GENERAL

Melissa D. Aaron, *Global economics: a history of the theatre business, the Chamberlain's Men/ King's Men and their plays 1599–1642* (Newark, 2005).

Pascale Aebischer, *Jacobean drama: a reader's guide to essential criticism* (Basingstoke, 2012).

John H. Astington, *Actors and acting in Shakespeare's time* (Cambridge, 2010).

Jonathan Bate, *The genius of Shakespeare* (London and Basingstoke, 1997).

Jonathan Bate, *The soul of the age: the life, mind and world of William Shakespeare* (London, 2008).

Jonathan Bate and Dora Thornton, *Shakespeare: staging the world* (London, 2012).

John D. Cox and David Scott Kastan (eds.), *A new history of early English drama* (New York, 1997).

Gregory Doran, *The Shakespeare almanac* (London, 2009).

Stuart Gillespie, *Shakespeare's books: a dictionary of Shakespeare's sources* (London, 2001).

Frank Kermode, *Shakespeare's Language* (London, 2000).

Frederick Kiefer, *Shakespeare's visual theatre: staging the personified characters* (Cambridge, 2003).

Charles Nicholl, *The Lodger: Shakespeare on Silver Street* (London, 2008).

Terence G. Schoone-Jongen, *Shakespeare's companies: William Shakespeare's early career and the acting companies, 1577–1594* (Farnham, 2008).

James Shapiro, *1599: a year in the life of William Shakespeare* (London, 2005).

S. Shoenbaum, *William Shakespeare: a documentary life* (New York and Oxford, 1987).

Tiffany Stern, *Documents of performance in early modern England* (Cambridge, 2009).

Peter Thomson, *Shakespeare's theatre* (London and New York, 1983).

CHAPTER ONE
England Goes Global

Peter Barber, 'Was Elizabeth I interested in maps?', *Transactions of the Royal Historical Society* 14 (2004), 185–98.

J. B. Hartley, 'Silence and secrecy: the hidden agenda of cartography in early modern Europe', *Imago Mundi* 40 (1988), 57–76.

Catherine Delano Smith, 'Map ownership in sixteenth-century Cambridge: the evidence of probate inventories', *Imago Mundi* 47 (1995), 67–93.

N. J. W. Thrower (ed.), *Sir Francis Drake and the famous voyage, 1577–1580* (Berkeley/London, 1984).

CHAPTER TWO
Communion and Conscience

Eamon Duffy, 'Bare ruined choirs: remembering Catholicism in Shakespeare's England', in Richard Dutton, Alison Findlay and Richard Wilson (eds.), *Theatre and religion: Lancastrian Shakespeare* (Manchester, 2003), 40–57.

Edgar I. Fripp, *Shakespeare's Stratford* (London, 1928).

Steven Marx, *Shakespeare and the Bible* (Oxford, 2000).

J. R. Mulryne, 'Professional players in the Guild Hall, Stratford-upon-Avon, 1568–1597', *Shakespeare Survey* 60 (2007), 1–22.
Shakespeare's church: a parish church for the world.

CHAPTER THREE
Snacking Through Shakespeare

Julian Bowsher, *Shakespeare's London theatreland; archaeology, history,* Museum of London Archaeology (London, 2012).

Julian Bowsher and Pat Miller, *The Rose and the Globe – playhouses of Shakespeare's Bankside, Southwark: excavations 1988–90,* Museum of London Archaeology Monograph 48 (London, 2009).

Joan Fitzpatrick, *Food in Shakespeare: early modern dietaries and the plays* (Aldershot, 2007).

Michael Hattaway, *Elizabethan popular theatre* (reprinted Oxford, 2005).

Chris Meads, *Banquets set forth: banqueting in English Renaissance literature* (Manchester/New York, 2001).

CHAPTER FOUR
Life Without Elizabeth

Margaret Aston, *The King's Bedpost: reformation and iconography in a Tudor group portrait* (Cambridge, 1993).

Lisa Hopkins, *Drama and the succession to the crown, 1561–1633* (Farnham, 2011).

Lisa Jardine, 'Gloriana rules! The waves; or, the advantage of being excommunicated (and a woman)', *Transactions of the Royal Historical Society*, 6th series, 14 (2004), 209–22.

P. J. Matthews, 'Portraits of Philip II as King of England', *Burlington Magazine* 142 (2000), 13–19.

Louis Montrose, *The subject of Elizabeth: authority, gender and representation* (Chicago, 2006).

CHAPTER FIVE
Swordplay and Swagger

Tobias Capwell, *The noble art of the sword: fashion and fencing in Renaissance Europe, 1520–1630* (London, 2012).

Andrew Gurr, *Playgoing in Shakespeare's London* (3rd edition, Cambridge, 2004).

Joan Ozark Holman, '"Draw if you be men": Saviolo's significance for *Romeo and Juliet*', *Shakespeare Quarterly* 42 (1994), 163–89.

Angus Patterson, *Fashion and armour in Renaissance Europe: proud lookes and brave attire* (London, 2009).

CHAPTER SIX
Europe: Triumphs of the Past

Patricia A. Cahill, 'Nation formation and the English history plays', in Richard Dutton and Jean E. Howard (eds.), *A companion to Shakespeare's works: the histories* (Oxford, 2006), 70–93.

Lisa Monnas, 'Textiles from the Funerary Achievement of Henry V', in Jenny Stratford (ed.), *The Lancastrian Court*, Harlaxton Medieval Studies 13 (Donington, 2003), 125–54.

W. H. St John Hope, 'The funeral monument and chantry chapel of King Henry the Fifth', *Archaeologia* 65 (1913), 129–83.

Brian Walsh, *Shakespeare, the Queen's Men and the Elizabethan performance of history* (Cambridge, 2009).

CHAPTER SEVEN
Ireland: Failures in the Present

Paul E. J. Hammer, *Elizabeth's wars* (Basingstoke, 2003).

Graham Holderness, '"What ish my nation": Shakespeare and national identities', in Emma Smith (ed.), *Shakespeare's histories* (Oxford, 2004), 225–45.

Willy Maley, 'The Irish text and subtext of Shakespeare's histories', in Richard Dutton and Jean E. Howard (eds.), *A companion to Shakespeare's works: the histories* (Oxford, 2006), 94–124.

Hiram Morgan, '"Never any realm worse governed": Queen Elizabeth and Ireland', *Transactions of the Royal Historical Society*, 6th series, 14 (2004), 295–309.

Andrew Murphy, 'Shakespeare's Irish history', in Emma Smith (ed.), *Shakespeare's histories* (Oxford, 2004), 203–24.

Michael Neill, 'Broken English and broken Irish: nation, language and the optic of power in Shakespeare's histories', *Shakespeare Quarterly* 45 (1994), 1–32.

CHAPTER EIGHT
City Life, Urban Strife

James Holstun, 'Riot and rebellion in Shakespeare's histories', in

Richard Dutton and Jean E. Howard (eds.), *A Companion to Shakespeare's works: the histories* (Oxford, 2006), 194–219.

Alexander Leggatt, *Jacobean public theatre* (London and New York, 1992), especially ch. 2 'The audiences and their culture', 28–48.

Charles Whitney, '"Usually in the working daies": playgoing journeymen, apprentices and servants in guild records, 1582–92', *Shakespeare Quarterly* 50 (1999), 433–58.

CHAPTER NINE
New Science, Old Magic

Silke Ackermann and Louise Devoy, '"The Lord of the smoking mirror": objects associated with John Dee in the British Museum', *Studies in History and Philosophy of Science* (2011).

Deborah E. Harkness, 'Shows in the showstones: a theatre of alchemy and apocalypse in the angel conversations of John Dee (1527–1608/9)', *Renaissance Quarterly* 49 (1996), 707–37.

Glyn Parry, *The arch-conjuror of England: John Dee* (New Haven and London, 2011).

Keith Sturgess, *Jacobean private theatre* (London and New York, 1987), especially ch. 5 '"A Quaint Device": The Tempest at the Blackfriars', 73–96.

Benjamin Wooley, *The Queen's conjuror: the science and magic of Dr Dee* (2001).

CHAPTER TEN
Toil and Trouble

Julian Goodare (ed.), *The Scottish witch-hunt in context* (Manchester, 2002).

Anthony Harris, *Night's black agents: witchcraft and magic in seventeenth-century English drama* (Manchester, 1980).

Diane Purkiss, 'Shakespeare, ghosts and popular folklore', in Stuart Gillespie and Neil Rhodes (eds.), *Shakespeare and Elizabethan popular culture* (London, 2006), 136–54.

David Stevenson, *Scotland's last royal wedding: the marriage of James VI and Anne of Denmark* (Edinburgh, 1997).

Keith Thomas, *Religion and the decline of magic* (Aylesbury, 1971).

CHAPTER ELEVEN
Treason and Plots

Nicholas W. S. Cranfield, 'George Carleton (1557/8–1628), bishop of Chichester', *Dictionary of National Biography*.

David Cressy, 'The Protestant calendar and the vocabulary of celebration in early modern England', *Journal of British Studies* 29 (1990), 31–52.

Carol Z. Wiener, 'The beleaguered isle: a study of Elizabethan and early Jacobean anti-Catholicism', *Past and Present* 51 (1971), 27–62.

CHAPTER TWELVE
Sex and the City

John Drakakis, 'Shakepeare and Venice', in Michele Marrapodi (ed.), *Italian culture in the drama of Shakespeare and his contemporaries* (Aldershot, 2008), 169–86.

Graham Holderness, *Shakespeare and Venice* (Farnham, 2010).

Carole Levin and John Watkins, 'Shakespeare and the decline of the Venetian Republic', in *Shakespeare's foreign worlds: national and transnational identities in the Elizabethan age* (Ithaca and London, 2009), 111–44.

James Shapiro, *Shakespeare and the Jews* (New York, 1996).

Hugh Tait, *The golden age of Venetian glass* (London, 1979).

CHAPTER THIRTEEN
From London to Marrakesh

Jack d'Amico, *The Moor in English Renaissance drama* (Tampa, 1992).

Kim F. Hall, 'Othello and the problem of blackness', Richard Dutton and Jean E. Howard (eds.), *A Companion to Shakespeare's works: the tragedies* (Oxford, 2006), 357–92.

Ania Loomba, *Shakespeare, race and colonialism* (Oxford, 2002).

Nabil Matar, *Britain and Barbary, 1589–1689* (Tampa, 2005).

Venetia Porter and Patricia Morison, 'The Salcombe Bay Treasure', *British Museum Magazine* vol. 30 (1998) 16–18.

Daniel J. Vitkus (ed.), *Piracy, slavery and redemption: Barbary captivity narratives from early modern England* (New York, 2001).

CHAPTER FOURTEEN
Disguise and Deception

Adam Fox, 'News and popular political opinion in Elizabethan and early Stuart England', *Historical Journal* 40 (1997), 597–620.

Richard Dutton, Alison Findlay and Richard Wilson (eds.), *Region, religion and patronage: Lancastrian Shakespeare* (Manchester, 2003).

Lisa McClain, 'Without church, cathedral or shrine: the search for religious space among Catholics in England, 1559–1625', *Sixteenth Century Journal* 33 (2002), 381–99.

Margaret Spufford, 'The pedlar, the historian and the folklorist: seventeenth-century communications', *Folklore* 105 (1994), 13–24.

William Collins Watterson, 'Shakespeare's confidence man', *Sewanee Review* 101 (1993), 536–48.

CHAPTER FIFTEEN
The Flag That Failed

D. Baker and W. Maley (eds.), *British identities and English Renaissance literature* (Cambridge, 2002).

Glenn Burgess, Rowland Wymer and Jason Lawrence (eds.),

The accession of James I
(Basingstoke, 2006).

Bruce Galloway, *The union of England and Scotland 1603–1608* (Edinburgh, 1986).

W. Maley, '"This sceptred isle": Shakespeare and the British problem', in J. J. Joughin (ed.), *Shakespeare and national culture* (Manchester, 1997), 83–108.

CHAPTER SIXTEEN
A Time of Change, a Change of Time

Paul Glennie and Nigel Thrift, *Shaping the day: a history of timekeeping in England and Wales 1300–1800* (Oxford, 2009).

Ronald Pollitt, '"Refuge of the Distressed Nations": perceptions of aliens in Elizabethan England', *Journal of Modern History* 52 (1980), D1001–D1019.

Irwin Smith, 'Dramatic time versus clock time in Shakespeare', *Shakespeare Quarterly* 20 (1969), 65–9.

David Thompson, *Clocks* (London, 2004).

CHAPTER SEVENTEEN
Plague and Playhouse

John H. Astington, *English court theatre 1558–1642* (Cambridge, 1999).

Leeds Barroll, *Politics, plague and Shakespeare's theatre: the Stuart years* (Ithaca and London, 1991).

F. P. Wilson, *The plague in Shakespeare's London* (Oxford, 1927).

CHAPTER EIGHTEEN
London Becomes Rome

Paul Dean, 'Tudor humanism and the Roman past: a background to Shakespeare', *Renaissance Quarterly* 41 (1988), 84–111.

C. Martindale and A. B. Taylor (eds.), *Shakespeare and the classics* (Cambridge, 2004).

David L. Smith, Richard Strier and David Bevington (eds.), *The theatrical city: culture, theatre and politics in London 1576–1649* (Cambridge, 1995).

CHAPTER NINETEEN
The Theatres of Cruelty

Thomas Cooper, 'Edward Oldcorne (1561–1606), Jesuit', *Dictionary of National Biography*.

Gillian Murray Kendall, 'Overkill in Shakespeare', *Shakespeare Quarterly* 43 (1992), 33–50.

Alexandra Walsham, 'Miracles and the Counter-Reformation mission to England', *Historical Journal* 46 (2003), 779–815.

CHAPTER TWENTY
Shakespeare Goes Global

Douglas Lanier, *Shakespeare and modern culture* (Oxford, 2002).

Robert Shaughnessy (ed.), *The Cambridge Companion to Shakespeare and popular culture* (Cambridge, 2007).

Nigel Wheale, *Writing and society: literacy, print and politics in Britain 1590–1660* (London and New York, 1999).

References

CHAPTER ONE
England Goes Global

p. 1 'We the globe can compass soon . . .': *A Midsummer Night's Dream*, 4.1.96–7.

p. 1 'I'll put a girdle round the earth . . .': *A Midsummer Night's Dream*, 2.1.175–6.

p. 3 'And the 26 of September we safely with joyful minds . . .': Francis Fletcher's account, reproduced in *The World encompassed by Sir Francis Drake, Being his next voyage to that to Nombre de Dios, formerly imprinted; carefully collected out of the notes of Master Francis Fletcher* (London, 1628).

p. 5 'She is spherical, like a globe; I could find out countries in her . . .': *The Comedy of Errors*, 3.2.120–47.

p. 7 Richard Hakluyt, *The Principal Navigations, Voyages, Traffics and Discoveries of the English Nation* (London, 1589). And the later edition: *The Principal Navigations, Voyages, Traffics and Discoveries of the English Nation* (1598–1600).

p. 7 Sir Walter Raleigh, *The Discovery of the Large, Rich, and Beautiful Empire of Guiana with a relation of the great and golden city of Manoa (which the Spaniards call El Dorado) and the provinces of Emeria, Arromaia, Amapaia, and other countries, with their rivers, adjoining* (1596).

p. 7 'Here's another letter to her; she bears the purse, too . . .': *Merry Wives of Windsor* 1.3.62–7.

p. 8 Abraham Ortelius, *Theatrum Orbis Terrarum* (1570).

CHAPTER TWO
Communion and Conscience

p. 10 'Stay, give me drink. Hamlet, this pearl is thine ...': *Hamlet*, 5.2. 276–86.

p. 16 'Bare ruined choirs, where late the sweet birds sang': Sonnet 73.

p. 16 'I am thy father's spirit ...': *Hamlet*, 1.5.9–13.

p. 17–18 'Grief fills the room up of my absent child ...': *King John*, 3.4.93–7.

p. 18 'Give him the cup ...': *Hamlet*, 5.2.277.

CHAPTER THREE
Snacking Through Shakespeare

p. 23 'On September 21st after lunch ...': Thomas Platter, *Platter's Travels in England* (1599); cited in Newton Key and Robert Bucholz, *Sources and debates in English history, 1485–1714* (John Wiley, 2009), p. 98.

p. 24 'a place ... onely for the Nobilitie': Thomas Heywood, *Gynaikeion: or, Nine Books of Various History concerning Women* (1624).

p. 25 'My doe with the black scut! Let the sky rain potatoes ...': *Merry Wives of Windsor*, 5.5.18–21.

CHAPTER FOUR
Life Without Elizabeth

p. 28 'And here I prophesy: this brawl today ...': *Henry VI*, 2.4.124–30.

p. 28–29 'We will unite the white rose and the red ...': *Richard III*, 5.5.19–34.

p. 29 'Canst thou, O partial sleep, give thy repose ...': *Henry IV, Part 2*, 3.1.26–31.

p. 35 Peter Wentworth, *A Pithy Exhortation to Her Majesty for Establishing Her Successor to the Crown* (1598).

p. 36 'Abate the edge of traitors, gracious Lord ...': *Richard III*, 5.5.35–42.

CHAPTER FIVE
Swordplay and Swagger

p. 37 'Gentle Mercutio, put thy rapier up ...': *Romeo and Juliet*, 3.1.82–91.

p. 39 'That's meat and drink to me, now ...': *Merry Wives of Windsor*, 1.1.274–9.

p. 40–41 'He fights as you sing prick-song, keeps time, distance ...': *Romeo and Juliet*, 2.4.20–26.

p. 42 'The King, sir, hath wager'd with him six Barbary horses ...': *Hamlet*, 5.2.145–50.

p. 42 'Tybalt, Mercutio, the prince expressly hath ...': *Romeo and Juliet*, 3.1.86–7.

p. 42 'that men might butcher one another here at home in peace': George Silver, *Paradoxes of Defence* (1599).

p. 42 'carry two daggers or two rapiers in a sheath always about them ...': *Holinshed's Chronicles* or *The first and second volumes of Chronicles comprising 1 The description and history of England, 2 The description and history of Ireland, 3 The description and history of Scotland: first collected and published by Raphaell Holinshed, William Harrison, and others* (1587), vol. 1, p. 199.

p. 42–43 'None shall wear spurs, swords, rapiers, daggers ...': Royal proclamation enforcing a range of sumptuary-law statutes, published in Paul F. Hughes and James F. Larkin, *Tudor royal proclamations* (3 vols., New Haven, 1964, 1969), no. 601.

p. 43–44 'That had his hand continuall on his dagger': Dedication to 'The Gentleman Reader' in Samuel Rowlands, *The Letting of Humours Blood in the Head-Vaine with a new Morissco* (1600), page A2.

p. 44 'Now to let you understand the news, I will tell you some ...': J. Payne Collier (ed.), *Henslowe and Alleyn: being the diary of Philip Henslowe and the life of Edward Alleyn* (London, 1853), vol. 2, p. 51.

CHAPTER SIX
Europe: Triumphs of the Past

p. 45 'Once more unto the breach, dear friends, once more ...: *Henry V*, 3.1.1–2.

p. 45 'In peace there's nothing so becomes a man ...': *Henry V*, 3.1.3–8.

p. 46 'For he today that sheds his blood with me ...': *Henry V*, 4.3.60–64.

p. 46 'I see you stand like greyhounds in the slips ...': *Henry V*, 3.1.31–4.

p. 47 'Hung be the heavens with black, yield day to night! ...': *Henry VI, Part 1*, 1.1.1–7.

p. 49 'You may imagine him upon Blackheath ...': *Henry V*, 5, prologue, 16–22.

p. 50 'But there's a saying very old and true ...': *Henry V*, 1.2.166–71.

p. 51 'Plays have made the ignorant more apprehensive ...': Thomas Heywood, *Apology for Actors* (1612).

p. 52 'You have witchcraft in your lips ...': *Henry V*, 5.2.272–6.

p. 52 'here we did see, by particular favour, the body of Queen ...': Samuel Pepys's diary, 23 February 1699. Available online at: http://www.pepys.info/1669/1669.html.

CHAPTER SEVEN
Ireland: Failures in the Present

pp. 53–54 'The day is hot ...': *Henry V*, 3.2.103–30.

p. 54 'The town is beseeched, and the trumpet call us to the breach ...': *Henry V*, 3.2.104–6.

p. 55 John Derricke, *The Image of Irelande with a Discovery of Woodkern* (London, 1581).

p. 56 'There was not in Ireland a greater destroyer against foreigners . . .': the *Annals of Loch Cé: a chronicle of Irish affairs from AD 1014 to AD 1590*, partly compiled by B. MacDermot; edited with a translation by W. M. Hennessy (London, 1871). Available online at: http://www. ucc.ie/celt/published/T100010A/index.html. At LC1578.8.

p. 57 'Now for our Irish wars . . .': *Richard II*, 2.1.155.

p. 58 'The Duke of York is newly come from Ireland . . .': *Henry VI, Part 2*, 4.9.24–7.

p. 58 'My Lord of York . . .': *Henry VI, Part 2*, 3.1.309–14.

p. 60 'And then it was when the unhappy king . . .': *Henry IV, Part 1*, 1.3.146–50.

p. 61 'Were now the general of our gracious Empress . . .': *Henry V*, 5, chorus, 30–34.

City Life, Urban Strife

p. 62 'Then mother you are willing . . .': Samuel Pepys, 1.260, 'A country new jig', stanza 8; this can be found in Hyder E. Rollins (ed.), *A Pepysian garland: black-letter broadside ballads of the years 1595–1639* (Cambridge, MA, 1971), pp. 132–8.

p. 64 'My lord, as I was sewing in my closet . . .': *Hamlet*, 2.1.77–84.

p. 65 '[He] will work nyver but ly drinking at the ale house . . .': The Carpenters' Company Court Papers, GL7784/1, no. 63; quoted in Charles Whitney, '"Usually in the working daies": Playgoing journeymen, apprentices and servants in guild records, 1582–92', *Shakespeare Quarterly* 50 (1999), 433–58.

p. 66 'A tradesman's wife of the Exchange . . .': Henry Peacham, *The Art of Living in London, Or, A Caution how Gentlemen, Countrymen and Strangers, drawn by occasion of business, should dispose of themselves in the thriftiest way, not only in the City, but in all other populous places* (1642), p. 4.

p. 67 'You are all resolved rather to die than to famish? . . .': *Coriolanus*, 1.1.4–12.

p. 68 'You are they . . .': *Coriolanus*, 4.6.131–4.

pp. 69–70 'assembled themselves by occasion, & pretence of their meeting at a play': cited in Jessica A. Browner, 'Wrong side of the river: London's disreputable South Bank in the sixteenth and seventeenth century', *Essays in History* 36 (1994), 35–73.

p. 70 'heartily wish they might be troubled with none of their youth . . .': 'Pierce Penniless', in Thomas Nashe, *The Unfortunate Traveller and other works* (London, 2006).

p. 70 'Let us kill him, and we'll have corn at our own price': *Coriolanus*, 1.1.4–12.

CHAPTER NINE
New Science, Old Magic

p. 71 'Spirits, which by mine art . . .': *The Tempest*, 4.1.120–22.

p. 71 'I'll give thee fairies to attend on thee . . .': *A Midsummer Night's Dream*, 3.1.148–53.

p. 71 'Come, you spirits . . .': *Macbeth*, 1.5.38–41.

p. 73 'I am *Prince of the Seas* . . .': Meric Casaubon, *A True & Faithful Relation of What Passed for Many Years between Dr. John Dee and Some Spirits Tending* (London, 1659).

p. 74 'her Majestie's great contentment and delight': 'The Compendious Rehearsal' of John Dee, first published in T. Hearne (ed.), *Johannis, confratris et monachi Glastoniensis, chronica dive historia de rebus Glastoniensibus* (Oxford, 1726), vol. 2, pp. 497–551.

p. 74 'dreaded him because he was accounted a Conjurer': John Aubrey, *Brief lives* (London, 2000); Dee's life is discussed pp. 366–9.

p. 75 'And for these and other such like marvellous Actes . . .': John Dee's preface to *The Elements of Geometry of the most Ancient philosopher Euclid of Megara. Faithfully (now first) translated into the English tongue, by H. Billingsley, citizen of London* (London, 1570), p. A1.

p. 77 'It was mine Art that made gape the pine': *The Tempest*, 1.2.290–92

p. 79 'But this rough magic . . .': *The Tempest*, 5.1.50–58.

CHAPTER TEN
Toil and Trouble

p. 81 'Double, double, toil and trouble . . .': *Macbeth*, 4.1.35–6.

p. 81 'Fair is foul, and foul is fair . . .': *Macbeth*, 1.1.9–10.

p. 83 'And because it may appeare unto the world what treacherous . . .' Reginald Scot, *The Discovery of Witchcraft* (1584).

p. 84 James VI of Scotland, *Daemonologie, In Form of a Dialogue, Divided into three Books* (1597); reprinted in 1603 (as James I of England).

p. 86 'at the time when his Maiestie was in Denmarke . . .': *Newes from Scotland*, 1591/2. Available online at: http://special.lib.gla.ac.uk/exhibns/month/aug2000.html.

p. 87 'pretended to bewitch and drowne his Majesty . . .': ibid.

p. 88 'Here I have a pilot's thumb . . .': *Macbeth*, 1.3.28–9.

p. 88 'Liver of blaspheming Jew . . .': *Macbeth*, 4.1.26–34.

p. 89 'Double, double, toil and trouble . . .': *Macbeth*, 4.1.35–8.

CHAPTER ELEVEN
Treason and Plots

pp. 90–91 'For God's sake, let us sit upon the ground . . .': *Richard II*, 3.2.155–70.

p. 91 'let me prophesy . . .': *Richard II*, 4.1.136–49.

p. 92 George Carleton, Bishop of Chichester, *A Thankful Remembrance of God's Mercy: An Historical Collection of the great and merciful Deliverances of the Church and State of ENGLAND, since the Gospel began here to flourish, from the beginning of Queen Elizabeth* (1624).

p. 94 'O, what a fall was there, my countrymen!...': *Julius Caesar*, 3.2.191–9.

CHAPTER TWELVE
Sex and the City

p. 99 'Ho, no, no, no, no! My meaning in saying he is a good man...': *The Merchant of Venice*, 1.3.15–26.

p. 100 'Truely such is the stupendious...': Thomas Coryate, *Coryate's Crudities, Hastily Gobbled Up in Five Months Travels in France, Savoy, Italy, Rhetia Commonly Called the Grisons Country, Helvetia Alias Switzerland, Some Parts of High Germany and the Netherlands* (1611) p. 171.

p. 101 'I'll give my jewels for a set of beads...': *Richard II*, 3.3.147–50.

p. 102 'Why, yet it lives there uncheck'd that Antonio...': *The Merchant of Venice*, 3.1.2–7.

p. 104 'The duke cannot deny the course of law...': *The Merchant of Venice*, 3.3.26–31.

p. 105 'Fayre Venice, flower of the last worlds delight...': Edmund Spenser, *Sonnet IV*.

p. 106 'So infinite are the allurements of the most famous Calypsos...': Thomas Coryate, *Coryate's Crudities* (1611) p.171.

pp. 106–7 'It surpasseth for Cities, buildings and outward magnificence...': Robert Johnson's translation of Giovanni Botero, *An historical description of the most famous kingdoms and common-wheals in the world* (London, 1603).

CHAPTER THIRTEEN
From London to Marrakesh

p. 108 'The Sultana Isabel, who has high position and majestic glory...': Nabil Matar, *Britain and Barbary, 1589–1689* (Tampa, 2005), p. 25.

p. 109 Sir Walter Raleigh, *The Discovery of Guiana* (1596).

p. 109 'Mislike me not for my complexion...': *The Merchant of Venice*, 2.1.1–3.

p. 109 'They have in England...': *The Merchant of Venice*, 2.7.55–60.

p. 112 'Even now, now, very now, an old black ram...': *Othello*, 1.1.89–92.

p. 113 'Wherein I spake of most disastrous chances...': *Othello*, 1.3.133–7.

p. 114 Richard Hakluyt, *The Principal Navigations, Voyages, Traffics and Discoveries of the English Nation* (1598–1600); the reference to pirates can be found in the following edition: *Principal Navigations* (Glasgow, 1905), vol. 5, pp. 280–82.

p. 115 'Being boarded so, and robbed then are they tied...': Anonymous, *The Lamentable Cries of at leas*.

CHAPTER FOURTEEN
Disguise and Deception

p. 118 'If I were a woman, I would kiss as many of you . . .': *As You Like It*, 5.4.211–16.

p. 119 'Were it not better . . .': *As You Like It*, 1.3.112–20.

p. 119 'some squeaking Cleopatra': *Antony and Cleopatra*, 5.2.220.

p. 120 'Will you buy any tape . . .': *The Winter's Tale*, 4.4.313–21.

p. 121 'goeth abroad to sell sope and candels from towne to towne . . .': Cited in Adam Fox, 'News and popular political opinion in Elizabethan and early Stuart England', *The Historical Journal* 40 (1997), 597–620, at p. 602.

p. 123 'his chief employment was in making of secret places to hide . . .': *The condition of Catholics under James I: Father Gerard's narrative of the Gunpowder Plot*, ed. J. Morris (1872).

p. 123 'Those Snakes that do naturally sting . . .': Thomas Morton, *An Exact Discovery of Romish Doctrine in the Case of Conspiracy and Rebellion* (1679).

p. 123 'Faith, here's an equivocator . . .': *Macbeth*, 2.3.8–11.

p. 124 'I'll play the orator as well as Nestor . . .': *Henry VI, Part 3*, 3.2.188–93.

p. 124 'I heard myself proclaim'd . . .': *King Lear*, 2.3.1–5.

p. 125 'Whiles I may 'scape . . .': *King Lear*, 2.3.5–12.

p. 126 'the weasel Scot': *Henry V*, 1.2.170.

CHAPTER FIFTEEN
The Flag That Failed

p. 127 'She shall be, to the happiness of England . . .': *Henry VIII*, 5.5.56–62.

p. 128 'So shall she leave her blessedness to one . . .': *Henry VIII*, 5.5.43–49.

p. 128 'Wherever the bright sun of heaven shall shine . . .': *Henry VIII*, 5.5.50–55.

p. 131 'Oh where is Britaine?': William Herbert, *Lamentation of Britaine* (1606).

p. 133 'What God has conjoined then let no man separate': full text available online: http://www.british-history.ac.uk/report.aspx?compid=8962.

p. 135 'let / A Roman and a British ensign wave': *Cymbeline*, 5.5.477–83.

CHAPTER SIXTEEN
A Time of Change, a Change of Time

p. 137 'For now hath time made me his numbering clock . . .': *Richard II*, 5.5.50–51.

p. 138 'Now, sir, the sound that tells what hour it is . . .': *Richard II*, 5.5.55–6.

p. 138 'I seek a wife?': *Love's Labour's Lost*, 3.1.186–9.

p. 139 'not a jar o'th'clock': *The Winter's Tale*, 1.2.43.

p. 139 'In most places they descend no lower than the half or quarter': *The first and second volumes of Chronicles comprising 1 The description and history of England, 2 The description and history of Ireland, 3 The description and history of Scotland: first collected and published by Raphaell Holinshed, William Harrison, and others* (1587), vol. 1, p. 118.

p. 140 'Seven of my people, with an obedient start ...': *Twelfth Night*, 2.5.57–61.

p. 141 'There's no clock in the forest': *As You Like It*, 3.2.287–8.

p. 141 'Where heretofore they began not their Plaies till towards fower a clock ...': cited in Peter Thomson, *Shakespeare's theatre* (London, 1992), p. 21.

p. 142 'I that please some, try all; both joy and terror ...': *The Winter's Tale*, 4.1.1–9.

p. 143 'There is no fear in him; let him not die ...': *Julius Caesar*, 2.1.190–93.

pp. 144–5 'Doth not the world see, that you, beastly brutes ...': Cited in Bernard Cottret, *The Huguenots in England: immigration and settlement, c. 1550–1700* (Cambridge, 1991), p. 77.

pp. 145–6 'As the dial hand tells o'er ...': 'To the Queen', published in Jonathan Bate and Eric Rasmussen (eds.), *The RSC Shakespeare: the complete works* (London, 2007).

CHAPTER SEVENTEEN
Plague and Playhouse

p. 148 'To report of her death (like a thunder-clap) ...': Thomas Dekker, *The Wonderfull Yeare* (1603), published in Rev. Alexander B. Grosart (ed.), *The non-dramatic works of Thomas Dekker* (London, 1884), p. 86. Available online at: http://openlibrary.org/books/OL14030908M/The_non-dramatic_works_of_Thomas_Dekker.

p. 149 'I hear of none but the new proclamation ...': *Henry VIII*, 1.3.17–18.

p. 149 'These things indeed you have articulate ...': *Henry IV, Part 1*, 5.1.72–3.

p. 151 'Long may they kiss each other, for this cure!': *Venus and Adonis*, 505–10.

p. 153 'By heaven, I would most gladly have forgot it ...': *Othello*, 4.1.19–22.

p. 153 'the searchers of the town ...': *Romeo and Juliet*, 5.2.5–12.

p. 156 'Death ... (like stalking Tamberlaine) ...': Thomas Dekker, *The Wonderfull Yeare* (1603), published in Rev. Alexander B. Grosart (ed.), *The non-dramatic works of Thomas Dekker* (London, 1884).

CHAPTER EIGHTEEN
London Becomes Rome

pp. 158–9 'I do not like the Tower, of any place . . .': *Richard III*, 3.1.68–79.

p. 160 'But now behold . . .': *Henry V*, 5, prologue, 22–8.

p. 161 Quotations from Dekker's pamphlet are from Thomas Dekker, *The Magnificent Entertainment given to King James, Queen Anne his wife and Henry Frederick the Prince, upon the day of his Majesties triumphant passage (from the Tower) through his honourable City (and Chamber) of London* (1604), reproduced in Sir Walter Scott, *A collection of scarce and valuable tracts on most entertaining subjects*, vol. 3 (London 1810), pp. 3–35.

p. 162 'Grandsire, 'tis Ovid's *Metamorphoses* . . .': *Titus Andronicus*, 4.1.42–3.

p. 162 'Where left we last?': *The Taming of the Shrew*, 3.1.26–36.

p. 164 'Great monarch of the West . . .': 'Pageant 5, The Arches of Triumph', in Gary Taylor and John Lavagnino (eds.), *Thomas Middleton: the collected works* (Oxford, 2010), p. 254.

p. 164 'Begin our Spring, and with our Spring the Prime . . .': 'Part of the King's entertainment', in William Gifford (ed.), *The works of Ben Jonson in nine volumes* (London, 1816), vol. 6, p. 649.

CHAPTER NINETEEN
The Theatres of Cruelty

pp. 168–9 Stage directions: *Henry VI, Part 2*, 4.4; *Henry VI, Part 2*, 4.7; *Henry VI, Part 2*, 5.1; *Henry VI, Part 3*, 1.1; *Richard III*, 3.5; *King John*, 3.2; *Macbeth*, 5.8; *Cymbeline*, 4.2; and *Titus Andronicus*, 2.4 and 3.1.

pp. 170–1 'Ballard the priest, who was the first broacher of this treason': *Holinshed's Chronicles or The first and second volumes of Chronicles comprising 1 The description and history of England, 2 The description and history of Ireland, 3 The description and history of Scotland: first collected and published by Raphaell Holinshed, William Harrison, and others* (1587), vol 3, p. 1555.

p. 172 George Peele, *The Battle of Alcazar* (1594).

p. 173 'What studied torments, tyrant, hast for me?': *The Winter's Tale*, 3.2.173–7.

p. 173 Thomas Kyd, *The Spanish Tragedy* (1592).

pp. 174–5 'Fellows, hold the chair . . .': *King Lear*, 3.7.66–83.

p. 175 'There is no question whether there wanted people at this public spectacle . . .': *Holinshed's Chronicles or The first and second volumes of Chronicles comprising 1 The description and history of England, 2 The description and history of Ireland, 3 The description and history of Scotland: first collected and published by Raphaell Holinshed, William*

Harrison, and others (1587), vol. 4. (This can be found at p. 915 of the 1808 published version: Raphael Holinshed, *Chronicles of England, Scotland and Ireland*, vol. 4 (London, 1808).)

CHAPTER TWENTY
Shakespeare Goes Global

pp. 177–8 Extracts from Marcel Reich-Ranicki speech at the Bundestag, Berlin, 27 January 2012.

p. 178 'Was ever woman in this humour wooed?': *Richard III*, 1.11. 227.

p. 180 'Who, as he was a happie imitator of Nature . . .': Heminge and Condell's dedication 'To the Great Variety of Readers', First Folio (1623).

p. 183 'Cowards die many times before their deaths . . .': *Julius Caesar*, 2.2.32–7.

p. 183 'You call me misbeliever, cut-throat dog . . .': *The Merchant of Venice*, 1.3.108–26.

p. 185 'These our actors . . .': *The Tempest*, 4.1.148–57.

Quotations from Shakespeare's plays are taken from the following Penguin Classic editions:

As You Like It (2005)
The Comedy of Errors (2005)
Coriolanus (2005)
Cymbeline (2005)
Hamlet (2005)
Henry IV, Part 1 (2005)
Henry IV, Part 2 (2005)
Henry V (2010)
Henry VI, Part 1 (2005)
Henry VI, Part 2 (2005)
Henry VI, Part 3 (2007)
Henry VIII (2006)
Julius Caesar (2005)
King John (2005)
King Lear (2005)
Love's Labour's Lost (2005)
Macbeth (2005)
The Merchant of Venice (2005)

The Merry Wives of Windsor (2005)
A Midsummer Night's Dream (2005)
Much Ado About Nothing (2005)
Othello (2005)
Pericles (2008)
Richard II (2008)
Richard III (2005)
Romeo and Juliet (2005)
The Taming of the Shrew (2006)
The Tempest (2007)
Titus Andronicus (2005)
Twelfth Night (2005)
The Winter's Tale (2005)

Picture Credits

The Swan Theatre by Arnoldus Buchelius, based on original by Jan de Witt (Utrecht, University Library, MS.842, fol. 132r)

1. Sir Francis Drake's Circumnavigation Medal, 1589, designed by Michael Mercator (© The Trustees of the British Museum. Inv. No.: 188,0507.1)
2. The Stratford Chalice (image provided by the British Museum, courtesy of Martin Gorick, Vicar of Stratford upon Avon)
3. Brass-handled iron fork from the Rose Theatre (© Museum of London)
4. *The Family of Henry VIII: an Allegory of the Tudor Succession* by Lucas de Heere (1534–84) (National Museum of Wales)
5. Rapier and dagger set from the Thames foreshore (© Royal Armouries)
6. The 'Funeral Achievements' of Henry V (© Dean and Chapter of Westminster)
7. Rorie Oge, woodcut from John Derricke, the Image of Ireland, London, 1581 (Edinburgh University Library, Edinburgh)
9. Dr Dee's wax seal made under angelic instruction, late sixteenth century (© The Trustees of the British Museum. Inv.No.: 18838, 1232.90.a)
10. Model ship from Leith, *c.* 1589 (© National Museums Scotland)
10. Four witches of Berwick with cauldron and shipwreck, *Newes from Scotland*, 1591?, woodcut (Bodleian Library, University of Oxford. Douce 210)
11. 'Parry not able to kill the Queene' from George Carleton, *A Thankfull Remembrance of Gods Mercy* (© The Trustees of the British Museum. Inv. No.: 1873,0510.153)
11. 'Babington with his complices in S. Giles fields,' woodcut illustration from George Carleton, *A Thankfull Remembrance of Gods Mercy*, London, 1627 (© The British Library Board. 807.c.22).
12. Detail from glass goblet enamelled with the figure of a woman on one side and a Germanic coat of arms on the other, Venice or in the style of Venice, 1590–1600. (© The Trustees of the British Museum. Inv. No.: S.853)

13. Gold coin of Sharif al-Mansur, 1600 from the Salcombe hoard, 1600 (© The Trustees of the British Museum. Inv. No.: 1999, 1207.30)

13. Portrait of Abd Al-Wahid bin Masoud bin Muhammad Al-annuri, Moorish ambassador to Queen Elizabeth I, by unknown artist, c. 1600 (the Unversity of Birmingham Research and Cultural Collections, Birmingham)

14. Pedlar's trunk (by permission of the Governors of Stonyhurst College)

15. Designs for the Union Flag of 'Great Britain', c. 1604 (by permission of the Trustees of the National Library of Scotland. MS 2517, f. 67)

16. Weight-driven musical clock by Nicholas Vallin, 1598 (© The Trustees of the British Museum. Inv. No.: 1958,1006.2139)

17. By the King 'A Proclamation directing all the Nobility and Gentry not in attendance at Court to return to their country residences . . . ', 29 July 1603 (© the British Library Board. C.112.h.I(23)

18. *Londinium*, from Stephen Harrison, *The Arches of Triumph*, London, 1604 (© The Trustees of the British Museum. Inv. No.: 1880, 1113.5777)

19. Eye relic of the Blessed Edward Oldcorne (by permission of the British Jesuit Province)

20. Nelson Mandela's signature on page of Robben Island 'Bible' (image provided by the British Museum, courtesy of Sonny Venkatrathnam)

Acknowledgements

Like all British Museum projects, this book is the result of many people's work. It began as a series of radio programmes on BBC Radio 4, a joint venture between the two public service institutions. The idea was first floated by Mark Damazer, then Controller of Radio 4, and was energetically supported by his successor, Gwyneth Williams.

It is not always easy for large organizations to work together. That it has been possible – and enjoyable – in this case is thanks to the rare coordinating and cooperating talents of Joanna Mackle at the British Museum and Jane Ellison at the BBC.

Neither the programmes, with their accompanying website, nor this book could have happened without the scholarship, skill and commitment of the colleagues in both the British Museum and the BBC.

My greatest debt is to Barrie Cook, whose store of knowledge is exceeded only by his appetite for further research, and who not only contributed to every aspect of the project, but effectively co-created it.

At the British Museum, Mark Kilfoyle played a key part in shaping and sharpening the scripts – and the ideas – for broadcast; Ruth Levis worked closely with the BBC to develop and deliver the project's web presence; and Rosalind Winton calmly project-managed the whole process.

The team of Museum Assistants, led by Jim Peters, worked closely with the Photographic Department to ensure that objects were available for study and photography.

Many thanks also go to Matthew Cock, Lena Zimmer, Hannah Boulton and Olivia Rickman.

At the BBC, I would like to thank the Documentaries Unit, BBC Audio & Music Production. Philip Sellars brought a rigorous and creative editorial eye (and ear) to the programmes, which Paul Kobrak produced with outstanding skill and astonishing patience, abetted at every step by Anne Smith. The project was supported and extended digitally by Katherine Campbell and

Andrew Caspari. Many thanks also go to Hugh Davies, Sian Davis and Victoria Wawman.

For the making of the book, I owe a great debt of gratitude to the admirable team at Penguin, led by Stuart Proffitt, who masterminded the transition from broadcast to print. I should like to thank Andrew Barker, Chloe Campbell, Richard Duguid, Caroline Hotblack, Ilaria Rovera, Jim Stoddart, Shan Vahidy and David Watson. They have been as meticulous as they have been patient. Dr Colin Burrow of All Souls College, Oxford, very kindly read the proofs and saved me from a number of errors.

My final thanks go to those experts in the words and world of Shakespeare who appear in the different chapters of this book and who contributed so generously their knowledge and their time – above all to Jonathan Bate and to my colleague at the British Museum, Dora Thornton. Both of them, although hard at work on the Museum's exhibition 'Shakespeare: staging the world', always found the time to comment and encourage.

Index